David

and Neo-Classicism

SOPHIE MONNERET

·TERRAIL·

Front cover
Jacques-Louis David
PORTRAIT OF MADAME RÉCAMIER
Detail. 1800, oil on canvas,
173 × 243 cm (68 1/8 × 95 5/8 in).
Musée du Louvre, Paris.

Page 2
Jacques-Louis David
SELF-PORTRAIT
1790-91, oil on canvas,
64 × 53 cm (25 1/4 × 20 7/8 in).
Galleria degli Uffizi, Florence.

English Translation: Chris Miller with Peter Snowdon

Editor: Jean-Claude Dubost
Editorial Assistants: Geneviève Meunier and Christine Mormina
Editorial Aide: Hélène Cœur
Cover Design: Laurent Gudin
Graphic Design: Marthe Lauffray
Iconography: Sophie Lay-Suberbère
Typesetting and Filmsetting: DV Arts Graphiques, Chartres
Photoengraving: Litho Service T. Zamboni, Verona

© FINEST SA/ÉDITIONS PIERRE TERRAIL, PARIS 1999
The Art Books division of BAYARD PRESSE SA
Publisher's number: 245
ISBN 2-87939-217-9
English edition: © 1999
Printed in Italy

Jacques-Louis David
THE INTERVENTION OF THE SABINE WOMEN
Detail. 1799, oil on canvas,
385 × 522 cm (151 1/2 × 205 1/2 in).
Musée du Louvre, Paris.

Page 6
Jacques-Louis David
PORTRAIT OF LOUISE TRUDAINE
Detail. 1792, oil on canvas,
130 × 98 cm (51 1/8 × 38 1/2 in).
Musée du Louvre, Paris.

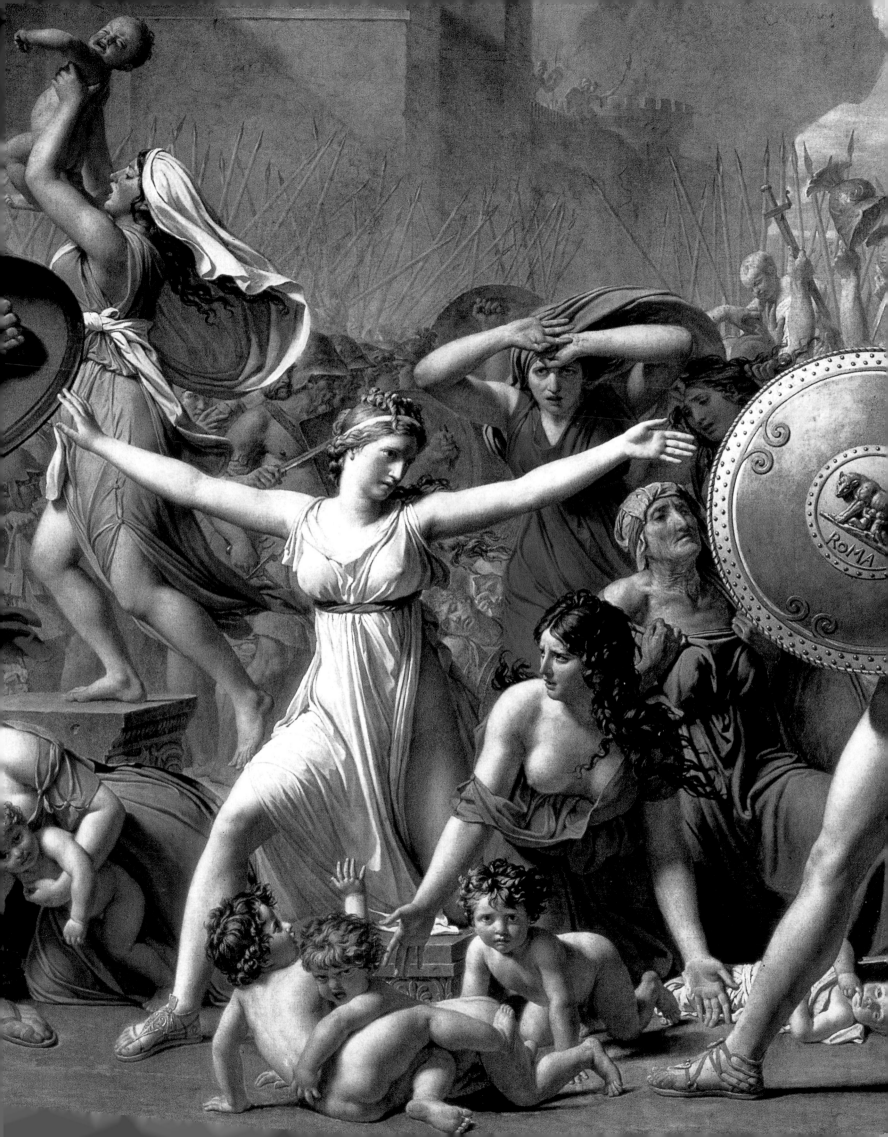

Contents

In August 1772, a young man locked himself in his room and embarked on a hunger strike; life was no longer worth living. Jacques-Louis David had failed to win the Académie Grand Prix for painting. David's career was built on a masterful exposition of the Stoic virtues, but his first appearance on the stage of history is closer to the behaviour of a Romantic hero. Fortunately, his mentor Sedaine, secretary of the Académie d'architecture, and Doyen, one of his teachers, made him see reason. Before long, the sulking youth had single-handedly wrought a revolution in art. In 1860, Delacroix observed: "He was the father of the whole modern school in painting and sculpture; he reformed our architecture too, and even the furniture in everyday use."

David's achievement, which had briefly fallen out of favour, is today clearer than ever. The fascination it held for his contemporaries has again taken hold. The crowds who make their way through the Louvre to see *The Coronation of Napoleon* testify to David's stature as an artist; only the room where the Mona Lisa hangs can boast more visitors. To understand his genius, we must grasp both the passionate character of the man and the times in which he lived, times "full of sound and fury". Rarely has an artist's work formed so integral a part of history.

| Jacques-Louis David
PORTRAIT OF ALEXANDRE LENOIR
1817, oil on canvas,
76.5 × 62.5 cm (30 1/8 × 24 5/8 in).
Musée du Louvre, Paris.

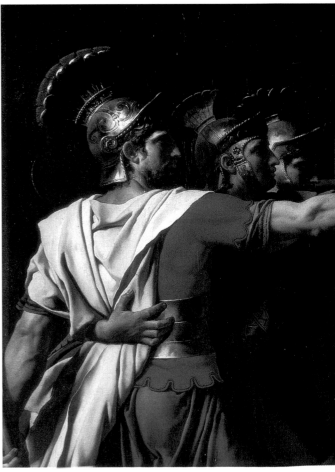

David's cyclothymic temperament provides a key not only to his violent passions, but to his style. He mastered his feelings with difficulty, and this counterpoints the rigorous discipline of his art. His career was that of an ambitious Parisian orphan promoted by an active circle of friends and relatives, but it ended in Brussels in disillusionment and exile. Throughout, it was shaped by the rapid succession of political regimes. His aim was set in his youth: to be the King's First Painter. Instead, he became court painter to Napoleon, and a republican in the service of the Empire. Yet his sensitivities were moulded by the *ancien régime* and the aspirations of the Enlightenment. Having pursued his studies and won his first laurels under Louis XVI, he subsequently voted for the King's execution.

David's fervent quest as a young man was to overcome the rococo tradition of his predecessors and the academic conventions of his training, and establish himself as the grand expositor of classical antiquity. His formalism was a reaction against the stylistic licence of the followers of Boucher and Fragonard. Theirs had been a feminine world in the image of the royal favourites; David replaced it with a masculine universe, where the warrior was paramount, and women were reduced to the roles of wife or supplicant. Themes from classical antiquity were already in the air; the subjects set

| Jacques-Louis David
THE OATH OF THE HORATII
| Detail. 1784, oil on canvas,
330 × 425 cm (130 × 167 3/8 in).
| Musée du Louvre, Paris.

Jacques-Louis David |
**THE CORONATION
OF NAPOLEON IN NOTRE-DAME**
Detail. 1805-1807, |
oil on canvas, 629 × 979 cm
(247 5/8 × 385 1/2 in).
Musée du Louvre, Paris. |

by the Académie, collectors' preferences and royal commissions all bear witness to the fact. But David neglected the most popular themes in favour of rare or unheard of subjects, and in this lay his originality.

In 1785, the prodigious impact made by the *Oath of the Horatii* secured David's place as the leading figure of international neo-classicism and the French school. His students Gros, Gérard, Girodet and Ingres continued this line with distinction. His career as a teacher lasted forty years and several generations of artists, in all of whom he instilled the same fundamental tenets: radical simplicity of composition and an obsession with form.

How did an artist so enamoured of classical antiquity come to paint contemporary scenes like *The Tennis Court Oath* or *The Coronation of Napoleon*? In this apparent contradiction lies the principal strength of David's work – its "singular combination of realism and the ideal", to quote Delacroix. For David identified the major figures of the Revolution – Le Peletier, Marat, and Bonaparte – with the virtuous heroes of the classical world. Republican values were his lodestone. By extolling them in his canvasses, he became an exemplary spokesman for the Revolution, which sought to emulate these heroic virtues in spirit if not in practice.

David was not merely a witness of his age. He was the archetype of the committed artist. He organized revolutionary festivals, reformed the arts, and painted great men and commemorative scenes. His passionate temperament lent itself to each successive cause of a passionate age. He briefly frequented progressive circles, but abandoned them for the Jacobin Club, espousing the dangerous utopianism of Robespierre. For David, art and politics were the two halves of a single coin, and his place was at the vanguard. Such convictions were a high road to extremity.

Though the keynote of his emblematic masterpieces is the 'ideal', his portraits demonstrate a formidable psychological acuity. It was a genre to which he returned throughout his career. "Painting the soul" could not compare with history painting, but his likenesses of relatives, friends and clients are intensely true to life, and he never succumbed to the temptation to prettify. Even unfinished, they move us by the sheer intensity of their presence, revealing the dogmatic author of *Brutus* in an altogether more human light.

1. The Years of Apprenticeship: from Rococo to Neo-Classicism

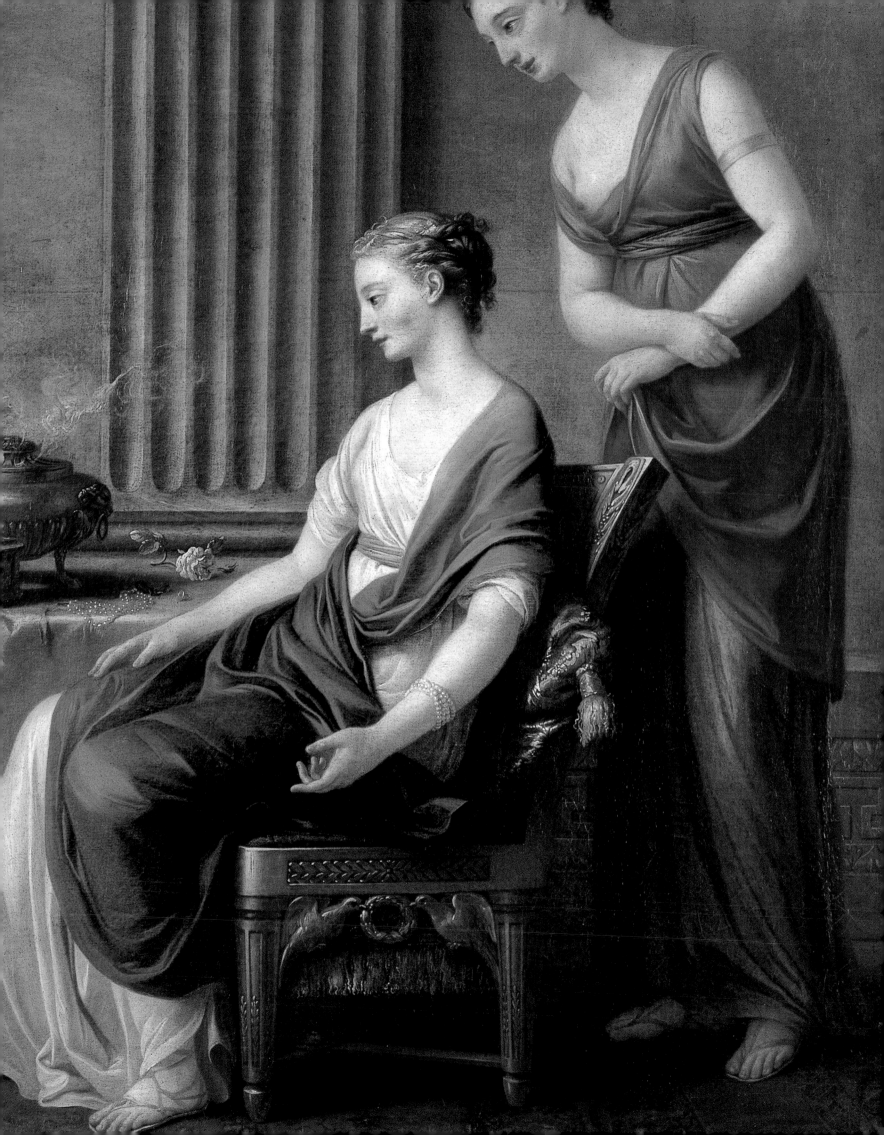

David's character and painterly ambitions were formed under the joint influence of art and commerce. His family belonged to the upper middle-classes, whose power was on the rise; his father, Louis-Maurice, was a haberdasher, providing the braid, ribbons, lace and flounces that were required items for the aristocracy. He combined this with the trade of wholesale iron merchant, at a time when the iron industry was in the ascendant. David's mother, Marie-Geneviève Buron, was the daughter of a master mason and building contractor. Her brother, François, and her brothers-in-law, notably Jacques Desmaisons, were contractors, carpenters and architects. The Buron family owed its recent wealth to a period of unprecedented activity in the construction industry; Paris grew rapidly throughout the second half of the 18th century.

Birth of a vocation

The Burons were naturally on good terms with the painters and sculptors who decorated the buildings they constructed. Moreover, they were related to one of the leading artistic figures of the century, the painter François Boucher, the favourite artist of both Madame de Pompadour and her brother, the all-powerful Director of Royal Buildings, the Marquis de Marigny. It was in this milieu that Jacques-Louis David was brought up.

At the age of seven, he went to board with the Franciscans of the Picpus convent. Two years later, on 2 December 1757, his father was killed in a duel in mysterious circumstances, while travelling in Calvados in connection with his recently acquired job as an exciseman. He was only thirty-one years old. In his book *Le Tableau de Paris*, Louis-Sébastien Mercier describes the wave of duelling which swept through high society at that time: "The craze had reached such a point that even the sanest and most careful man could not avoid quarrelling and bloodshed." The young David was then only nine years old, and was marked for life. His art is haunted by the loss of his father, and what became, for him, its cognate forms: mourning, oath-taking, vengeance and honour. A funeral procession wends its way through his paintings, linking the figures of Andromache, the Horatii and Socrates. 'Marked for life' is no metaphor. While the young orphan, in his turn, learnt to fence, an opponent's foil caught him on the corner of the mouth, leaving him with a bony growth that slightly deformed his cheek: a badge of mourning for the victim of a duel. In the patriarchal figures of his paintings, the tragedy of his father resounds.

The bereavement brought a great upheaval in the life of the young Jacques-Louis. His mother retired to Evreux, and her family took charge of the child, with his uncles taking a leading role. After studying at the Collège de Beauvais on the Montagne Sainte-Geneviève in Paris, he was admitted to the prestigious Collège des Quatre-Nations for his final year, in which rhetoric was studied. There, in what Mercier describes as "the finest, richest, most sought-after college of the University of Paris, and the poorest in able teachers and well-educated students", pupils were forbidden to read 'contentious' authors such as Montaigne and Molière. Contemporary philosophers

like Voltaire and Rousseau were quite beyond the pale. Corporal punishment was common, even for the final year. The two masters of the rhetoric class inculcated Latin oratory and verse, which their pupils were expected to improvise. This was the custom in all the colleges; perfect Latin and a detailed knowledge of Greek and Roman history made up the bulk of a contemporary education. Mercier, David's colleague in the Convention and the Institut de France, wrote, "The name of Rome was the first to etch itself in my memory. The names of Brutus, Cato and Scipio haunted my dreams. I too was a republican who hastened to defend the Republic... I razed proud Carthage to the ground... I followed the eagles on their triumphant march into Gaul." It was almost certainly at the Collège des Quatre-Nations that David, by no means an exceptional student, first felt the fascination of classical history and the heroic gestures with which it abounds. By the time he encountered these themes at the Académie, his mind was already full of the prowess of the ancient world. By an irony of fate, David twice returned to his Alma Mater: once in 1796, as a political prisoner, when the college was temporarily converted into a gaol; and again in 1806, this time as a member of the Académie, when the buildings on the quai de Conti became the home of the Institut de France. The Institut is still housed there today.

By the time David left the Collège des Quatre-Nations, he had time for one thing only: drawing. His mother wanted him to pursue a military career, in the hope of his securing a title for the family, while his two guardians hoped he would follow in their footsteps and become an architect. In later years, David wrote of himself (always in the third person): "From his early childhood, he showed an exclusive passion for drawing (...). His love for painting growing in proportion to the resistance of his relatives, who were opposed to his becoming an artist, he sought information on all sides about ways of studying drawing in greater depth." The young man badgered his uncle Buron, with whom he was then living, so persistently that his guardians decided to ask the advice of their relative, François Boucher.

The young David, however, already had a valuable protector – a friend of the family, who remained loyal to him throughout his life. Indeed, it was probably thanks to Michel-Jean Sedaine that he had secured a place at the Collège des Quatre-Nations. Sedaine was a well-known dramatist, and on good terms with many of the leading writers of the day, notably Diderot. Sedaine's childhood was a subject worthy of that arch-sentimentalist, Greuze. Born the son of a bankrupt architect, he soon found himself an orphan, and worked as a stonecutter to support his family. Self-taught, he began to write the songs and light comedies that made him famous. His employer, Jacques Buron, noticed him, promoted him, and sponsored his admission to the Académie d'Architecture, of which Sedaine became the secretary. In his turn, Sedaine grew fond of his sponsor's ward, encouraged him in his vocation and later obtained for him a studio in the Louvre. Diderot's daughter, Mme de Vandeul, pronounced the funeral oration for Sedaine, who died in 1797. She spoke of Sedaine's attachment for David: "He had sensed the child's talent, and was proud of his success. Indeed, he was so attached to him that many

people believed the boy to be his son." Alphonse Rabbe was a student of David's in 1802; after David's death, he remarked that Sedaine showed David "a warmth of affection that bore all the signs of fatherly tenderness". Sedaine's involvement was decisive in forming David's taste. He taught David simplicity, and the realism and lack of pretension of David's portraits owe much to his example. Sedaine also endowed his protégé with the sense of theatre that pervades David's entire corpus. Sedaine's plays drew on his experience of the people, familiarising David with emotions he would again encounter during the Revolution.

Resigned to the fact that his adolescent nephew would never follow in his footsteps, François Buron, aided and abetted by Sedaine, took him to meet François Boucher. The old artist was then at the height of his fame. He would not take David on as a pupil; he was too tired, and his health too weak, to deal with a beginner, though he acknowledged David's talent. Instead, he recommended him to Joseph-Marie Vien, who was famous throughout Europe as a teacher. Vien accepted. David was seventeen years old. At last, he was able to devote himself entirely to painting.

An academic training

On entering Vien's studio, David was confronted with a rigid, indeed an ossified, artistic institution – at a time when artistic taste in Europe was changing. In Vien's world, the authority of the Académie de Peinture et d'Architecture was absolute, and the hierarchy of genres unquestionable. History painting – subjects drawn from history, the Bible, and mythology – was inherently superior to portraiture, landscape and genre scenes. Young painters aspired to the Grand Prix de l'Académie, with its period of study in Rome. To obtain it, become an academician in one's own right, and finally win the coveted (and highly paid) title of 'Painter to the King', an artist had to master the themes considered appropriate to the decoration of palaces and churches. This was the career on which David now embarked. Later, during the Revolution, he contributed to the destruction of the Académie as an institution, but he never cast doubt on the supremacy of history painting, despite his own genius for portraiture.

The length of his apprenticeship was determined by ancient guild conventions. Until 1780, he remained under the tutelage of his master Vien who, though a former pupil of Boucher, was an important exponent of the burgeoning neo-classical movement. It was a time of great upheaval in the world of art. The 'high style' of the baroque had long reigned supreme, finding contemporary practitioners in Restout and Natoire. It was abruptly supplanted by the French rococo style, by which all Europe had been seduced. Yet already the restrained manner of Van Loo, the poetry of Boucher and the informal brushwork of Fragonard were beginning to fall out of favour with connoisseurs.

Two tendencies had emerged in opposition to this 'high taste'. In one, the model was Greuze, and the goal was a return to the natural manner of the Flemish and Dutch masters. In the other, the goal was simplicity and

After Jacques-Louis David |
MICHEL-JEAN SEDAINE
Undated, lithograph,
14.5 × 11.3 cm (5 3/4 × 4 1/2 in).
Cabinet des estampes,
Bibliothèque Nationale de France, Paris.

| Joseph-Marie Vien
GLYCERA,
OR THE FLOWER SELLER
| 1762, oil on canvas,
91 × 68 cm (35 3/4 × 26 3/4 in).
Musée des Beaux-Arts, Troyes.

the model was ancient Greece and Rome. The excavations at Pompeii and Herculaneum had awakened a keen interest in the classical world, comparable to that of the Renaissance. Originating in Rome, this new classicising manner spread throughout Europe. In France, it revived the old quarrel between the Ancients and the Moderns. In 1749-1751, the architect Soufflot and the painter and engraver Charles-Nicolas Cochin had accompanied Vandières, Madame de Pompadour's brother and the future marquis de Marigny, on a journey through Italy. Now back in France, they were preaching their enthusiasm for a classical revival. Their friend Vien had returned from Rome in 1750, captivated by the elegant lines of the Bacchantes discovered at a site soon to be identified as Pompeii.

It was the architects who were the first to respond, simplifying forms and emphasising the triangles of pediments and the vertical lines of colonnades. In 1764, Soufflot began building the church of Sainte-Geneviève, which

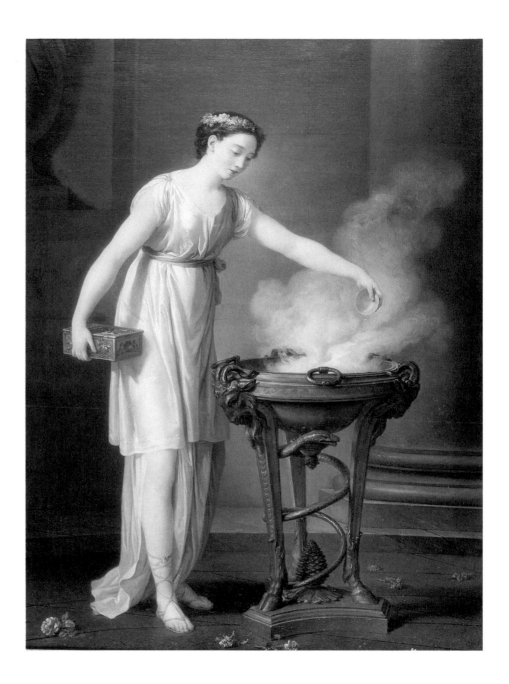

Joseph-Marie Vien |
THE VIRTUOUS ATHENIAN GIRL
Undated, oil on canvas,
89.5 × 67 cm (35 1/4 × 26 3/8 in).
Musée des Beaux-Arts, Strasbourg.

the Revolution transformed into the Pantheon. La Monnaie de Paris, built in 1768 by Antoine, was rigorously geometrical in design.

One of Vien's patrons was the comte de Caylus, a great-grand-nephew of Madame de Maintenon; as a young man, he had been a friend of Watteau's. He subsequently devoted his fortune and talents to disseminating the taste for classical art. In his works *Pictures from the Iliad, the Odyssey and the Aeneid*, and *New subjects for painting and sculpture*, he defined a new approach for young artists. The technique that had allowed the paintings of Ancient Rome to retain their freshness fascinated him. Disputing with Bachelier the credit for its rediscovery, he entrusted Vien with the formula; Vien employed it in his *Minerva*, which he exhibited to the Académies in December 1754.

In the same year, La Font de Saint-Yenne, in his *Reflections on certain works of painting, sculpture and engraving*, described the death of Socrates as a "moral

example". In 1762, Cochin proposed this as the theme for the Grand Prix de l'Académie. Twenty years later it received a definitive treatment at David's hands. Meanwhile, the neo-classicists scorned Boucher for his outdated style and pastoral themes, and the moralists deemed his work lightweight, and even licentious. His authority was still uncontested; in 1765, he was appointed the King's First Painter. But he seems to have seen where the future of painting lay. The painter to whom he entrusted David's future was the most resolutely anti-mannerist of all his contemporaries.

Vien had come to Paris from Montpellier; by the early 1760s, his authority was beginning to make itself felt. In 1762, he painted four pictures for Mme Geoffrin "in the classical taste and style of dress", and made copies for a collector in Strasbourg. The elongated forms, restrained gestures and quiet harmonies that characterised his work were in sharp contrast to the extravagant poses and provocative forms that defined rococo. At the 1763 Salon, his *Cupid Seller* introduced 'Greek taste' into French art. Inspired by a fresco from Herculaneum, it was praised by all the critics, in particular by Diderot, who eloquently applauded its simplicity. Vien, with his elegant and sober style, was hailed as the saviour of French painting, and his pupils unfailingly acknowledged him as the father of neo-classicism.

David took his first steps as an artist under the guidance of this newly recognised master. He probably studied at Vien's private school in the rue Montmartre. In 1766, he is mentioned as one of Vien's pupils in the register of the École des Beaux-Arts; the latter had been founded by the Académie Royale de Peinture et de Sculpture in 1648 as the École des Beaux-Arts de l'Académie. There David studied until he left for Rome in 1775. Vien became a surrogate father to the young David. Their relationship was often stormy, but the bonds between them remained strong. In his master's studio, the pupil rubbed shoulders with many promising young artists, among them Ménageot, Vincent and Régnault.

David was nonetheless obliged to follow the strict Academic programme, established over a century before, if he aspired to the 'official' title of *grand peintre*. At that time, the Académie de Peinture et de Sculpture was housed, along with the four other royal academies, in the old Louvre, where it occupied the first floor offices that had previously belonged to the king's cabinet. In 1763, it also took over the Apollo Gallery, where several favoured students already had their studios. Under the Académie, decoration of the gallery resumed after a gap of eighty-five years. The Academicians – all men, save for two women, Mme Vien and Mme Vallayer-Coster – exhibited every year in the Salon Carré. Their presentation pieces hung in the Assembly Room. The school employed twelve principal teachers (including Vien, Boucher, Lagrenée and Doyen) and eight assistants (each for a month at a time). The masters, almost all Academicians, were strong personalities in their own right, and often contradicted the theories of their colleagues. During the Revolution, David criticised them for this.

The pupils met in the Assembly Room, worked in their studios, and drew naked men in the life study room, which was out of bounds to the women

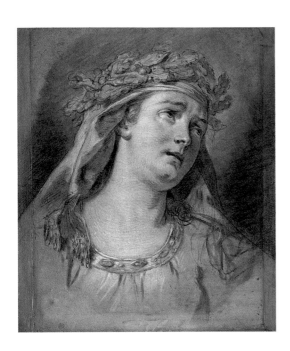

| Jacques-Louis David
SUFFERING
| 1773, pastel,
| 53.5 × 41 cm (21 × 16 1/8 in).
| École Nationale des Beaux-Arts, Paris.

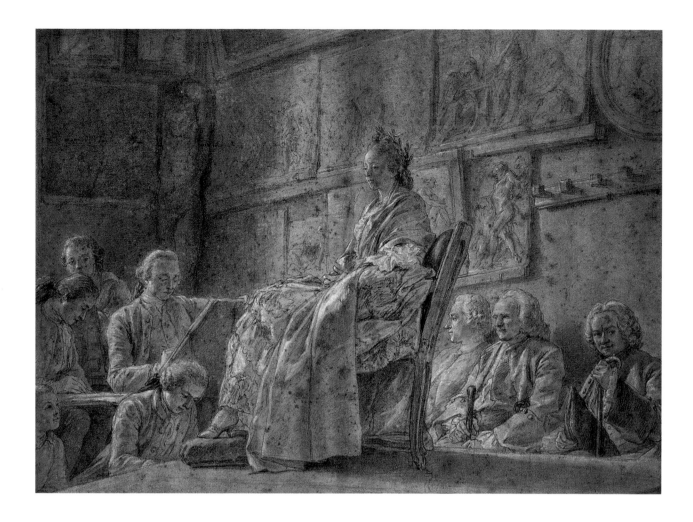

Charles-Nicolas Cochin |
**COMPETITION FOR THE PRIZE
FOR A STUDY OF AN EXPRESSIVE HEAD**
1761, black chalk and gouache
highlights on beige paper,
23 × 39 cm (9 × 15 3/8 in).
Musée Carnavalet, Paris.

students. Before graduating to painting, they had to work on drawing for two years. They first copied engravings of the great masters, then drew casts of classical statues, and finally were allowed to draw from life. They studied in the Academy's own collections, among the classical figures, so-called 'Etruscan' vases, plaster casts, and copies sent back by residents of the Académie de France in Rome. Copies by Natoire, Van Loo, Trémolières and others, were hung in the Apollo Gallery, alongside canvases by Rigaud and Mignard and tapestries after Le Brun. All these were examples of the 'high style', which was still fiercely defended by some of their teachers – men like Jean-Baptiste Pierre, who was appointed First Painter to the King on the death of Boucher in 1770. The subjects taught included history, perspective (with which David had great difficulty) and anatomy (which he studied in great depth). Recently reintroduced to the curriculum, following Caylus' proposition that there should be a "class for the study of the skeleton", this was a cutting-edge discipline. The teacher was Jean-Joseph Sue, grandfather to the author of *The Mysteries of Paris*; he was professor at the Academy of Surgery. His students witnessed dissections at the Faculté de Médecine. Cochin wished to spare them "the disgust inspired by corpses", and had an anatomical figure made out of coloured wax; its muscles could "be lifted up so that one can see underneath". All of David's later work reflects the importance he attached to the study of anatomy.

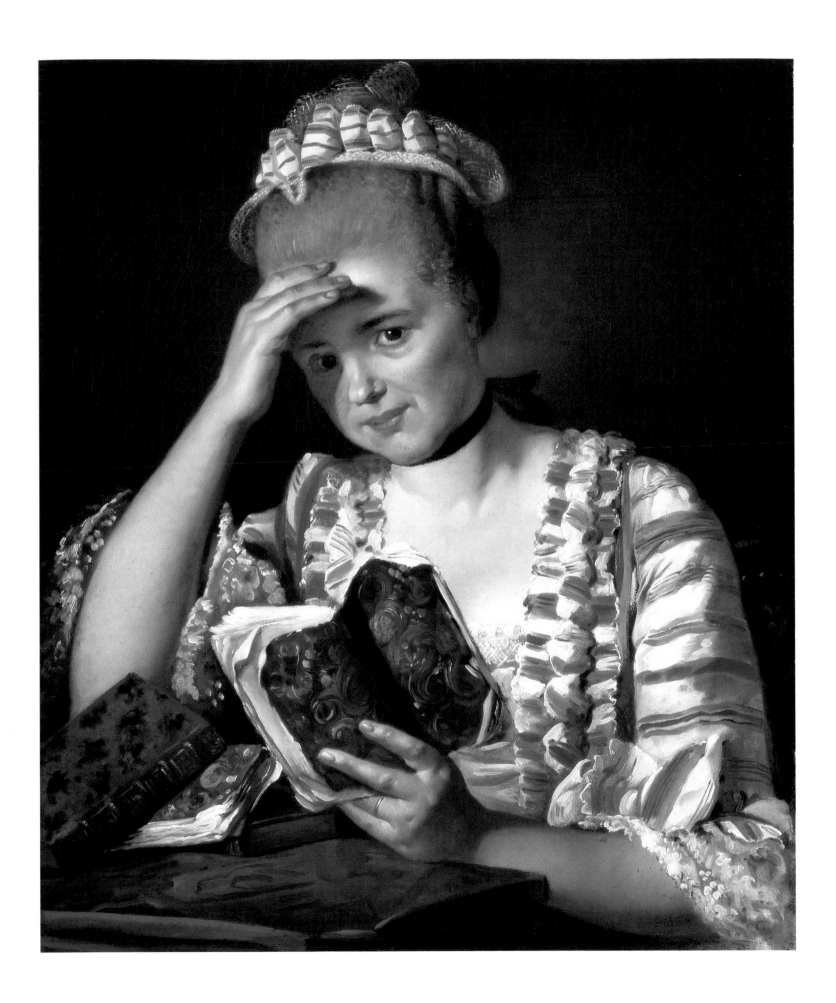

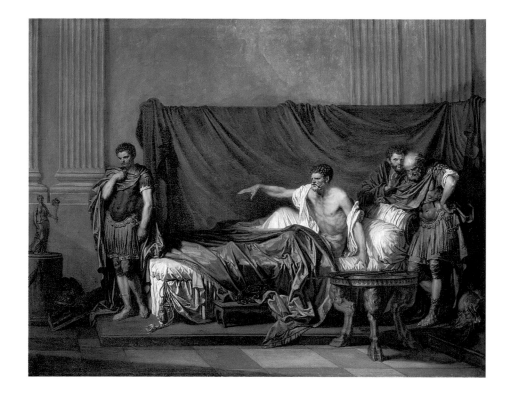

Jean-Baptiste Greuze |
SEPTIMUS SEVERUS REPROACHING HIS SON CARACALLA
1769, oil on canvas,
124 × 160 cm (48 3/4 × 63 in).
Musée du Louvre, Paris.

| Jacques-Louis David
PORTRAIT OF MARIE-JOSÈPHE BURON
1769, oil on canvas,
66 × 55 cm (26 × 21 5/8 in).
The Art Institute of Chicago.

Page 24 |
Jean-Baptiste Greuze |
SEPTIMUS SEVERUS REPROACHING HIS SON CARACALLA
Detail. |

Competition between the students was encouraged by a number of prizes, each awarded according to a precisely defined ritual. In 1769, David received the 'Life Drawing Prize' and, in 1773, the 'Expressive Head Prize' for his drawing *Suffering*. This latter prize had been founded by Caylus; tired of stereotyped faces, the count gave the Académie two hundred francs per annum for the best study of a head (one hundred for the winner, and one hundred to pay the models). Cochin made a drawing of one of these events: while the competing students pore over their task and the model strikes a serious pose, the invigilating Academicians smile wryly.

Art textbooks are a further indication of changing tastes. In 1765, one of the teachers at the Académie, Dandré-Bardon, published a *Treatise on painting*. There we find that "Classical beauty must usually be considered the model of true beauty (...). The beauty that is appropriate to youth is very exactly rendered in the figures of Castor and Pollux. Blooming skin softly spread over firm flesh. Their forms are large and simple, a layer of fat somewhat noticeable giving every part that roundness and blossoming quality characteristic of the spring of life." As for heroic action, one should study *The Gladiator* in order to learn "how the muscles (...) stretch and flatten (...) and the tendons appear through the flesh of the skin that covers them".

In his first days as a student, David lodged with his uncles. Then in 1768, he moved into the Louvre itself to stay with Sedaine, who had twenty-two rooms at his disposal in the north wing, above the Académie d'Architecture of which he was secretary. There he provided David with a studio in return for lessons to Sedaine's protégées, the Guéret sisters.

At that time the Louvre was the centre of the French art world, an eclectic and highly privileged campus inhabited by a multitude of artists. There

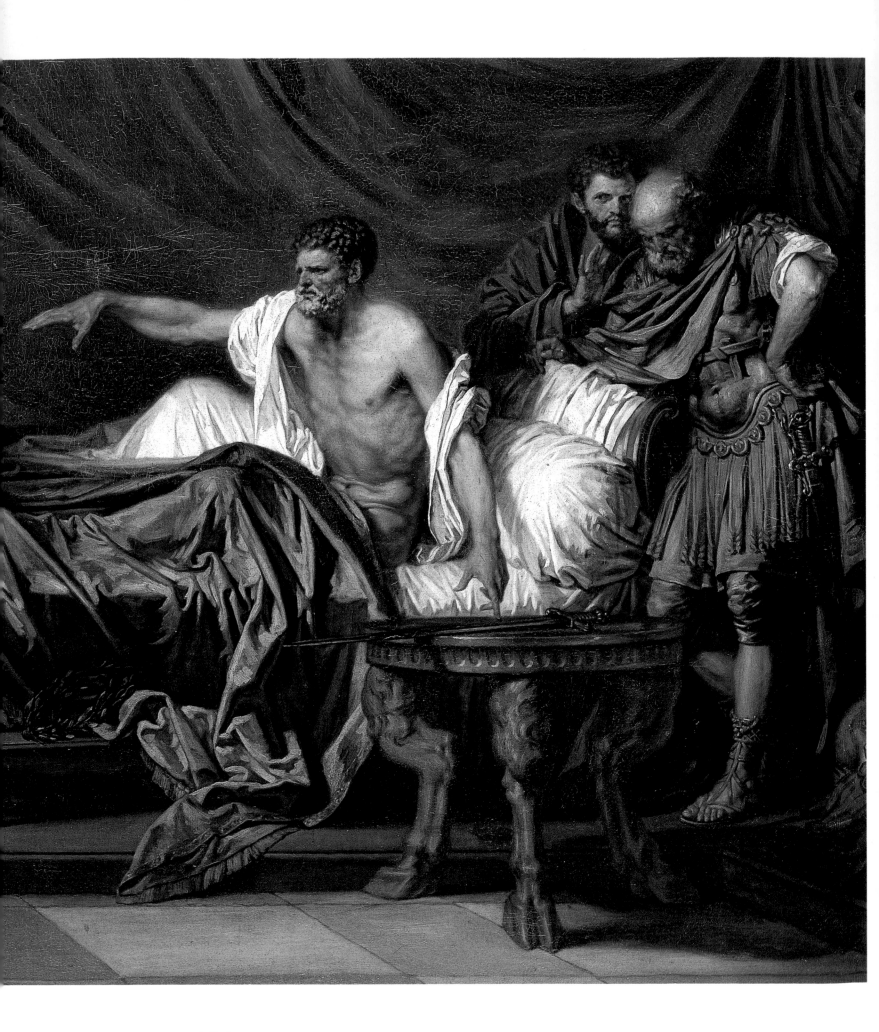

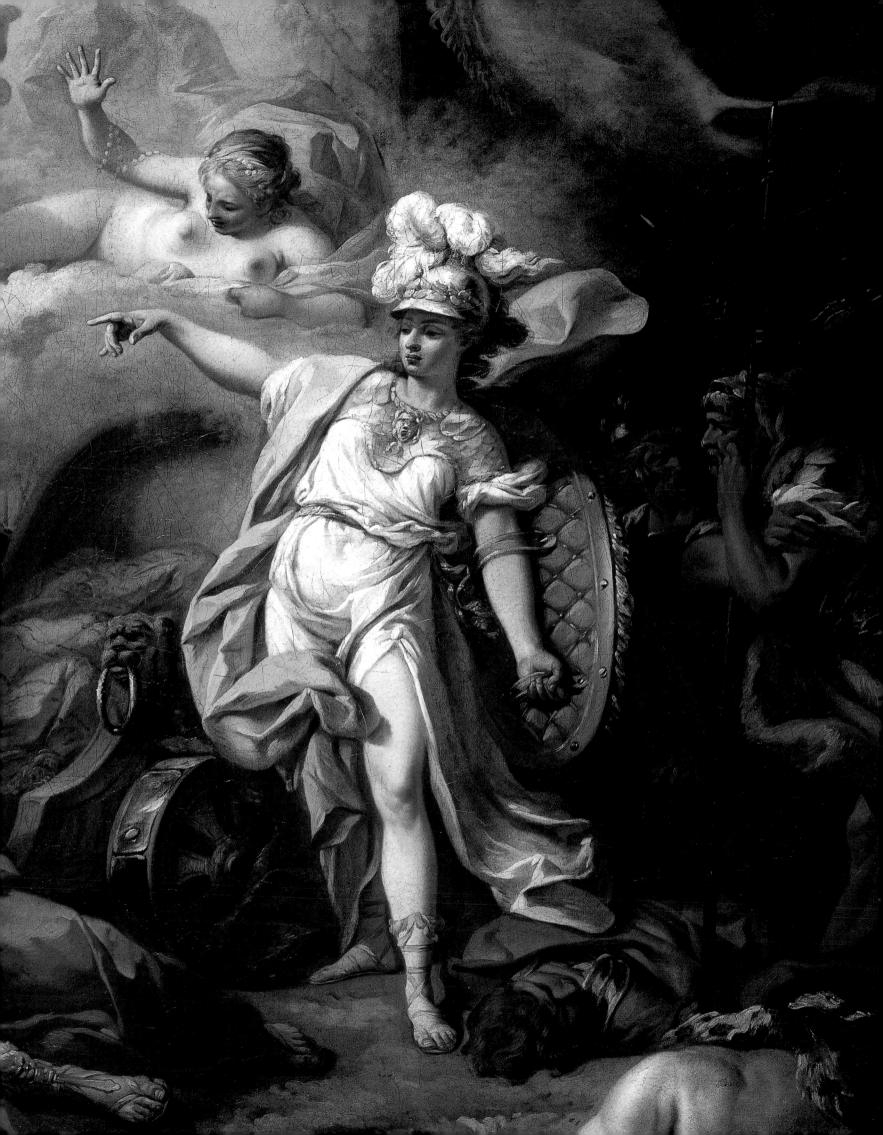

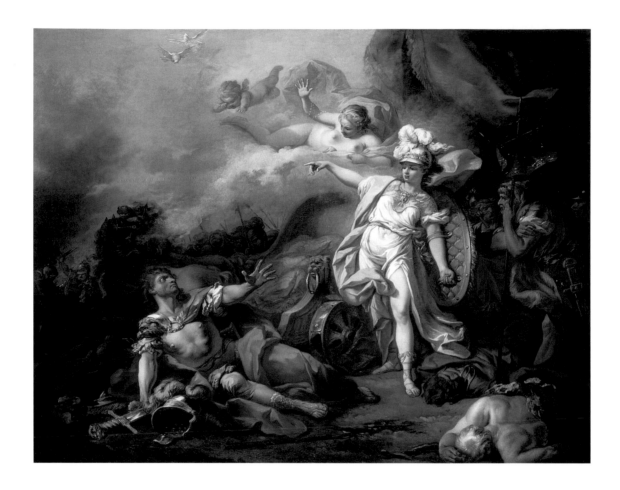

Jacques-Louis David |
**THE COMBAT OF MARS
AND MINERVA**
1771, oil on canvas,
114 × 140 cm
(45 7/8 × 55 1/8 in)
Musée du Louvre, Paris.

Page 25
Jacques-Louis David
**THE COMBAT OF MARS
AND MINERVA**
Detail.

pupils found not only their teachers, but the theoreticians associated with the *Encyclopédie*, along with connoisseurs, dealers and foreign visitors. Many of David's future friendships, rivalries and enmities began there. The palace resounded now with the virulent opinions of the pastel painter Quentin de la Tour, now with Greuze's outbursts against Academicians. Greuze could not forgive the jury of 1769 for admitting his picture *Septimus Severus Reproaching His Son Caracalla* only as a 'genre painting'. In the corridors, the students whispered their hypotheses about the Grand Prix; plots were contrived to influence its award, and rumours about backing solicited or lost were urgently discussed. Certain teachers were suspected of improving the sketches submitted by their pupils.

A corridor running along the north side of the Grande Galerie led to the masters' apartments. Fragonard, who lived next to Vien, had turned his into a museum. Their friend Joseph Vernet lived above the guardroom, near the church of Saint-Germain-l'Auxerrois. Doyen's rooms looked out onto the rue du Coq. Chardin, secretary of the Académie de Peinture, refused to let anyone see how he prepared his pigments. Hubert Robert, back in Paris after eleven years in Rome, preached the theories of Winckelmann, but refrained from practising them. The portraitist François-Hubert Drouais, a handsome giant of a man, would take his friends and pupils to study the faces of the lunatics in the Petites-Maisons asylum. David's study, *The Mad Woman* (now in the Musée de Grenoble), may well be the product of such a visit.

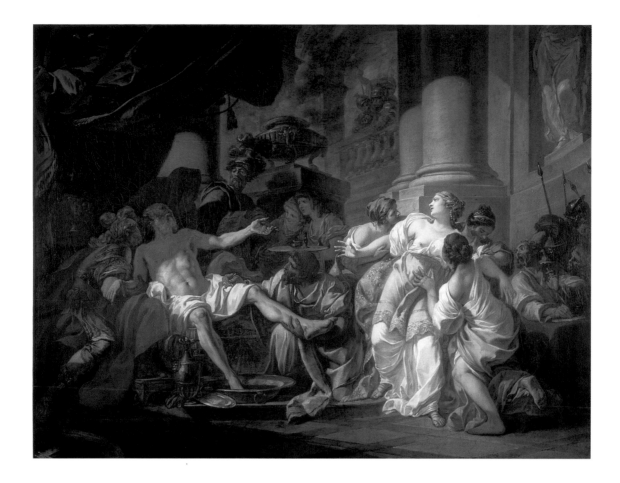

Portraits of Sedaine, his wife, and the Buron family, are among the few pictures of the young David which point towards his mature work. The treatment is conventional, but the respect for truth that was to become his hallmark is already present. There is no attempt to improve nature. Above all, the 1769 portrait of his aunt, Marie-Josèphe Buron, reveals a powerful colourist, despite the disproportion of the arms. The model's expression, half-playful, half-frowning, and the disorderly pile of books on the table, suggest an artist in search of pictorial truth. This unflinching 'bourgeois' realism was quite different from the grandiloquent compositions with which David hoped to impress the jury of the Prix de Rome.

Sedaine did not merely offer lodgings; he also admitted David to his salon. There the most brilliant intellectuals of the capital foregathered. The young man probably did little more than watch and listen. But it was here he first encountered the ideals of the Enlightenment and completed his intellectual education. The principles he learned helped him formulate his radical critique of the hidebound society in which he lived.

First failures, first success

Buffeted by so many contradictory influences, David had difficulty in establishing his own personal style. The path that led to the Grand Prix was long and arduous. Winners were admitted to the Royal School for Protected

Pupils, created in 1749 after a project by Coypel. Diderot described its functioning thus: "The School of Painting, Sculpture and Architecture, known as the School for Protected Pupils, recruits its students through a competitive examination. The talented and the incompetent are equally free to apply. Those who succeed are housed, fed, heated, lit, educated and in addition receive three hundred livres a year. After three years's study, they are sent to Rome, where they enjoy the same privileges as in Paris, with an additional one hundred francs a year. Every year, three students leave for Rome and three new students are admitted in Paris". The examination was in three parts. In March, the candidates had to execute a sketch on a theme proposed by the Academy; seven or eight were then selected to go forward to the next round, in which they had two days to produce a life study. If they passed this test, they were admitted to the final stage. In this, the painter or sculptor spent ten weeks in complete isolation, turning their initial sketch into a finished canvas or low-relief. These works were then exhibited until the Saturday following the feast of Saint Louis, when the winner was announced. In 1766, it was François-Guillaume Ménageot, a pupil of Boucher. Two years later, Vincent, a pupil of Vien, took the prize with his *Germanicus Quelling a Revolt*. His friends carried him in triumph on their shoulders around the place du Louvre. The son of a Geneva miniaturist, his style was austere, as befitted his Protestant background. His severely balanced compositions made him a natural rival to David.

That same year, a riot greeted the award of the sculpture prize to Jean-Guillaume Moitte. His teacher, Pigalle, had threatened to resign if his pupil did not win. As the Academicians arrived for the awards ceremony, the students applauded Van Loo, Dumont, and above all Boucher, who had supported Millot, the students' choice, with the energy of a younger man. When the other masters arrived, amongst them Pigalle and Monsieur and Madame Vien, the cry went up "About face!" and the students turned round and "saluted with the rump".

David fell victim to a similar plot. Caught between conflicting demands, his style was still indebted to the baroque of Van Loo and to Boucher's rococo. He had not adopted the neo-Greek austerity of Vien. And he was mindful of the opinions of Cochin, the all-powerful secretary of the Académie, only "moderately in favour of the classical revival", and of Fragonard, whose rapid brushwork was still much sought after by rich farmer generals.

In 1770, David was eliminated in the second round. In 1771, the year Vien was appointed director of the School for Protected Pupils, he reached the final stage. His *Combat of Mars and Minerva* displayed lurid colours and a theatricality reminiscent of Boucher. He was placed second. Vien had not backed him, feeling that David was not yet ready. Suvée, who won, had successfully depicted Minerva in flight, where David had avoided the difficulty by showing the goddess stepping down from her chariot. Boucher had told Diderot in 1763: "I paint fantastic events in novelistic fashion." This was not an exercise at which David excelled. His genius was of another kind, though he had not yet accepted the fact.

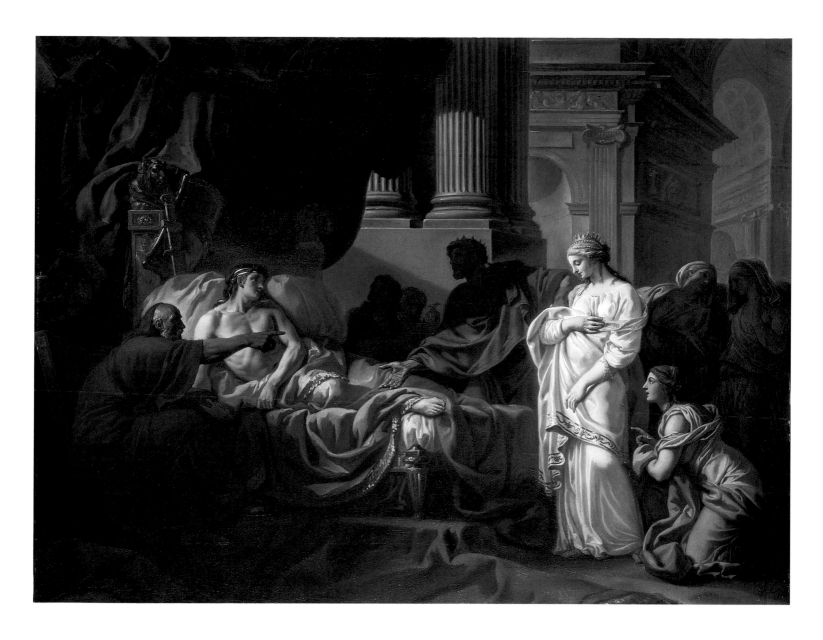

Jacques-Louis David |
**ERASISTRATUS DISCOVERS THE CAUSE
OF THE ILLNESS OF ANTIOCHUS**
1774, oil on canvas,
120 × 155 cm (47 1/4 × 61 in).
École Nationale des Beaux-Arts, Paris.

When he was again admitted to the final stage in 1772, he felt certain of success. The subject was from Ovid: *Diana and Apollo Killing the Children of Niobe*. His approach was dramatic and severe. Convinced of his superiority, which his fellow pupils acknowledged, he waited calmly for the verdict. When a corrupt jury gave the first prize *ex aequo* to Jombert and Le Monnier, he broke down in tears.

David was deeply hurt. Outraged by the injustice of the verdict, overcome with despair, he decided on suicide. Thirty years later, he still remembered the incident and would retell it with hallucinatory intensity. This was not merely a story about the naivety and frustration of a young man. His cry for help bore witness to his pride, his passionate character and his conviction of his own emerging genius. It also explains why he later demanded that the Academies should, in accordance with the democratic principles of the Revolution, be abolished, since the institutional process was corrupt and inequitable.

To quote from his own account: "I planned no longer to expose myself to a new humiliation. I gave thought to my plan, affecting a calm expression in

the presence of my relatives (...). I retired to my rooms, with every appearance of calm indifference, but once free and alone with myself, I prepared to execute my plan. This was, alas, to starve myself to death. (...) Two and a half days passed before the people living in the same house as me, hearing my sighs, went to tell M. Sedaine, in whose home we were accommodated. He knocked on the door, no reply, knocked again, still less, although he had been told for certain that I was there.

"What this fine, affectionate man did next, was to go and find the painter Doyen, his friend and one of my judges, and tell him the facts and the decision I had taken. Doyen, who was then working on the ceiling of the Invalides, quickly left his work. They immediately came to knock at my door again, but, as I made no answer: – 'What!', said Doyen, raising his voice, 'Sedaine has told me your plan, there's no sense in it, my friend, when you paint a picture like that, you should consider yourself much more fortunate than those who defeated you, they would happily change places'."

Thus comforted, David returned to his senses. The following year he was again a candidate for the Grand Prix. This time the subject was an austere one: *The Death of Seneca.* The philosopher has been condemned to death by Nero. A doctor has just opened his saphena veins and the blood is flowing slowly into a bowl. David created a theatrical composition on a background of heavy columns and drapery. In the foreground, Seneca's wife faints in her attendants' arms, reinforcing the tragic lyricism of the scene. There is vigorous work in the painting, but it did not win the prize. Failure was not as bitter this time, however, because the winning canvas was excellent. The prize went to his friend Peyron, the neo-classical grandeur of whose composition was much more appropriate to the stoic philosopher than David's rather forced baroque grandiloquence.

On his fourth attempt, in 1774, David finally won the Grand Prix. The subject was *Erasistratus Discovers the Cause of the Illness of Antiochus.* The cause is his young mother-in-law, Stratonice, and she and her female companion are rather clumsily derived from Poussin, while Antiochus languishes in the manner of Greuze. But the doctor, Erasistratus, shows a hieratic and comminatory majesty as he reveals the truth to the prince's father. Here we see the first faint inklings of David's mature style.

2. Rome: the Shock of the Old

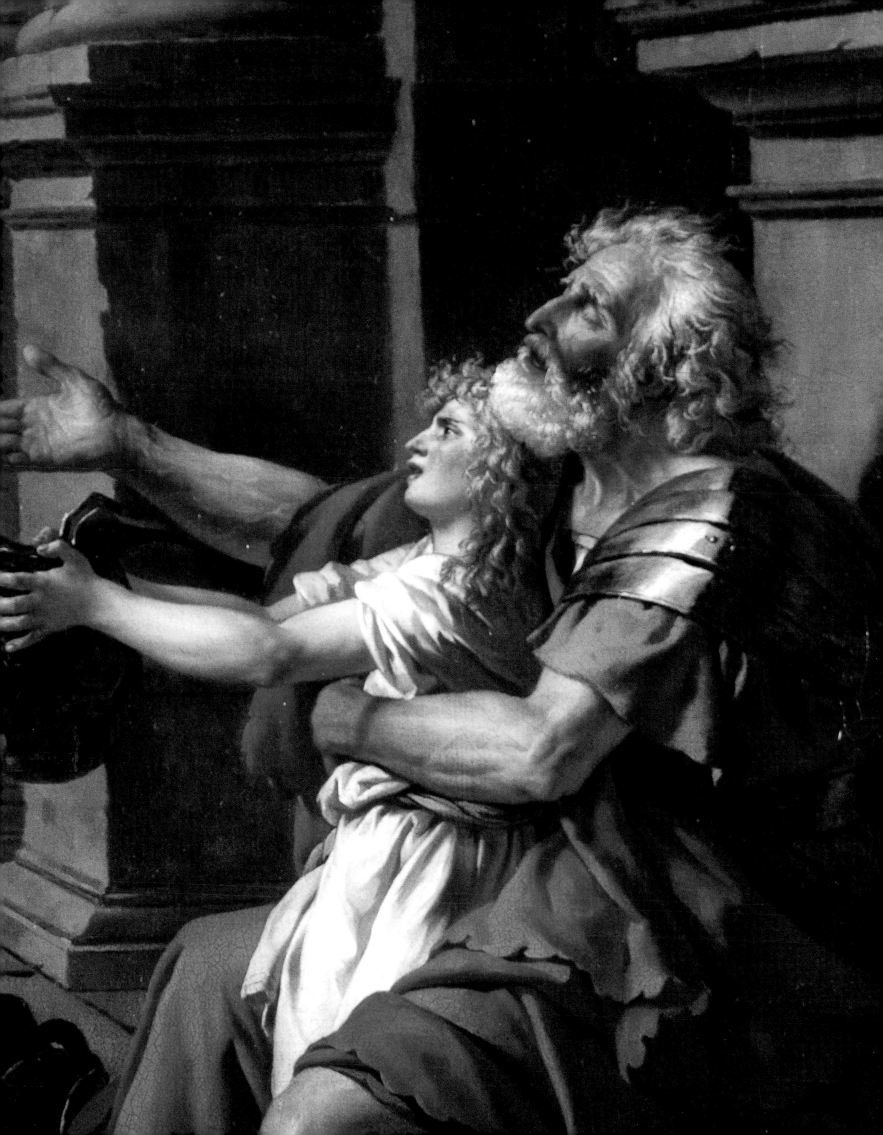

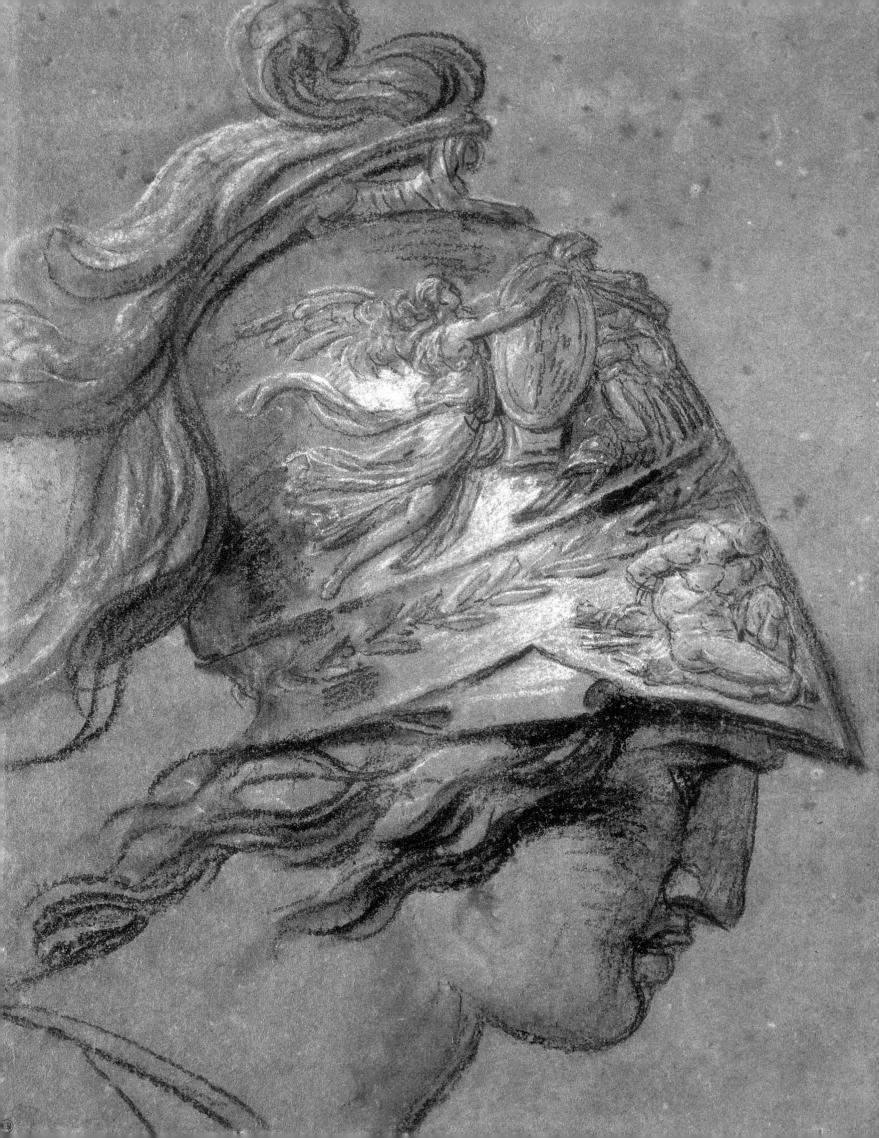

Jacques-Louis David
THREE FIGURES TALKING
Undated, ink and wash,
15.3 × 21.2 cm (6 × 8 3/8 in).
Musée du Louvre, Département
des Arts Graphiques, Paris.

Jacques-Louis David
HEAD OF MINERVA
Undated, black chalk
with white highlights,
33 × 26.4 cm (13 × 10 3/8 in).
Musée Bonnat, Bayonne.

Pages 32-33
Jacques-Louis David
BELISARIUS RECEIVING ALMS
Detail. 1784, oil on canvas,
101 × 115 cm (39 3/4 × 45 1/4 in).
Musée du Louvre, Paris.

A t that time, Rome was a meeting place for the whole of fashionable
Europe. The 'grand tour' popularised by the English was increasingly
focused on classical art, now that Herculaneum and Pompeii were emerging
from their shell of lava and ash. In the Capitoline Museum, David mixed
with German, British and Scandinavian artists, as he studied the *Dying
Gladiator*, the *Antinous*, the *Venus* and Praxiteles' *Faun*. At the Villa
Borghese, the much-admired statue of *Hermaphrodite* was displayed beneath
Buonvicini's frescoes of the unhappy love affair between Hermaphrodite
and the nymph Salmacis. The Villa Albani, built between 1758 and 1760 on
the plan of a house at Pompeii, provided a magnificent showcase for statues
of the great men and gods of antiquity. Within the Vatican was the Pio
Clementino Museum, opened in February 1773 by Pope Clement XIV,
and its collection of classical sculpture. Among the works displayed were
the *Belvedere Torso*, which Michelangelo had so admired, the *Laocoon*, dis-
covered in the ruins of Titus' palace, and the *Apollo Belvedere*, found at Porto
d'Anzio and purchased by the future Pope Julius II. The centrepiece of
Cardinal Aldobrandini's collection was the so-called *Aldobrandini Wedding*,
the most famous ancient Roman painting before the discovery of Pompeii.
Bought by Pope Pius VII, it is now in the Vatican. At a time when an artist's
training was so heavily dependent on copying classical models, it was treas-
ures such as these that made the journey to Rome indispensable. David was
twenty-six when he set off for Italy. He undertook the journey without any
great conviction: "Antiquity will not seduce me," he told Cochin before he
left, "it lacks energy and does not move me!" But the five years he spent in
Italy were to have a profound effect on his artistic development.

An rite of passage:
the Académie de France in Rome

"Rome is a theatre open to the entire world, where you can do nothing without its becoming public knowledge within twenty-four hours," wrote one of the first Rectors of the Académie de Rome. Founded in 1666 by Colbert, at the prompting of Le Brun, the Académie had taken up residence in the Palazzo Mancini on 15 June 1725. The Palazzo was the work of Carlo Rainaldi, who built it in 1622 for Philippe Julien Mancini Mazzarini, duc de Nevers and nephew to Cardinal Mazarin.

There the students were "maintained for three years", according to Pernety's *Dictionary of Painting* of 1757, "so that they might have time to perfect their art and to educate their taste through the fine works, both classical and modern, with which Italy is so abundantly endowed". The statutes, promulgated by Louis XIV, specified that religious observance was obligatory, that virtue should be treated with reverence, and that "blasphemers" should be expelled and stripped of their privileges. They forbade the students to exercise their talents on any but a single goal: to contribute to the decoration of Versailles and the royal palaces by "copying Antiquity in all its purity, without any addition". Colbert's instructions were categorical: "His Majesty absolutely forbids all those who have the honour of being maintained at the said Academy to work for anyone other than His Majesty, since it is his desire that the painters should make copies of all the fine pictures that are to be found in Rome."

In the 18th century, the curriculum was expanded to include life drawing and anatomy. Till then reserved for painters, sculptors and architects, the

Jacques-Louis David |
DANCER WITH TAMBOURINE AND VESTAL VIRGIN
Undated, brown ink, grey wash, black chalk, 15.3 × 20.1 cm (6 × 7 7/8 in).
Musée du Louvre, Département des Arts Graphiques, Paris.

| Jacques-Louis David
KNEELING WOMAN STABBING HERSELF, known as **THE MAGDALEN**
| Undated, black chalk, 13.2 × 9.7 cm (5 1/4 × 3 3/4 in).
Musée du Louvre, Département des Arts Graphiques, Paris.

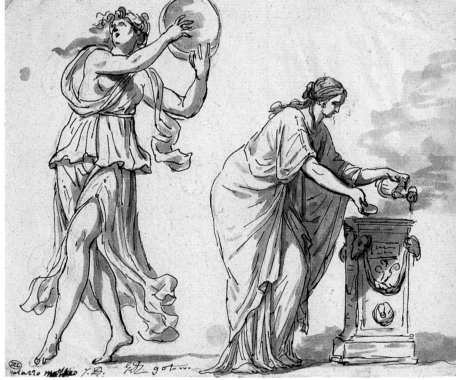

school now opened its doors to musicians; the first to take up residence was Gilbert. There were also foreign *pensionnaires,* among them Mannlich, who was in Rome from 1767 till 1771. He was later elected to the Institut de France, of which David was a member, and became Director of the Munich Academy. The French Academy in Rome "corresponded in friendship and instruction for the sake of the perfection of art" with its Roman equivalent, the Accademia di San Luca; the post of *princeps* at the latter establishment was often held by a Frenchman. Likewise, pupils from Paris could compete along with Italians and other visitors for prizes awarded by the San Luca.

The post of Rector of the French Academy was both a great honour – Natoire, Vien's predecessor, travelled in a carriage bearing the French coat of arms – and a great burden. The Academy served as a second embassy, and a hotel for prestigious travellers. The Marquis de Sade stayed there on his journey through Italy in 1775-1776. Séroux d'Agincourt, who had come to Rome to study the revival of the arts in 1779, spent almost all his evenings there, discussing aesthetic theory; David may well have been present on these occasions.

The Palazzo Mancini stands on the Corso, the most fashionable street in Rome. Its location provided the students with countless distractions from their work, some of which ended in brawls. Temptation was rife. (Already in 1697, Teulière had observed that "women present a greater danger here than anywhere else," especially since "the young people who have come from France have introduced the vice of the tavern".) Keeping the students under control was hard work. Natoire left an account of the difficulty he faced in imposing discipline. The boarders, he insisted, must "ask my permission

Jacques-Louis David |
CLASSICAL STATUES IN THE VATICAN
1780, pen and Indian ink wash, |
15.2 × 21 cm (6 × 8 1/4 in).
Musée du Louvre, Département
des Arts Graphiques, Paris. |

| Jacques-Louis David
CLASSICAL STATUES
IN THE COLONNA GARDEN
| Undated, red chalk
and bistre wash, 15.5 × 11 cm
(6 1/8 × 4 3/8 in).
Musée du Louvre, Département
des Arts Graphiques, Paris.

when they stay out for even a single night to visit the country round Rome". A trip to Naples was permitted only at the end of their stay.

Religious discipline was strict, too, in the city of the Vatican, and Easter communion was obligatory. The Vatican threatened to deport pupils who could not produce their confessional record. Resistance arose in the form of Protestant visitors and the rising tide of atheism. In 1767, Adrien Mouton refused to take communion at Easter, and was sent back to Paris by Natoire. Mouton brought his case before the Parlement, and won. This affair was the cause of much bad feeling. The marquis d'Angiviller had no sooner been appointed Director of Buildings than he sent Noël Hallé to restore order at the Academy, and chose Vien as the new Rector. The precursor of French neo-classicism took the place of an aging representative of the baroque. Natoire retired to Castel Gandolfo, where he died in 1777.

Vien received detailed instructions. Thus, in 1776, he was told to reestablish the annual requirement for painters to send a painting, study or copy to Paris, as evidence of progress. The number of resident pupils was not to exceed twelve. Students must not damage the works that they had been allowed to copy, nor should they, like Deshait in 1756, "use the study of nature as a pretext" to bring to the Académie "women who set a bad example". The rector even proposed that a uniform should be worn, because "the pupils dress too carelessly and wander round the piazza di Spagna disguised as savages". The old statutes, imposing a monastic discipline, were revived: students were to rise at five o'clock, the life class would last from six to eight, meals were to be taken *in situ* – lunch at half past twelve and dinner at eight – and the curfew set at ten in winter, changing to eleven in the summer. David travelled to Rome with Vien and his family. They stopped at Parma, home to one of the most celebrated of Renaissance schools, where David was astonished by the flying figures of Corregio's *Assumption* in the cupola of the *duomo*. A halt at Bologna to see works by Guido Reni, Guercino and the

Jacques-Louis David |
SARCOPHAGUS
Undated, pen
and Indian ink wash,
14.9 × 21.2 cm
(5 7/8 × 8 3/8 in).
Musée du Louvre, Département
des Arts Graphiques, Paris.

| Jacques-Louis David
SARCOPHAGUS IN THE PALAZZO BORGHESE
Undated, pen and Indian ink wash,
17.8 × 21.2 cm (7 × 8 3/8 in).
Musée du Louvre, Département
des Arts Graphiques, Paris.

Carracci brothers was equally indispensable; here David made the first of his surviving Italian sketches. In Florence, where he drew the courtyard of the Palazzo Vecchio, he was overwhelmed by Michelangelo's sculptures in the Medici chapel. By the time he reached Rome, he knew that he had much to learn.

Like his Parisian works, David's first Roman sketches bear no trace of Vien's Anacreontic neo-classicism. He spent time in those buildings which were under French protection, in particular Santa Trinità dei Monti, where he copied Daniele da Volterra's *Descent from the Cross*, a work which Rubens, too, had found inspiring. Shortly after his arrival, he made a drawing of the head of the *Saint Michael Overpowering the Dragon* by Guido Reni in the church of Santa Maria della Concezione (Victoria and Albert Museum, London). "When students were sent to Rome, in the days of Le Brun and even as late as David," Delacroix remarked in 1855, "they were advised to study only Guido Reni."

David's study of *litterae humaniores* had familiarised him with the major classical historians, such as Plutarch, Livy and Tacitus. He also knew his poets: Homer, Virgil and Ovid. He aspired to grandeur, and the *Iliad* was

Jacques-Louis David |
EPISODE DURING A PLAGUE
Undated, black ink and grey wash,
13.1 × 19.6 cm (5 1/8 × 7 3/4 in).
Musée du Louvre, Département
des Arts Graphiques, Paris.

Jacques-Louis David |
**VIEW OF TRINITÀ DEI MONTI
CHURCH IN ROME**
Undated, black pencil
and grey wash,
13.3 × 18.9 cm
(5 1/4 × 7 1/2 in).
Musée du Louvre, Département
des Arts Graphiques, Paris.

Jacques-Louis David |
ROMAN LANDSCAPE
Undated, pen
and Indian ink wash,
14.9 × 21 cm
(5 7/8 × 8 1/4 in).
Musée Bonnat, Bayonne.

his major source of inspiration. His drawing on paper, *The Battles of Diomedes*, brought together several episodes from the life of this hero. King of Argos, and the bravest of the Greeks after Achilles, Diomedes brought eighty galleys to join the Greek expedition against Troy. This fiery composition, dating from 1776, is reminiscent of the battles of Raphael and Giulio Romano, not to mention Le Brun. David's notebooks were filling up with architectural drawings and copies of bas-reliefs from tombs, all of which were put to good use in his later paintings. And the intellectual life of the Eternal City was acquainting him with new theories and perspectives.

The school of Antiquity

In Rome, the neoclassical movement, which found its greatest representative in David, had begun in the mid-18th century. Three figures had sought to disseminate their love of ancient art throughout Europe: the German historian and archaeologist, Johann Joachim Winckelmann, his compatriot Anton Raffael Mengs, and the Englishman, Gavin Hamilton. Winckelmann was a pioneer of the historical approach to classical art, and a vocal proponent of Greek art. He had discovered his life's vocation while studying the collections of the kings of Saxony in Dresden. His *Reflections on the Painting and Sculpture of the Greeks* was published in 1755, shortly before he arrived in Rome. His *History of Ancient Art* was *the* work of reference for the new classical style; the Pope was so impressed by it that he appointed Winckelmann Superintendent of the Antiquities of Rome in 1764. Four

| Gavin Hamilton
ACHILLES LAMENTING THE DEATH OF PATROCLUS
1760-1763, oil on canvas,
252 × 391 cm
(99 1/4 × 153 7/8 in).
National Gallery of Scotland, Edinburgh.

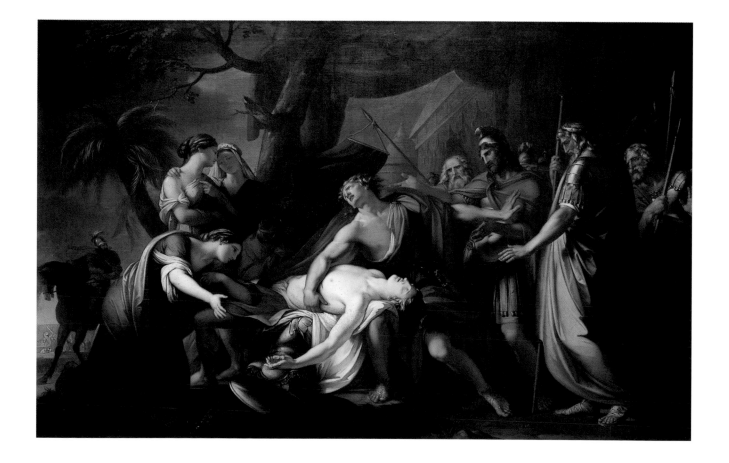

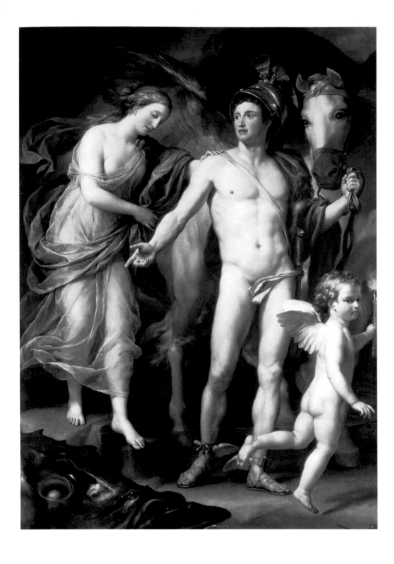

| Anton Raffael Mengs
PERSEUS AND ANDROMEDA
| 1777, oil on canvas,
227 × 153.5 cm (89 3/8 × 60 1/2 in).
| Hermitage Museum, Saint Petersburg.

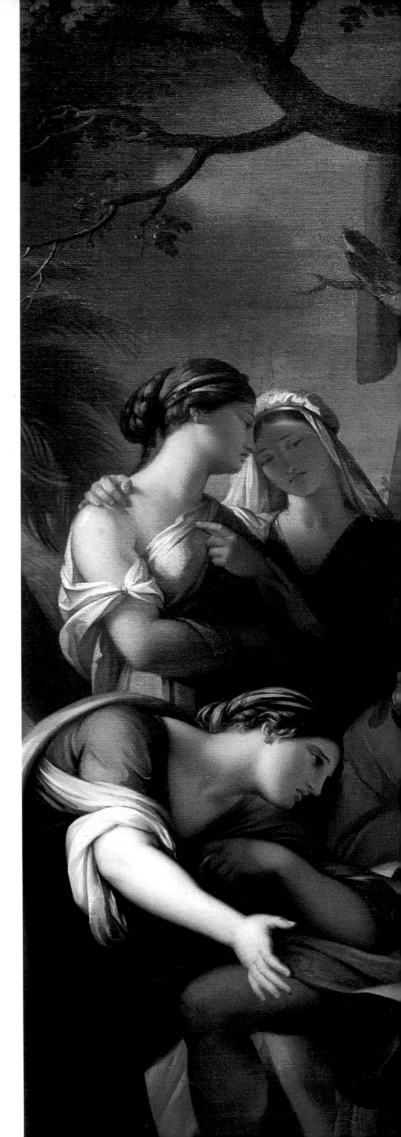

Gavin Hamilton |
**ACHILLES LAMENTING THE DEATH
OF PATROCLUS**
Detail.
1760-1763, oil on canvas,
252 × 391 cm (99 1/4 × 153 7/8 in).
National Gallery of Scotland, Edinburgh. |

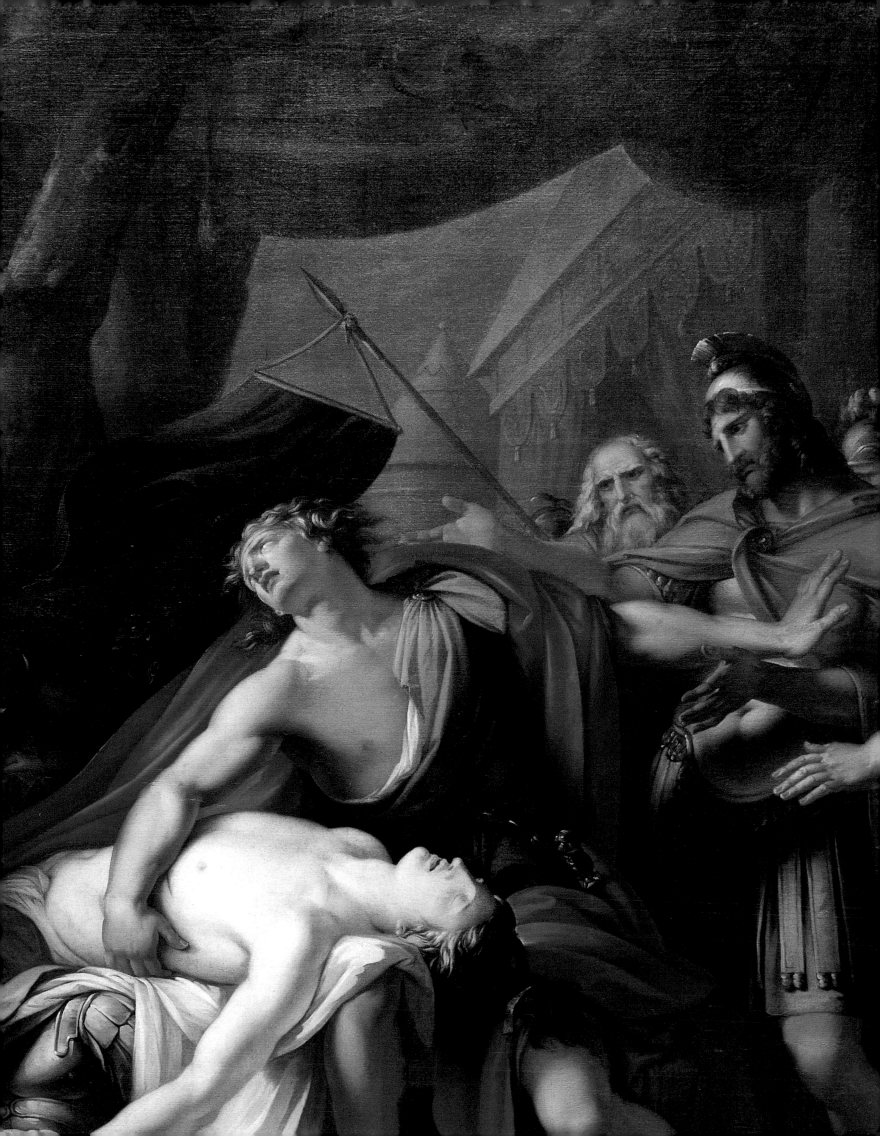

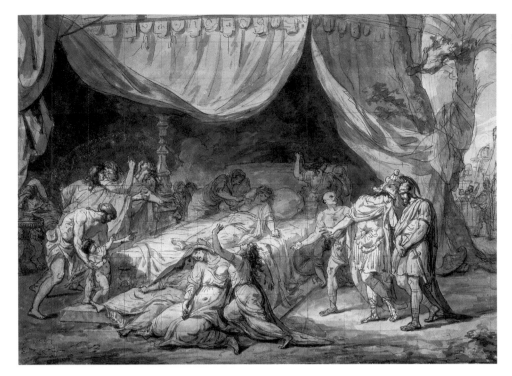

| Jacques-Louis David
ALEXANDER AT THE DEATHBED OF DARIUS' WIFE
| 1779, brown ink, grey wash over graphite sketch,
30.3 × 42.2 cm (11 7/8 × 16 5/8 in).
École Nationale des Beaux-Arts, Paris.

Jacques-Louis David |
THE BATTLES OF DIOMEDES
1776, black ink, grey wash
and white highlights,
111 × 203.5 cm (43 3/4 × 80 1/8 in).
Graphische Sammlung Albertina, Vienna.

years later, Winckelmann was murdered in an inn in Trieste, but his authority was unchallenged during David's stay in Italy, and for several subsequent generations the need to imitate the works of antiquity was considered unquestionable. This went with other Winckelmannian tenets, such as the self-evident superiority of sculpture over painting; the ideal of beauty remained "the noble simplicity and calm grandeur" of the *Laocoon.*

Winckelmann's friend Anton Raffael Mengs, also a native of Dresden, was both a painter and a theoretician. He set himself to rationalise the baroque style in Germany, Tuscany, Naples and Madrid, where Charles III encouraged his rivalry with Tiepolo. In Rome, he painted the ceiling of the great gallery at the Villa Albani with scenes from Parnassus in the antique style, frescoed the 'Papiri' rooms in the Vatican, and in 1770 was appointed *princeps* of the Accademia de San Luca. His *Studies on Taste and Beauty in Painting* (1762) were dedicated to Winckelmann, and inspired a devoted following among his many students. David's notebooks contain a study of a group sculpture, with Ajax holding the body of a slain soldier, the original of which stood in Mengs' studio.

Gavin Hamilton, for his part, was one of the best known figures in Roman society. A painter and a collector, he acted as a broker for old master paintings and classical art objects of all kinds. He painted only when commissioned to do so, promoting his works by making his own engravings of them. His studio was constantly thronged with visitors, among them English artists such as Romney and Wright of Derby. The latter had just returned to England when Vien and David arrived in Rome. Hamilton painted his *Wrath of Achilles* and *Achilles Lamenting the Death of Patroclus* between 1760 and 1763, and decorated the Palazzo Borghese with themes from the *Iliad*; his Poussinian style exercised an undeniable influence on David.

Other foreign residents involved in the neo-classical movement included the Swedish sculptor Sergel and the Danish painter Nicolai Abildgaard, who stayed in Rome from 1772 till 1777. Later, as a teacher at the Copenhagen Academy, Abildgaard would send his students to study with David in Paris. Fuseli, the Swiss painter who later worked in England, and Angelica Kauffmann also formed part of this group, whose shared taste for classical art and anti-absolutist politics foreshadowed David's own future positions.

Vien, keen to encourage the students in his charge, decided to organise an annual exhibition of their work. The first such event was held in 1777 in the Throne Room of the Palazzo Mancini. Among the works on show was *The Battles of Diomedes*. The following year, in September 1778, David exhibited his nude study of *Hector* and the oil study for an ambitious project related to it, *The Funeral of Patroclus*. Highly theatrical and very accomplished, this is

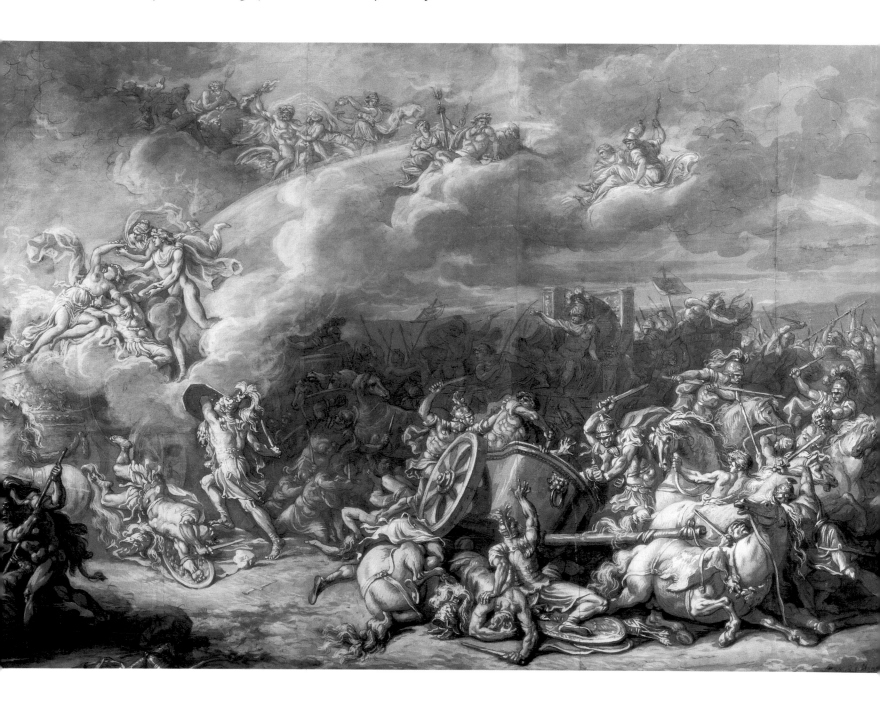

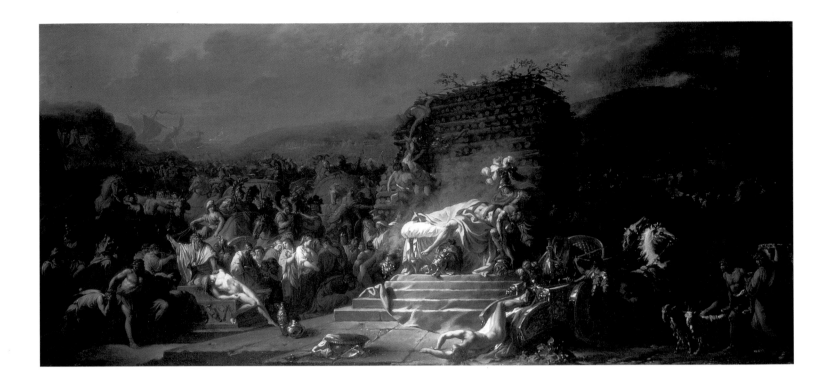

a work in the tradition of Le Brun. It was insufficiently classicizing to make much impression in Rome, and David, realising that it still exhibited "certain traces of France", did not take the project any further.

In Paris, the Academicians were impressed by David's work – not just by his productivity, but by his anatomical realism, his direct rendering of relief and volume, and the brilliance of his colours. They nonetheless advised him to "moderate and concentrate his genius". Recalling his time in Rome, he later wrote: "Colour is the most material aspect of art; it is the first thing to strike the senses. Thus, when I arrived in Italy, what first impressed me in the Italian paintings that I saw was the vigour of the tones and shadows. This was exactly the opposite of the great failing in French art. I was deeply impressed by this new relationship between light colours, this lively, decisive presentation of volumes; I had no idea it was possible. I was so struck by it that, in the early days of my stay in Italy, I thought that the whole secret of art was to reproduce – as certain Italian colourists of the late 16th century had done – the direct and unambiguous definition of volume that we almost always find in nature." And he added: "My eyes could only take in and comprehend works of quite brutal execution – very fine works nonetheless – by Caravaggio, Ribera and their pupil Valentin." Ribera's influence – particularly that of his Florence *Saint Bartholomew* – is visible in David's *Saint Jerome* of 1779.

Absorbed in the study of both classical and modern masterpieces, David nonetheless went through a period of melancholy and apathy. An affair with one of Vien's chambermaids – whom he made pregnant, but refused to marry – caused great anxiety to both the school (which found itself besieged by a furious crowd) and to David himself. "I cannot sympathise with the unspecified disgust of a young man so well-placed and cosseted," wrote the

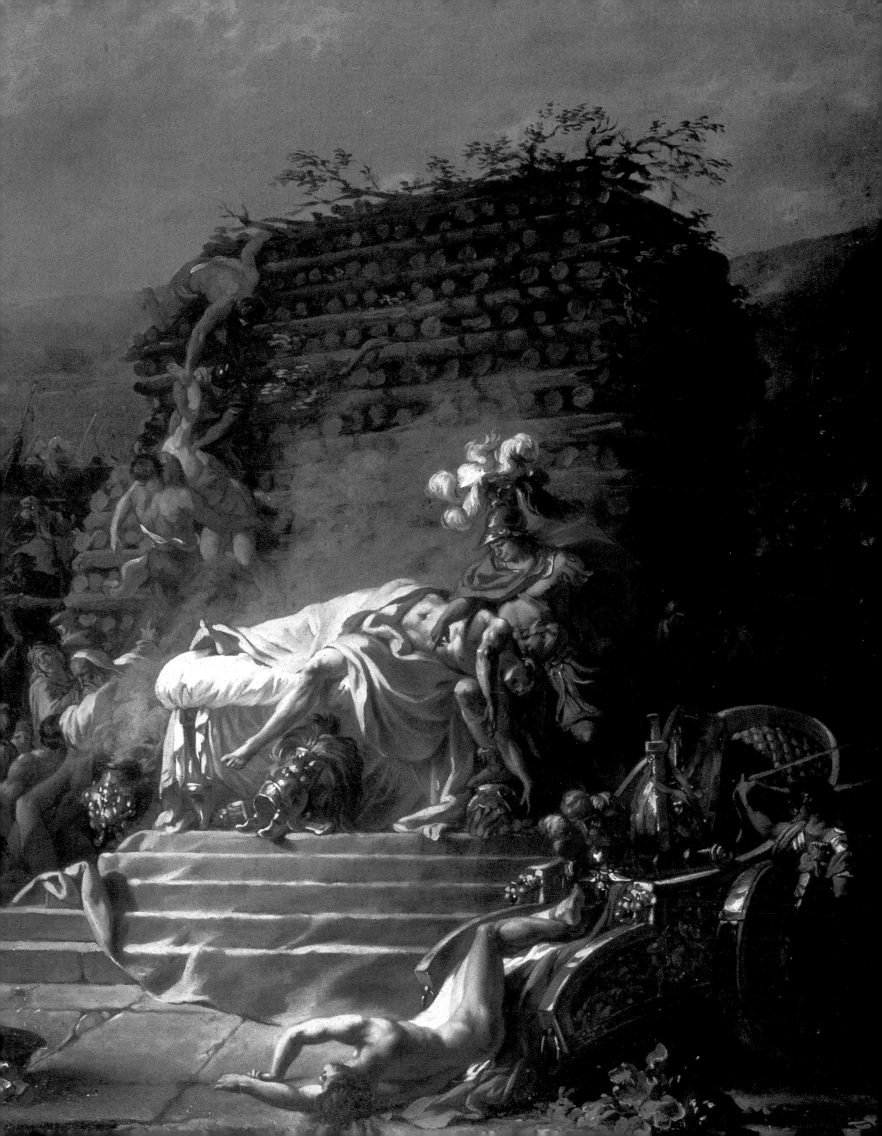

| Jacques-Louis David
MALE NUDE,
known as **PATROCLUS**

| 1780, oil on canvas,
| 122 × 170 cm (48 × 67 in).
| Musée Thomas Henry, Cherbourg.

Jacques-Louis David |
MALE NUDE,
known as **HECTOR**
1778, oil on canvas,
123 × 172 cm (48 1/2 × 67 3/4 in).
Musée Fabre, Montpellier.

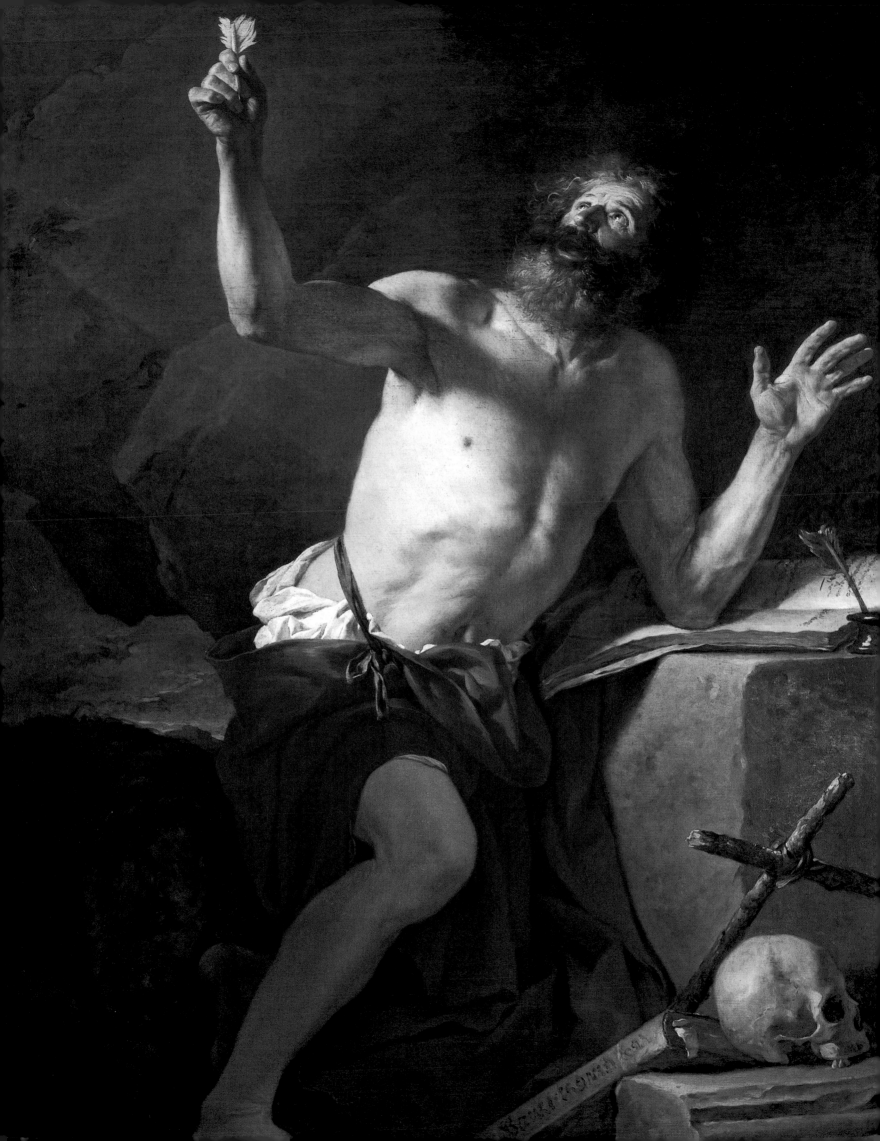

| Jacques-Louis David
SAINT JEROME
1779-1780, oil on canvas,
174 × 124 cm (68 1/2 × 48 3/4 in).
Musée de la Civilisation, Fabrique
Notre-Dame de Québec Collection, Québec.

painter Pierre. "He will either die, eaten up by this extended bout of melancholy, or he runs the risk of exploding, as strong souls do when their designs are frustrated. We are dealing with a frank and honest man, but one whose passions are so strong that they must be handled with care." His master, Vien, attentive as ever, decided that the problem was overwork. David did not deny this, and asked permission to go to Naples in July and August 1779, "to rest his excessively tired mind, worn out by his desire to excel himself in the figure painting that he must send this year". While he was in the south, on 8 August, there came the biggest eruption of Vesuvius since that which had buried Pompeii. The panic-stricken inhabitants fled towards the sea or took refuge in churches. David made use of these scenes when he came to paint his *Saint Roch Interceding for the Plague-stricken*.

Naples proved a turning point in David's approach to his art. He was accompanied by the sculptor Suzanne, and in Naples he met the theoretician of neoclassicism Quatremère de Quincy. Desprès, who had won the Grand Prix for architecture in 1776, was also in Naples. With Vivant Denon and Chatelet, he was working on the illustrations for the *Picturesque Journey*, the volume begun by Saint-Non in the Kingdom of the Two Sicilies. The friendships made in Naples were useful and lasting: Chatelet later sat with David on the Revolutionary Tribunal, and Vivant Denon's career was destined to parallel his own. Though drawing was strictly forbidden, people thronged to see the ruins of Pompeii and the objects from the site, which were exhibited in the Portici Museum. Among the paintings moved there were some frescoes from Herculaneum. When these were came to light in 1739, they overwhelmed their discoverer, Marchese Marcello Venuti: "Magnificent lifesize figures, startlingly true to life and much superior to those of Raphael", he wrote. David was captivated by the splendour of the works that he saw and copied. On his return to Rome, he was transformed: "For me," he later wrote, "it was if I had just been operated for a cataract. (...) I understood that I could not improve my style, which was based on false principles, and that I had to divorce myself from everything I had previously considered beautiful and true." And he added: "To proceed as the ancients and Raphael did is to be truly an artist."

With this discovery, David's genius began to flourish. In 1780, at the third Palazzo Mancini exhibition, his *Saint Roch Interceding for the Plague-stricken* was greeted with general amazement. Vien immediately wrote to d'Angiviller: "I must admit, Monsieur, that this was a real satisfaction for me; it is not the painting of a young man; there are passages which are worthy of the great masters." He added that David's picture "took all his fellow-students by surprise". The canvas was commissioned by the lazar-house of Marseille, where the plague of 1720 had left indelible memories. David must have had in mind the series of pictures by Mattia Preti on the terrible Neapolitan epidemic of 1656. The influence of Caravaggio is visible in the figure of the interceding saint, which was doubtless inspired by a shepherd in the *Madonna di Loreto* in San Agostino. But the plague victim in the foreground has a tragic and disturbing presence; contemporary rumours told of plague victims deliberately spreading the contagion. In his unexpected

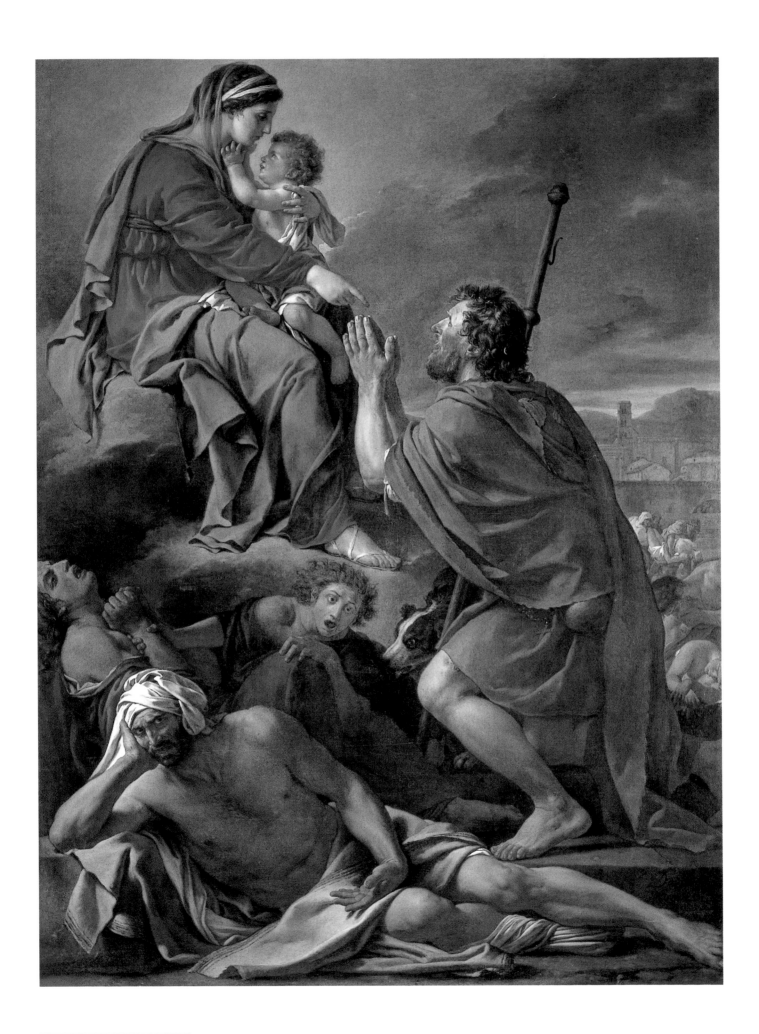

stone wall surmounted by the bases of a colonnade. The horseman salutes an invisible audience as he demonstrates his mastery of the *passage.* This attractive and very aristocratic portrait secured David a harvest of commissions.

For the Salon of 1781, David sought to distinguish himself with a major work. He returned to a drawing of *Belisarius Receiving Alms* that he had begun in Rome two years before. The name of the Byzantine general Belisarius was a legend in Rome, which he had defended against the Goths. Implicated in a plot against the Emperor Justinian, Belisarius allegedly had his eyes put out, and was reduced to beggary. Both Vincent and David's rival, Peyron, had painted versions of this parable of ingratitude; David had seen Peyron's canvas in Rome. Marmontel's morality tale, published in 1767, had turned the animus of the story against monarchical tyranny. On the eve of the Revolution, David's picture was inevitably interpreted as a resounding condemnation of injustice. The influence of Poussin – a new factor in the evolution of David's art – is clearly visible; the background landscape and the clarity of the composition are in the great tradition of the 17th century. "It was Peyron who opened my eyes", David would later confess. Peyron, David's friend and his rival, was an unconditional admirer of Poussin. Public recognition was immediate. Diderot said: "Every day I see it, and every day I seem to see it for the first time." His only criticism concerned the general's outstretched hand, which should, he felt, have been raised towards the heavens: "Was receiving alms not sufficient humiliation for Belisarius? Did

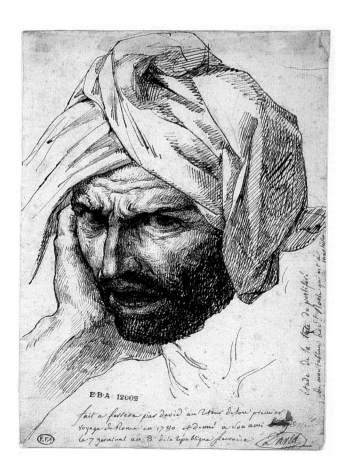

Jacques-Louis David |
HEAD OF A PLAGUE VICTIM
1780, black ink over pencil,
21 × 15.1 cm (8 1/4 × 6 in).
École Nationale des Beaux-Arts, Paris. |

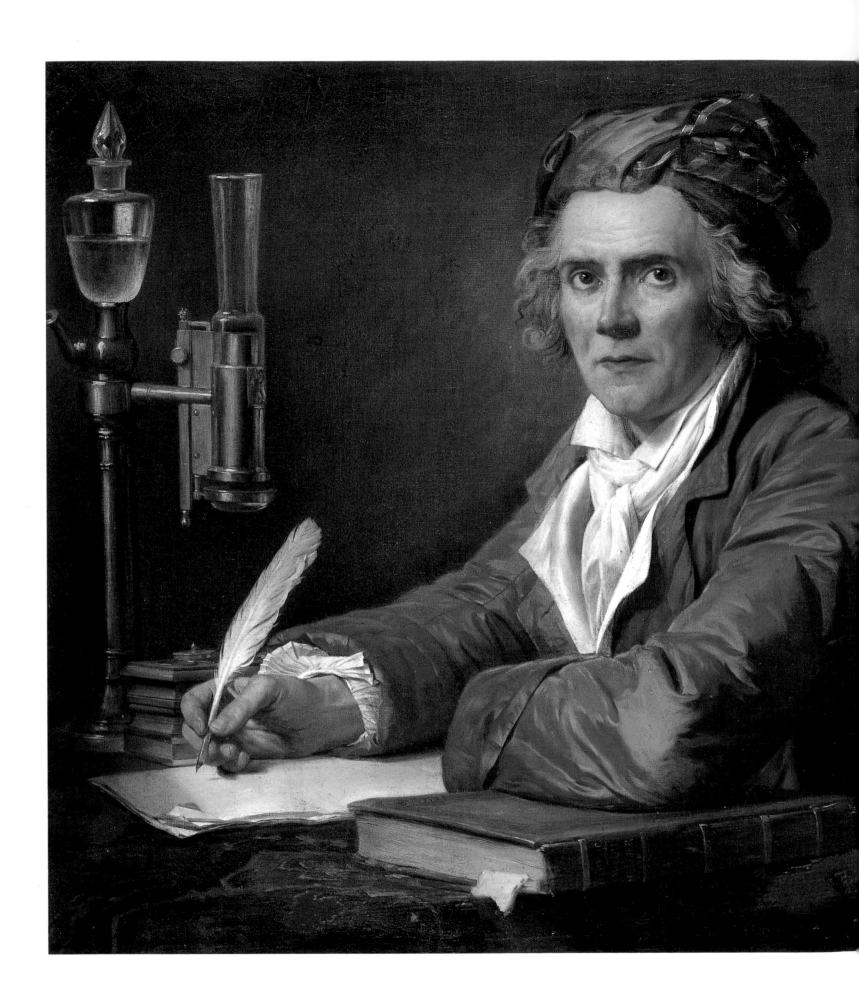

you have to make him ask for them as well?" The Académie, too, recognised the quality of this work and accepted it unanimously.

At the same Salon, besides the *Portrait of Count Stanislas Potocki* and *Belisarius*, David also exhibited the sketch for the *Funeral of Patroclus*, three nude studies and *Saint Roch Interceding for the Plague-stricken*, which he had brought to Paris to be copied and exhibited, before sending the original to Marseilles. His debut was a complete triumph. David was extremely proud of this success: "If you come to Paris to see my pictures at the Salon," he wrote to his mother, "the public flocking in to see them will tell you all you need to know. Great men, the 'garter knights', want to meet the artist; I am finally rewarded for my pains. (...) Please tell me whether you are coming to Paris; I am presently up to my neck in visits to and visits from (...). I am, as yet, rich only in reputation, and have much less money than fame, but I hope the money will follow; at all events, I have not been wasting my time." The acclamation of the critics and public was put in the shade by the fervent praise of young artists. The students wanted him as their master, just as they would Courbet and Manet a century later. "Many young people came to see me to ask for lessons", he noted in his memoirs. Thus the studio that was to dominate French art came into existence. Its members were: Jean-François Garneray (1755-1837), Jean-Baptiste Wicar (1762-1834), and Jean-Germain Drouais (1763-1788). Things began acrimoniously. Wicar accused Hennequin, to whom David had entrusted the studio during his absence, of stealing an engraving. Worse, Hennequin had helped himself to lapis lazuli powder, which was used to make ultramarine and was worth its weight in gold. He became *persona non grata* in the studio. As Rubens had discovered a century before, a large studio offering a variety of different skills made it possible to maintain a considerable volume of production.

David was now an acknowledged master, but still wanted to complete his education. In autumn 1781, he was granted three or four months' leave, so that he could travel to Flanders with the party of Piat Joseph Sauvage and "see this fine school". On his return, the palette of his portraits grew more varied and harmonious. He now rendered everyday objects with scrupulous attention to detail – witness the Argand lamp in his portrait of the doctor of medicine, Alphonse Leroy. In the portrait of his uncle, the architect Jacques-François Desmaisons (now in the Albright-Knox Art Museum, Buffalo), the outward signs of success are carefully recorded. This was a period when, as Mercier put it in the *Tableau de Paris*, "it is a great pleasure for a bourgeois to be able to dress like a lord". Desmaisons is shown surrounded by the instruments of his profession – compass, pencil and plans – while a copy of Palladio's *Architecture*, restored to favour by the neo-classical vogue, testifies to his excellent taste.

Jacques-Louis David
PORTRAIT OF ALPHONSE LEROY
1783, oil on canvas,
72 × 91 cm (28 3/8 × 35 7/8 in).
Musée Fabre, Montpellier.

On 16 May 1782, at the Church of Saint-Germain-l'Auxerrois, David married Marguerite-Charlotte Pécoul, the daughter of a wealthy Superintendent of the Royal Buildings. It was an arranged marriage, as all marriages of the period were; plans had probably been laid while David was still in Rome, where his future brother-in-law was a fellow student. The process was rapid; only six weeks after the couple's first meeting, David noted that "he was the husband of a woman whose virtues and characters ensure the happiness of his life." Witnesses to the marriage contract included the Viens, the Sedaines, Pierre (now First Painter to the King) and a number of lawyers and architects, including Boullée and de Wailly, the latter of whom had just completed the Comédie Française. They were all representative of a bourgeoisie whose wealth and social importance were steadily increasing. Indeed, it was the financial security granted by his marriage that allowed David to devote himself entirely to his major projects.

Jacques-Louis David |
PORTRAIT OF COUNT STANISLAS POTOCKI
1781, oil on canvas,
304 × 218 cm
(119 5/8 × 85 7/8 in).
National Museum, Warsaw.

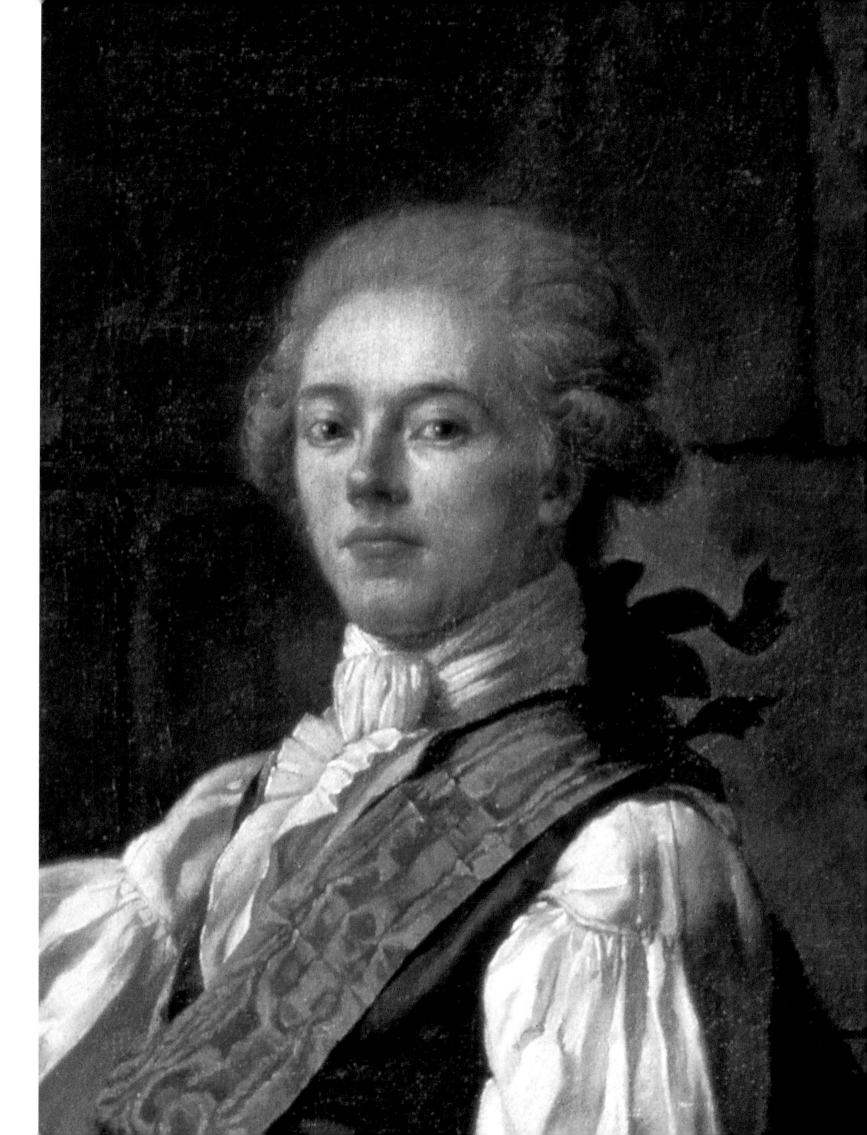

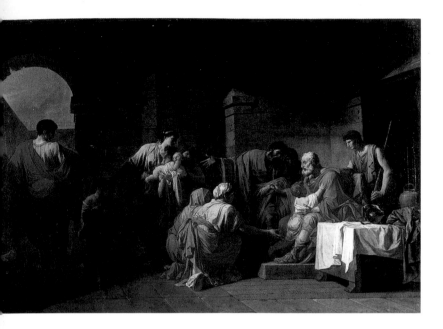

Jean-François-Pierre Peyron
BELISARIUS RECEIVING HOSPITALITY
FROM A PEASANT
WHO HAD SERVED UNDER HIM
1785, oil on canvas,
93 × 132 cm (36 5/8 × 52 in).
Musée des Augustins, Toulouse.

Page 62
Jacques-Louis David
PORTRAIT
OF CHARLES-PIERRE PÉCOUL
1784, oil on canvas,
92 × 73 cm (36 1/4 × 28 3/4 in).
Musée du Louvre, Paris.

Page 63
Jacques-Louis David
PORTRAIT
OF GENEVIÈVE JACQUELINE PÉCOUL
1784, oil on canvas,
92 × 72 cm (36 1/4 × 28 3/8 in).
Musée du Louvre, Paris.

Jacques-Louis David
BELISARIUS RECEIVING ALMS
1784, oil on canvas,
101 × 115 cm (39 3/4 × 45 1/4 in).
Musée du Louvre, Paris.

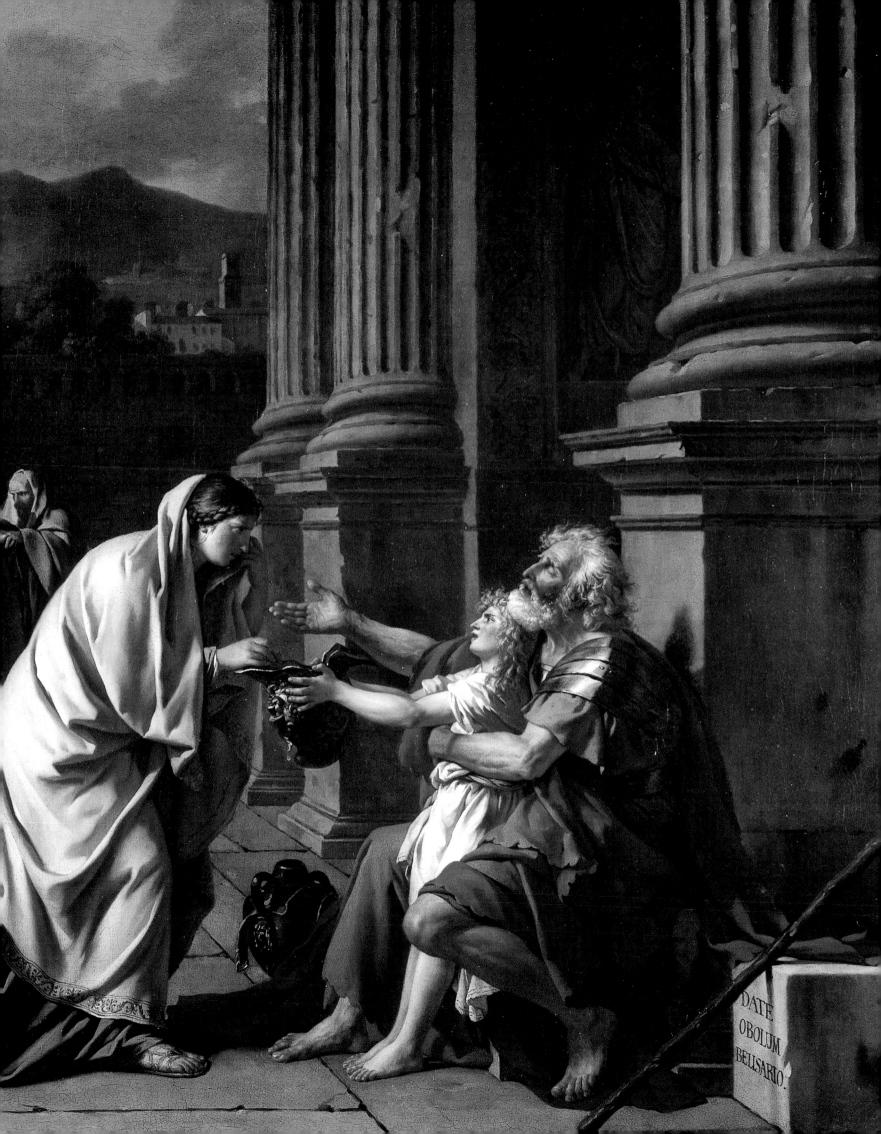

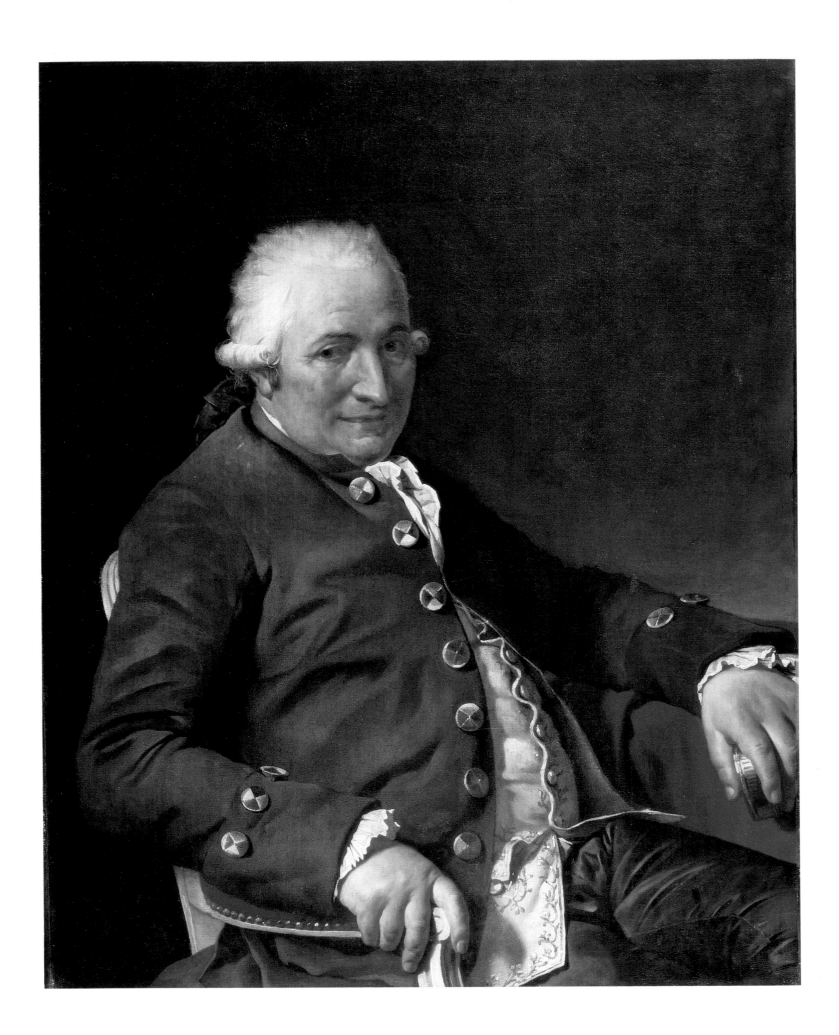

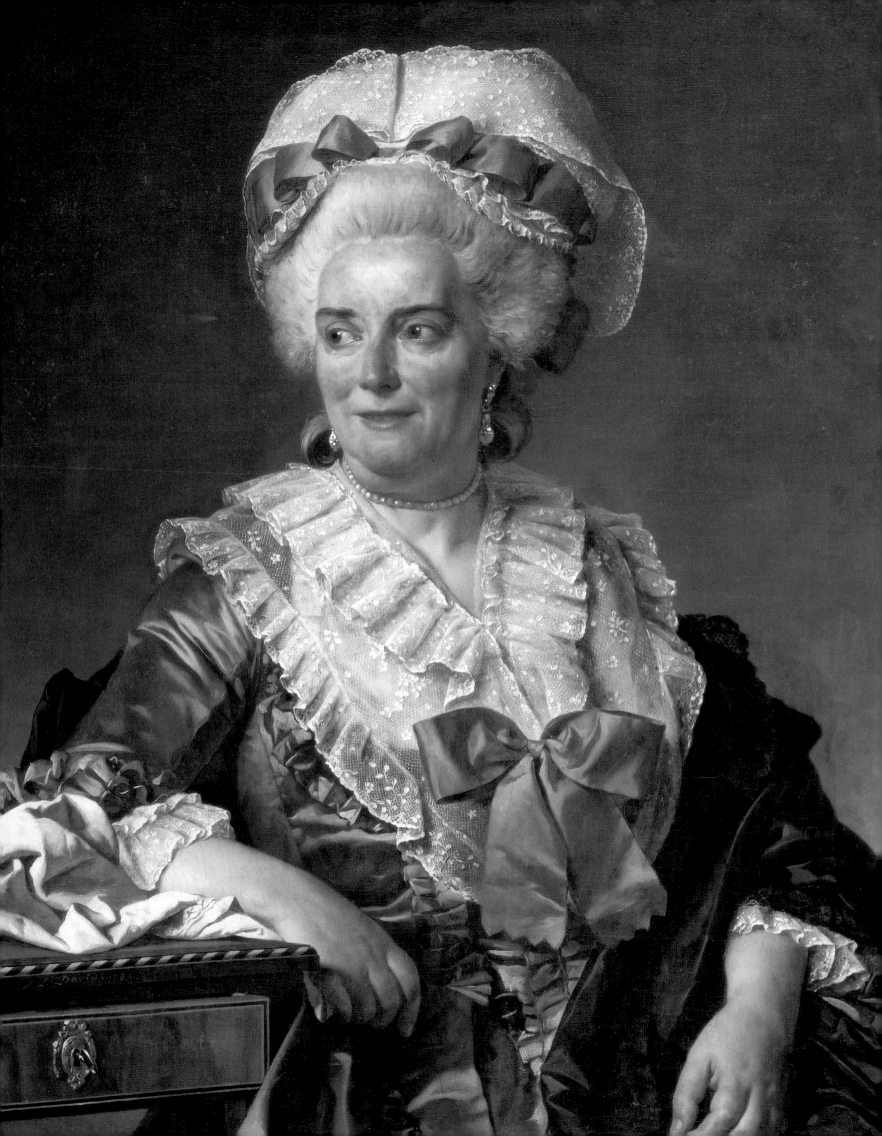

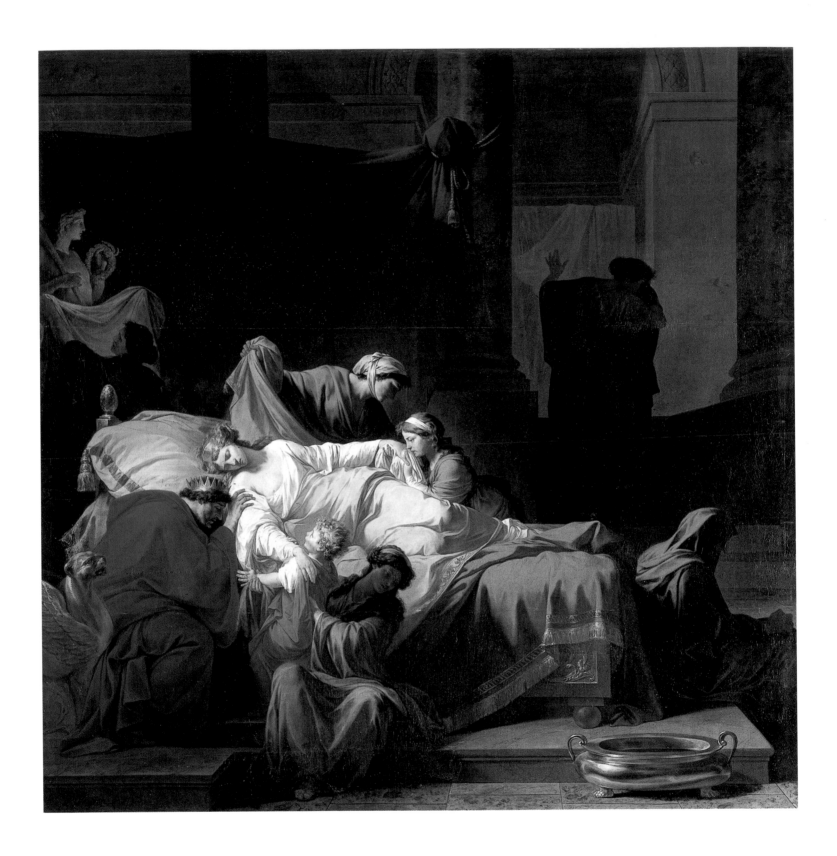

| Jean-François-Pierre Peyron
The Death of Alcestis,
or Conjugal Heroism
| 1785, oil on canvas,
| 327 × 325 cm (128 3/4 × 128 in).
| Musée du Louvre, Paris.

Jacques-Louis David |
Andromache Mourning
Hector
1783, oil on canvas,
123 × 172 cm (48 1/2 × 67 3/4 in).
École Nationale des Beaux-Arts, Paris.

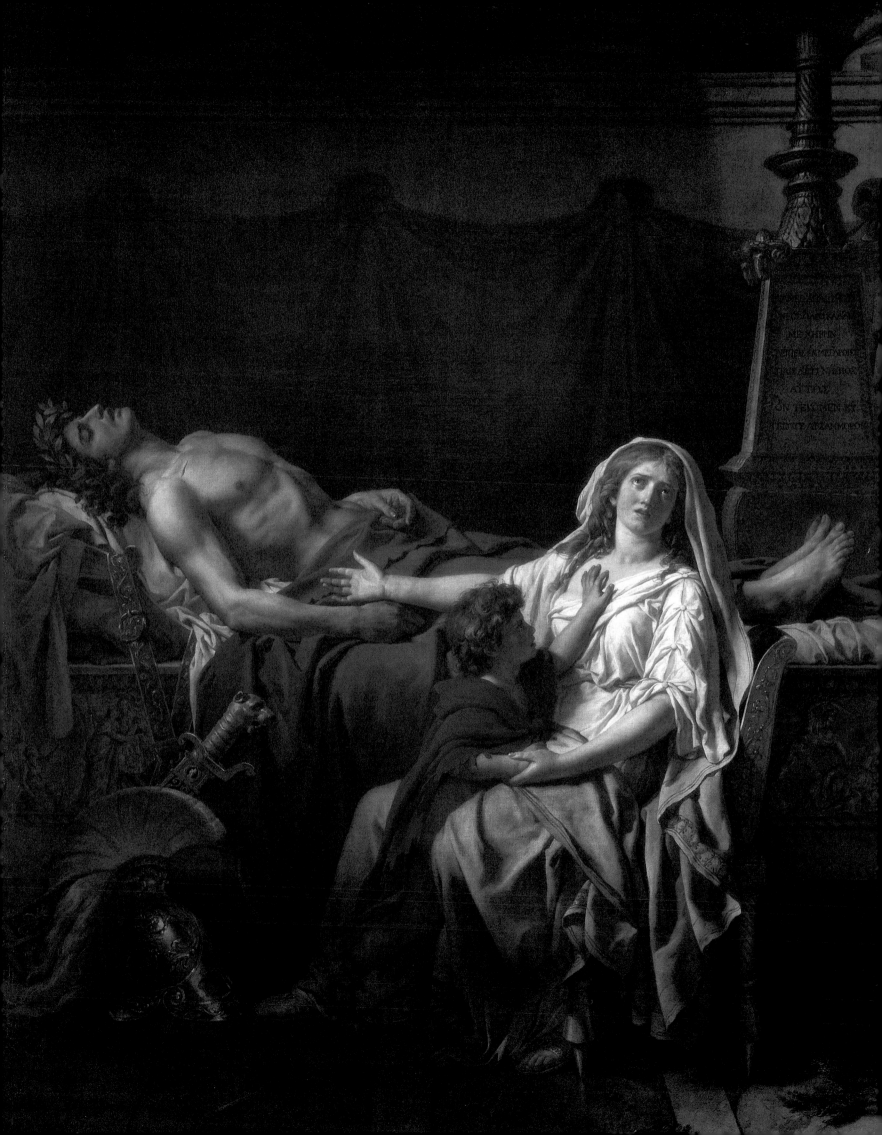

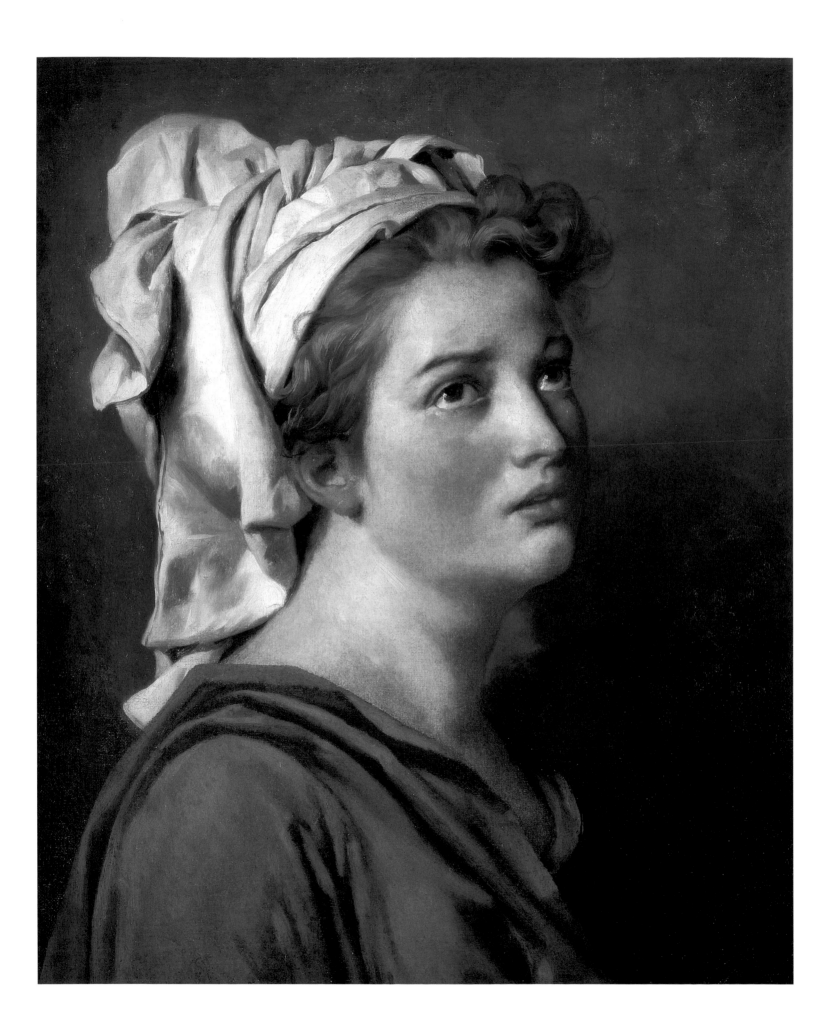

Jacques-Louis David |
THE VESTAL VIRGIN
Undated, oil on canvas,
81.3 × 65.4 cm (32 × 25 3/4 in).
Private collection.

| Jacques-Louis David
**PORTRAIT OF A YOUNG WOMAN
IN A TURBAN**
1780-1783, oil on canvas,
55 × 46 cm (21 5/8 × 18 1/8 in).
The Cleveland Museum of Art, Cleveland.

The right to exhibit at the Salon was confined to members of the Académie. His work having been accepted, David was now required to paint a presentation piece before his formal admission. On hearing that it had been unanimously accepted, he collapsed weeping into the arms of Sedaine. The subject, *Andromache Mourning Hector*, was taken not from Racine, but from the *Iliad*. The Trojan prince Hector, son of King Priam, has been slain by Achilles. His body is laid out on a bed; his grief-stricken wife sits at his feet. There is a trace of baroque declamation in Andromache, but the gesture of the child is intensely realistic. Perhaps it derived from experience. On the panels of the bed are scenes derived from the sarcophagi of the Villa Albani, recounting Hector's leave-taking and death. The whole painting follows Homer's narrative faithfully, down to the candelabra for the burning of aromatics.

At the Salon of 1783, this painting was shown alongside the *Frieze in the classical style*, two portraits (*Desmaisons* and *Leroy*) and a *Christ on the Cross* (now in Church of Saint-Vincent in Mâcon); the latter was commissioned by the wife of the maréchal de Noailles. It is a strange work, in which the realistic treatment of the body contrasts with the moonlit cityscape of Jerusalem, a utopian vision *à la* Boullée. The full variety of David's palette also found expression in a half-length figure entitled *The Vestal Virgin*. Carmontelle, a friend of the duc de Chartres, had recently written: "A wise and free people

| Studio of David
PORTRAIT
OF JEAN-GERMAIN DROUAIS
| Undated, oil on canvas,
46.2 × 38.3 cm (18 1/8 × 15 in).
| Musée Magnin, Dijon.

is naturally repelled by the simpering of Boucher, the smuttiness of Fragonard and the simplicities of Wille." The classical priestess – seen as a symbol of purity – had become a fashionable theme, allowing painters to exhibit a taste for virtue in virtuoso harmonies of pink and white. David's *Vestal* has a naive charm, and might equally well have been a *rosière* (a maiden granted a small dowry for virtuous conduct). The choice of subject probably relates to the 'Virtue Prize' founded in 1783 by the marquis de Montyon. Back in the studio, the talent of his pupil Drouais fascinated David. Drouais had been a child prodigy, an accomplished artist at the age of ten. In 1781, he painted a masterly interpretation of the *Return of the Prodigal Son,* but failed to reach the final round of the Grand Prix. In 1783, he was disqualified for showing his painting to David and asking for advice. David declared that he should be accepted without examination, as he was so clearly superior to the other competitors. The next year he won, and his fellow students celebrated so raucously that the First Painter and Superintendent felt insulted. His *Christ and the Woman from Canaan* (now in the Louvre) showed the softening of his style under the influence of Le Sueur. A superb study by David, *Portrait of a Young Woman in a Turban*, shows traces of the blond supplicant painted by his protégé.

Drouais was young, rich, handsome, bounding with energy and passionately devoted to painting. David recognised in him his own passions and doubts. And Drouais, too, was an orphan; his father, the painter François-Hubert, had died when his son was only twelve. David now wished to return to Rome, to execute a royal commission for a painting on the theme of the Horatii, and suggested taking his pupil with him. "You will be seeing Monsieur David again, fully armed and fully experienced", Pierre wrote to Lagrenée, the new director of the Palazzo Mancini. And he added: "The step he has taken will be a giant one, and if his students can keep pace, we shall be laden with heaps of gold."

Consecration

The David who arrived in Rome was very different from the young man of eight years before. "My intellect had a barbaric aspect," he later wrote, "and had to be stripped of it to achieve that state of erudition and purity, without which one may indeed admire the *Stanze* of Raphael, but only vaguely, without understanding and without profit. Raphael was much too refined a diet for my crude brain." Encouraged by the unstinting admiration of Drouais, he could now give free rein to his talents.

From September 1784 to 1786, the Accademia di San Luca rented David the studio of Placido Constanzi. This relative isolation suited him, for he preferred not to show his work until it was completely finished. All the same, he was less well treated, he felt, than he had been when Vien was Director, and complained about the quality of canvas and ground that the Académie supplied. He wrote to his former teacher that he now had no models "save Raphael, the Carracci and Domenichino"; "I work on my painting by day and copy the ancients by night." Drouais helped him prepare the canvas.

The subject originally proposed was the return of Horatius after his victory over the Curiatii. Shortly before leaving Paris, David had obtained his patron's permission to paint a different subject: *The Oath of the Horatii*. In this earlier episode, the three brothers pledge allegiance before going out to combat the Curiatii. The principle articulated by the architect Claude-Nicolas Ledoux – "Taste is present wherever there are pure lines" – might be said to define the composition. The harmony and purity of David's studies for the two sisters, Sabina and Camilla, are worthy of Poussin. And the painter's young sons may have been the inspiration for the children clutched in their grandmother's arms. Arlette Serullaz has studied David's notebooks – they show heads in helmets and Phrygian bonnets and women in flowing robes – and identified a group of prelates in a Vatican fresco as a probable source for the brothers' serried heads.

David finished the picture in July 1785. "Nothing can describe its beauty" wrote Drouais. At last, the studio was opened to visitors. The shock exceeded even David's expectations. All Rome came to see the *Horatii*, which was interpreted as a sublime homage to the Eternal City. Pompeo Batoni, the aged portraitist, and the German painter Tischbein, a pupil of Mengs, were among the most ardent admirers. Tischbein's enthusiasm clearly transpires in his *Goethe in the Roman Campagna* of 1787.

David wrote to the marquis de Bièvre, a friend to Sedaine and Count Potocki, describing his unexpected triumph. He also asked him to contact d'Angiviller, to ensure that the *Horatii* was not too badly hung at the Salon; he feared the jealousy of the First Painter, Pierre. It was now time to leave Rome again; the painting's reception in Paris was the important thing.

There was no cause for anxiety. Paris was scarcely less ecstatic than Rome. The painting was delivered late to the Salon, so that its impact would not be frittered away at the opening ceremony, when there were so many new works to attend to. It produced precisely the expected effect. We know from an engraving by Pietro Antonio Martini, showing the Salon Carré, that the *Horatii* could not have been better placed, hanging as it did just above the full-length portrait of *Marie-Antoinette and Her Sons* by Elisabeth Vigée-Lebrun. The Academicians praised David for abandoning the sombre colours of his earlier work. The Countess of Albany, mistress of the poet Alfieri, declared that David had "begotten Romans – something they seem unable to do themselves". Charles-Nicolas Cochin junior declared that David had triumphed over the entire Salon. Critics stressed the republican pride of the *Horatii*. Some interpreted it as an allusion to the youthful United States of America, which France had supported in its War of Independence. Others were struck by the austerity of the canvas, and the rhythms that subtly harmonise the patriotism of the men with the compassion of the women.

Amidst this general enthusiasm, David alone felt certain reservations. Later, speaking to his pupil Delécluze, he regretted "the theatrical composition", the "small, mean" draughtsmanship, the insensitivity of the colour to "local tone". "Ah," he exclaimed, "if I could have my studies over again, now that we know the Ancient World better, I should go straight to the goal!"

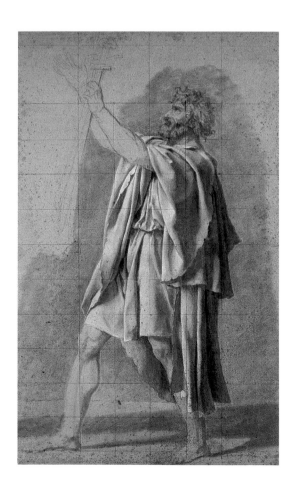

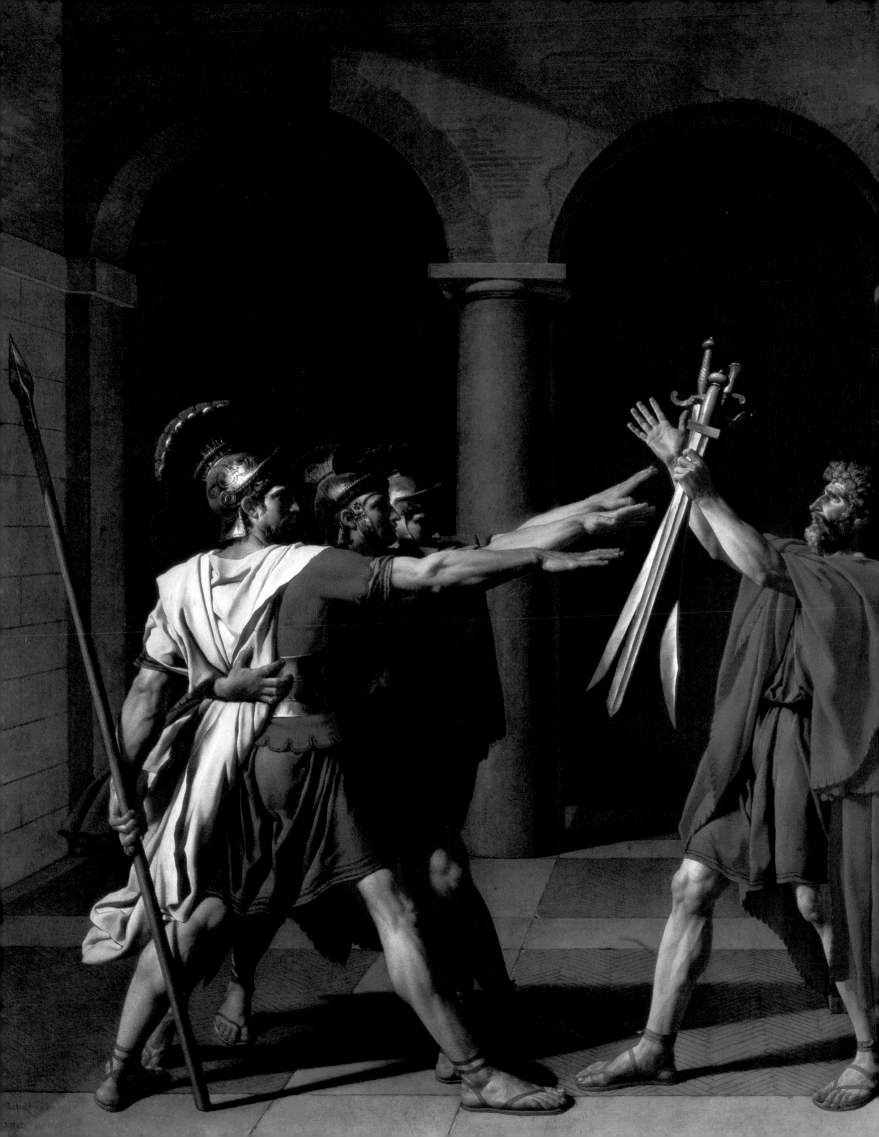

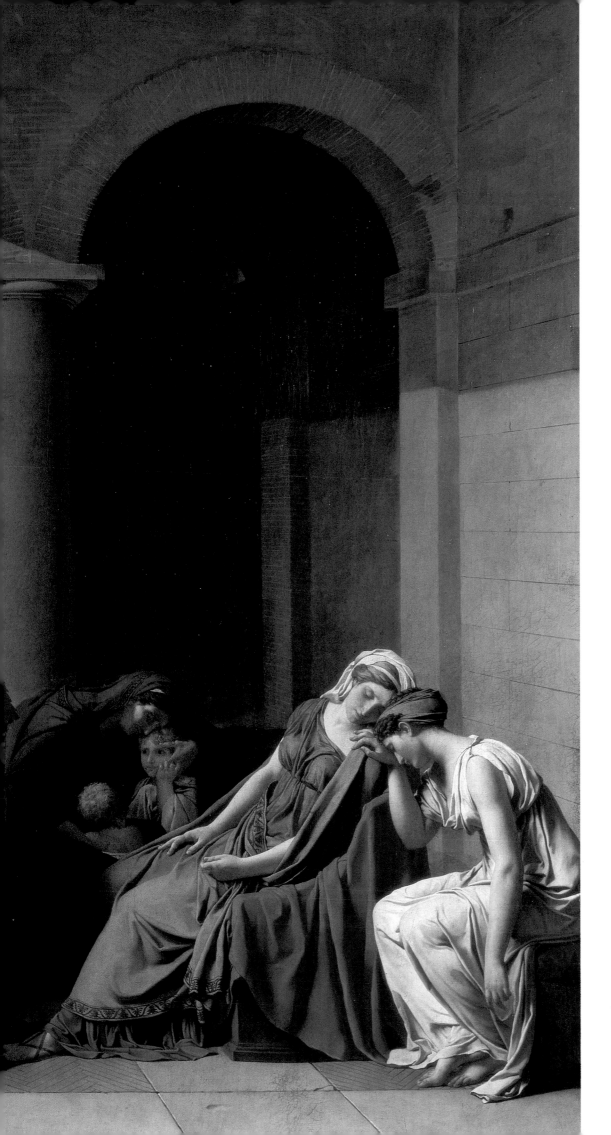

| Jacques-Louis David
THE OATH OF THE HORATII
| 1784, oil on canvas,
330 × 425 cm
(129 7/8 × 167 1/4 in).
| Musée du Louvre, Paris.

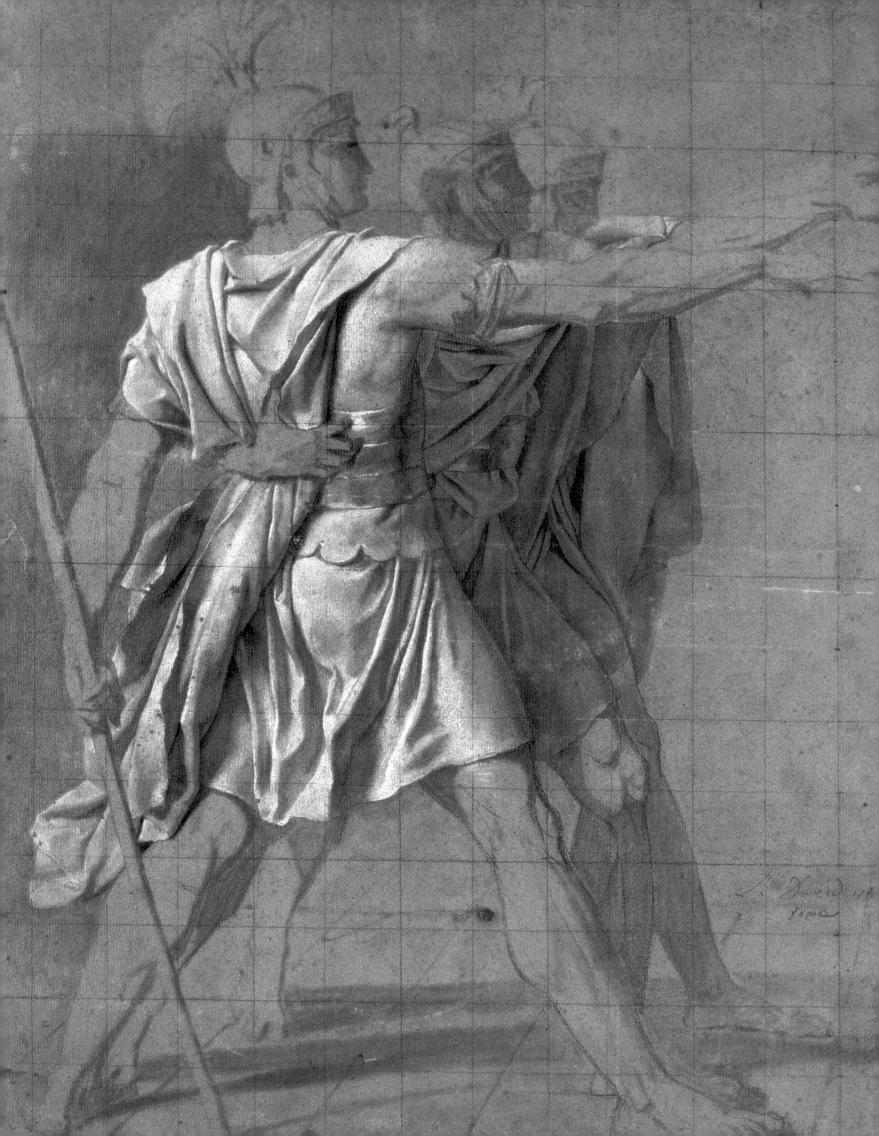

The Oath of the Horatii was a turning point in the history of art and in David's life. The feminine universe and curved lines that had dominated 18th century art gave way to the verticals of a masculine world, in which virtue, heroism and martial obligations were paramount. With this one canvas, David established his reputation throughout Europe.

Sedaine's good offices had secured for David the Louvre studio of Lépicié, who had just died. Hard worker though he was, David did not deny himself a social life; he was a habitué of the liberal Salon of Mme de Genlis, the mistress of the duc d'Orléans, but was also admitted to the circle of the comte d'Artois, the younger brother of the King. This he probably owed to the influence of Elisabeth Vigée-Lebrun. "I enthusiastically sought out the company of all the artists of repute," she wrote, "and above all of those of distinction in my own art (...). David was therefore a frequent visitor to my home". There he met Hubert Robert, Carle Vernet and his sister Emilie, wife to the architect Chalgrin. Their hostess was the mistress of the comte de Vaudreuil (for whom David made a reduced copy of the Horatii in 1786), himself a close friend of the comte d'Artois. This was an ultra-conservative milieu: yet it was in Vaudreuil's private theatre at Gennevilliers, and in the presence of the Prince, that The Marriage of Figaro received its première, after an attempted court performance had been banned by Louis XVI. This performance opened the way for others, and initiated a wave of intellectual protest against royal despotism.

David now dreamed of being appointed director of the Académie de France in Rome. The following year, despite the best efforts of his protector, the marquis de Bièvre, he was passed over. D'Angiviller confided to the marquis that it would be better to wait: "In six years' time, he will be less of a hothead". Instead, the post went to Vigée-Lebrun's teacher, Ménageot. David was disappointed, but continued to make his way in the world.

At the 1787 Salon, David's The Death of Socrates, commissioned by Trudaine de la Sablière, again demonstrated his superiority. This was the more satisfying because his rival Peyron had executed a royal commission on the same theme. David's picture appears to have been intended as a posthumous homage to Diderot, a friend of the Trudaine brothers' relatives, and a great admirer of Socrates. Indeed, Diderot had once remarked of this subject: "What a canvas for a poet!" Socrates was condemned to death for having, according to his accusers, "corrupted the young and neglected the gods". David had planned to represent him with the bowl of hemlock already in his hands. But the poet André Chénier, a childhood friend of the Trudaine brothers, had protested: "No, no! Socrates, entirely absorbed in the sublime thoughts he is expressing, must stretch out his hand towards the cup, but take it only when he has finished speaking." David followed his advice. He considered this picture "a masterpieces of expressivity". Some interpreted the image as "the triumph of philosophy". Others suspected that Socrates, who died for an ideal that the polis could not subordinate to its law, symbolised the challenge made by a new order to the sclerotic ancien régime. The Trudaine brothers were advisers to the Parlement, and through his

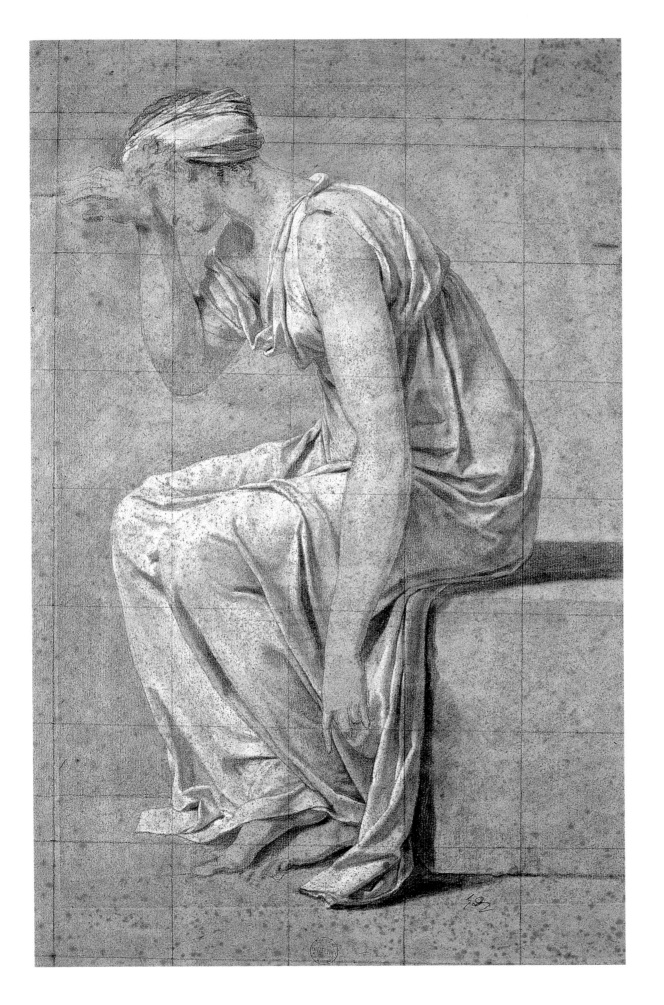

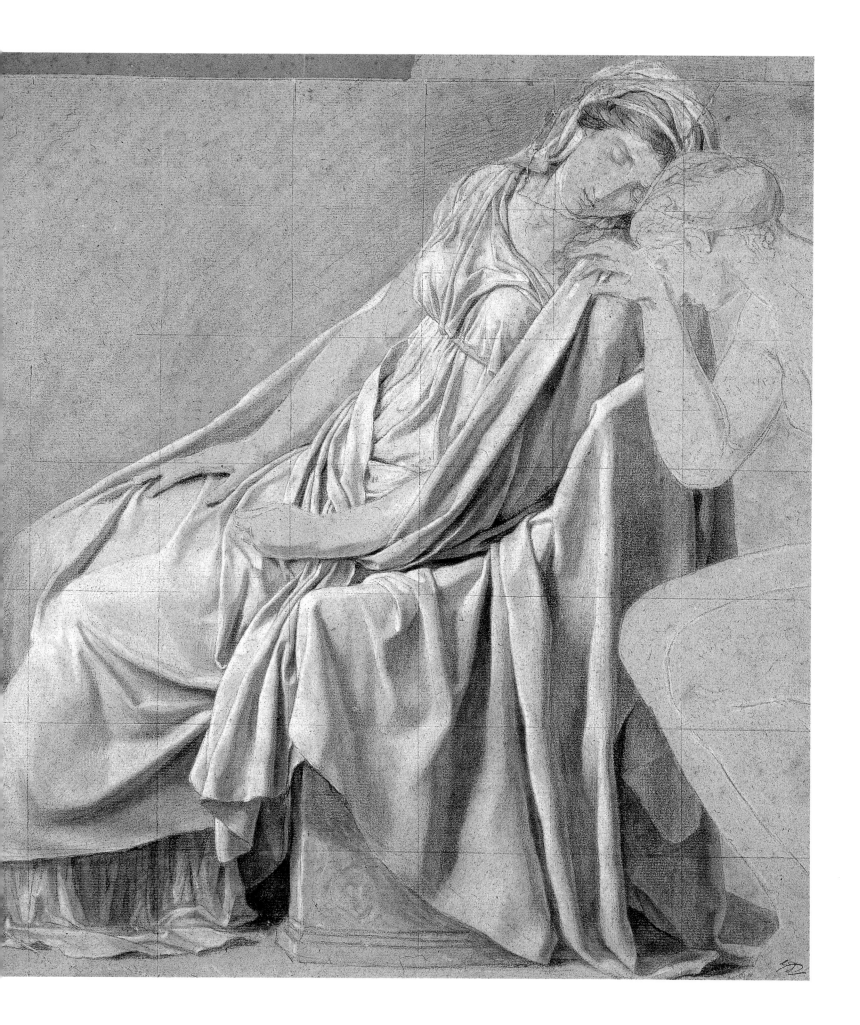

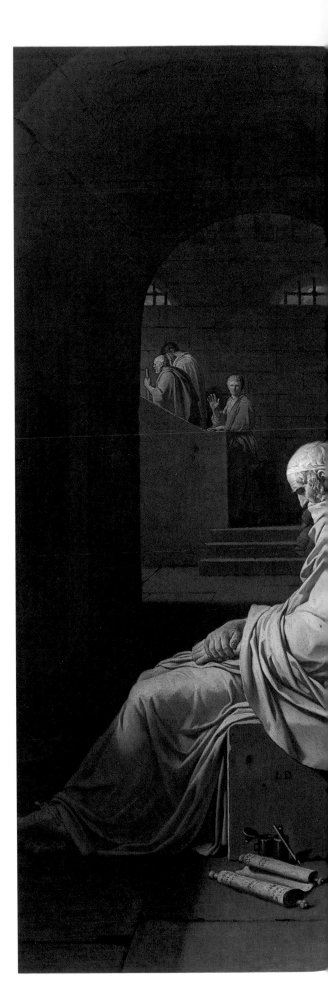

Jacques-Louis David |
THE DEATH OF SOCRATES
1787, oil on canvas,
150 × 200 cm (59 × 78 3/4 in).
The Metropolitan Museum of Art,
New York.

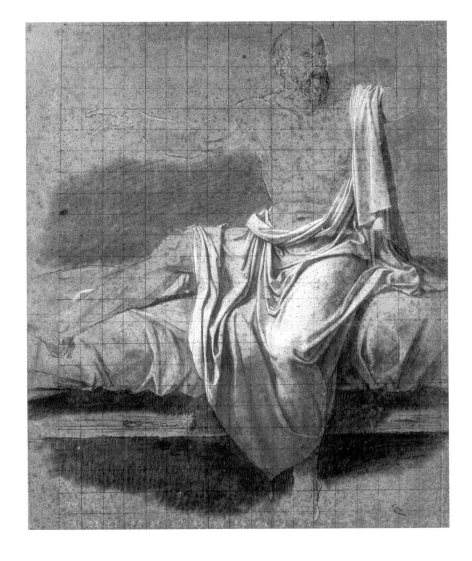

| Jacques-Louis David
STUDY FOR THE DEATH OF SOCRATES
1787, black chalk and white highlights,
52 × 43.2 cm (20 1/2 × 17 in).
Musée Bonnat, Bayonne.

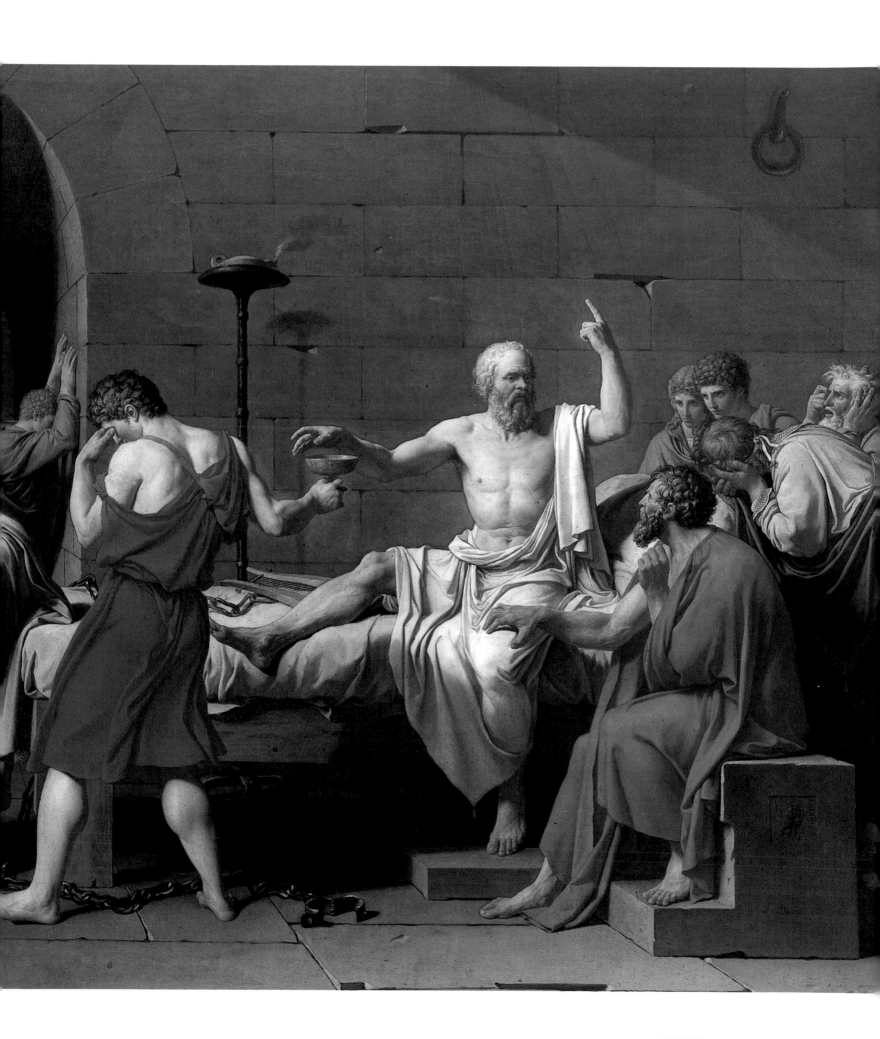

friendship with them and with André and Marie-Joseph Chénier, David encountered an enlightened circle frequented by famous scientists, such as the astronomer Bailly, the mathematician Condorcet and the chemist Lavoisier. The latter appears with his wife, David's pupil, Marie-Anne Paulze, in a double portrait. David was at the height of his powers. "Often," he said, "he relaxed by painting portraits, and more than once proved to the portraitists that, when history painters make portraits, they imbue them with a life they can never elicit from mere models." In this pre-photographic age, David was a master of 'the good likeness'. He combined this with uncompromising realism, refusing to do what many contemporaries did, that is, improve on the sitter's appearance. In the portrait of Lavoisier and his wife, David frankly depicts the couple's intimacy, showing the wife as lover, muse and colleague. Three tonalities – white, black and red – dominate the composition; the result is unostentatiously brilliant. The accuracy with which the scientific equipment is rendered, and the astonishing reflections in the glass of the balloon-flask on the ground, testify to the influence of the Flemish masters, especially Van Eyck.

At the request of the comte d'Artois, David briefly abandoned dramatic composition to paint a romantic scene: *The Courtship of Paris and Helen*. This was an "agreeable genre", which the painter had not previously tried. In retrospect, he was very satisfied with it: "It was done in the Greek style, completely classical. He surprised those who thought he could not succeed in the genre." Rarely, indeed, had he painted with such grace and abandon. Helen's nonchalance and Paris' resplendent nudity are set off by the 'Greek' setting with its repeated verticals. The result is a hymn to love, whose empire is confirmed throughout the painting: the judgement of Paris appears on the lyre, Eros and Psyche are seen in low relief, and Jean Goujon's caryatids, sculpted for the Louvre, speak of voluntary enslavement.

For Homer, Paris was an emblem of decadence: he fled from combat to luxury. Here, his bow and quiver hang carelessly from a statue of Aphrodite. This is, perhaps, an allusion to the comte d'Artois, who, unlike Lafayette, had not ventured his life in the American War of Independence. David faithfully observes the classical iconography; Paris is "handsome, effeminate, and beardless and wears a Phrygian cap". Contemporary spectators were conscious of the nuance of irony in this very charming work.

Paris and Helen had satisfied his self-respect, and "he returned," David later wrote, "to his natural genre – the tragic and historical style". His next subject was the legendary Lucius Junius Brutus.

The master of the avant-garde

On David's return from Rome, people began to speak of the 'school of David'; particular notice was taken of the works sent from Rome by his favourite pupil, Drouais. With his pupils, David discussed the revival of the arts mooted in the theories of Winckelmann, Lessing and Sulzer. He taught technique by example, involving his students in the production of originals

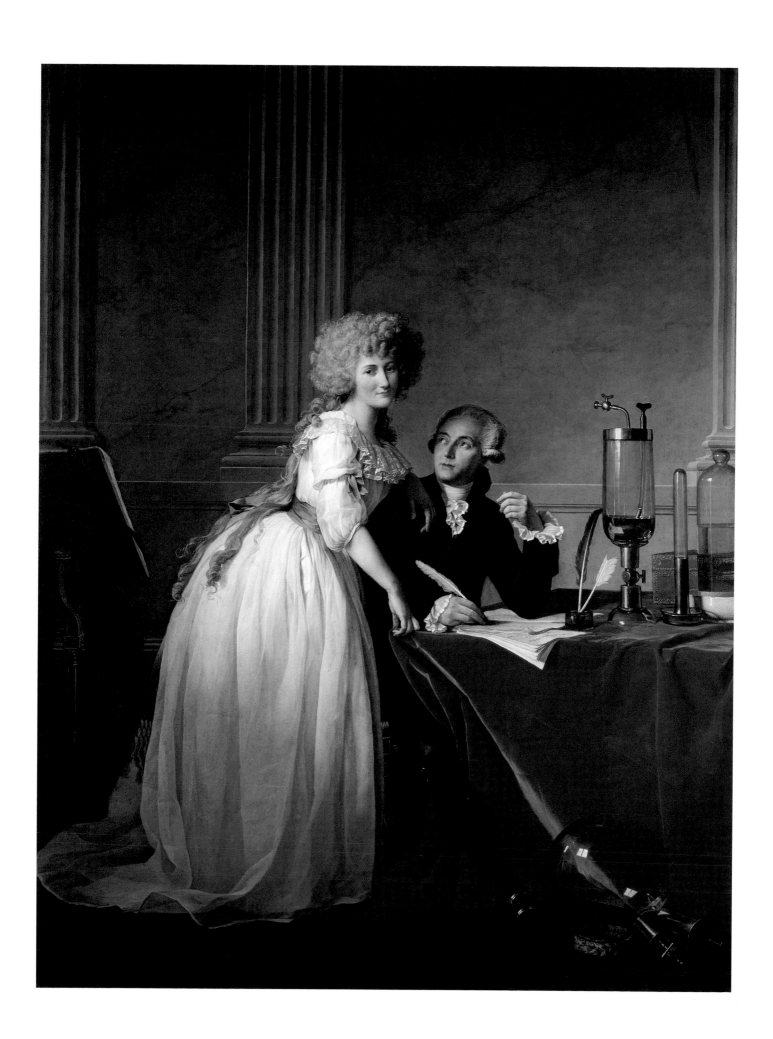

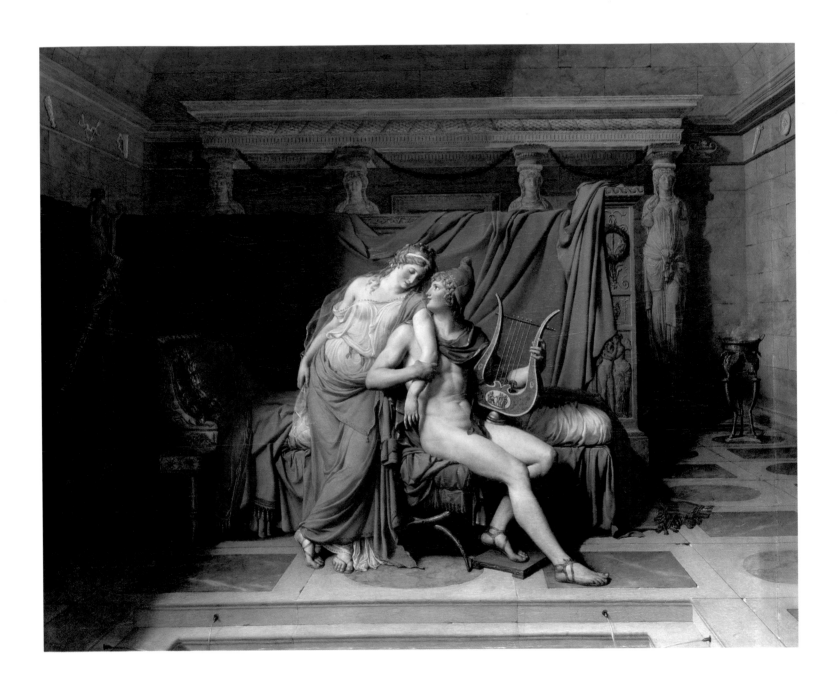

| Jacques-Louis David
THE COURTSHIP OF PARIS AND HELEN
| 1788, oil on canvas,
| 147 × 180 cm
| (57 7/8 × 70 7/8 in).
| Musée du Louvre, Paris.

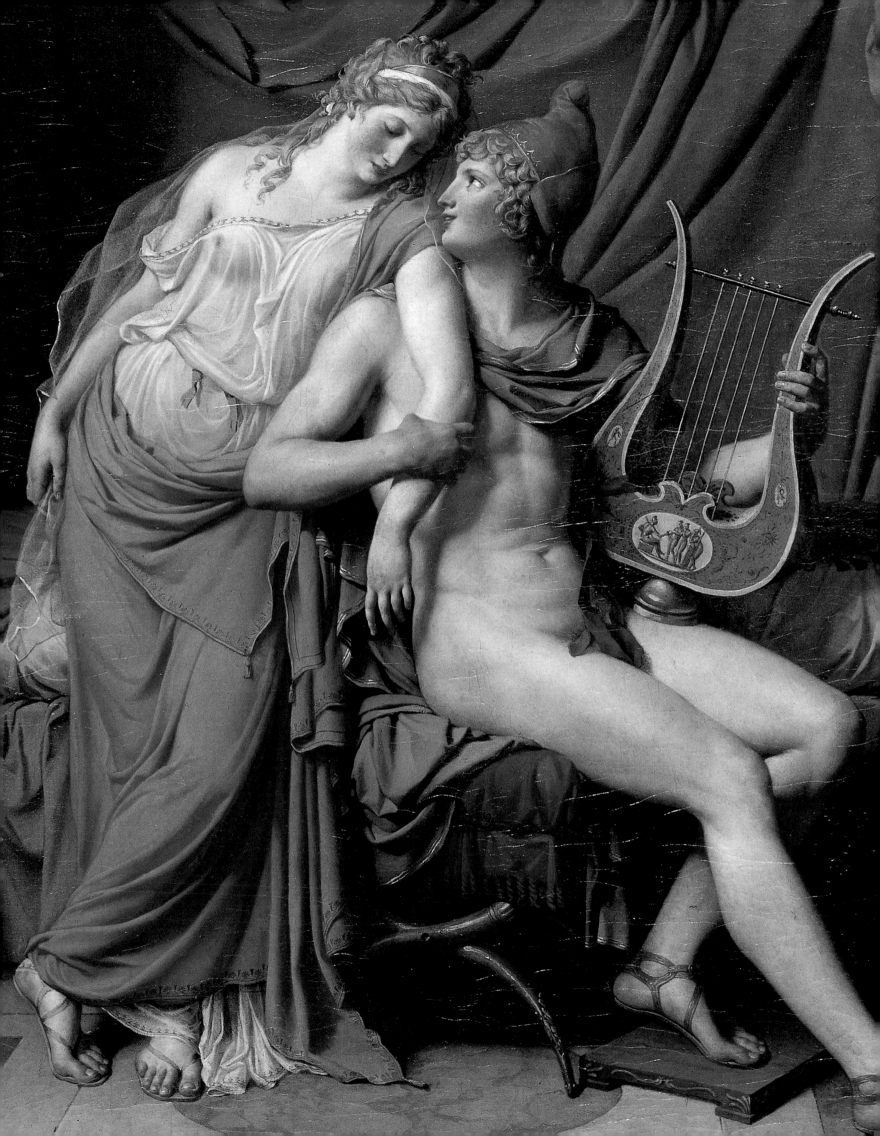

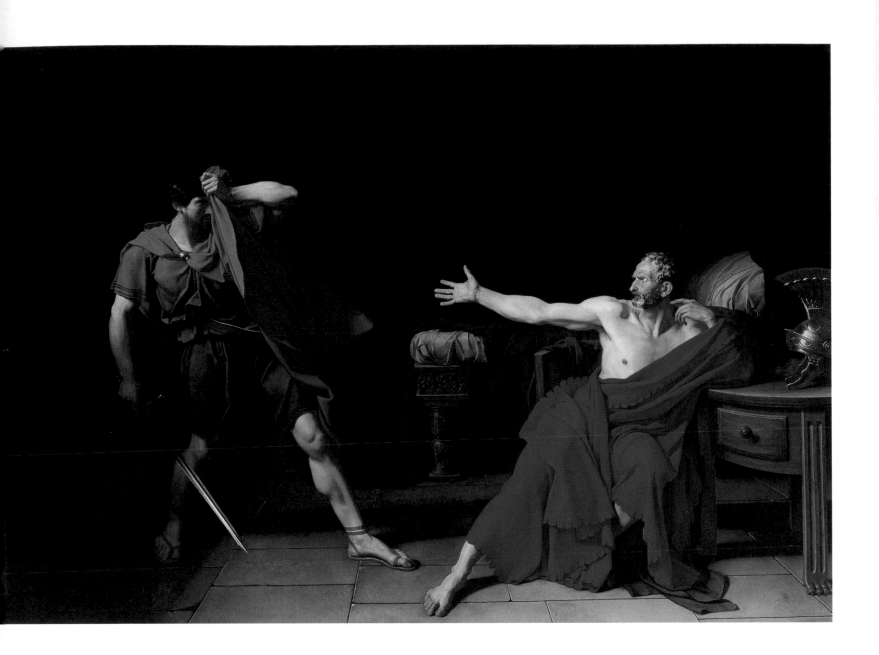

and copies alike. Drouais had worked on the *Horatii*; Girodet made a copy of the same canvas; Gérard copied the half-veiled nurse in *Brutus*. Drouais' *Dying Athlete*, exhibited in 1785, bore witness to the effectiveness of David's teaching.

Drouais had stayed on in Italy, far from David's supervision. His *Marius at Minturnae*, which had been a great success in Rome, was equally well received when it was shown in Paris in 1787. Pierre, the King's First Painter, ironically praised David for ordering Drouais "to forge himself a manner distinct from his own", claiming that the two men were already "at daggers drawn". But the young artist was aware of the danger, and forestalled mockery by avoiding themes too close to those of his master. His powerful composition, *Philoctetes at Lemnos* (1788) promised great things.

Drouais had just obtained a royal commission, and had his choice of subject approved: *Caius Gracchus the Younger Sets Out, Despite the Pleas of His Wife,*

| Jean-Germain Drouais
MARIUS AT MINTURNAE
| 1786, oil on canvas,
271 × 365 cm
(106 5/8 × 143 3/4 in).
| Musée du Louvre, Paris.

Anne-Louis Girodet-Trioson |
**HIPPOCRATES REFUSING
THE GIFTS OF ARTAXERXES**
Detail. 1793, oil on canvas,
134 × 98 cm (52 3/4 × 38 5/8 in). |
Faculty of Medicine, Paris. |

to Meet his Assassins. Gracchus, a Tribune of the Roman Republic, had taken up his brother's struggle in favour of the impoverished, and met the same fate. The theme could not have been more topical. But the huge picture was still incomplete when, on 13 February 1788, Drouais succumbed to small-pox. His shocked friends commissioned a monument to Drouais from Michallon, to be erected in Rome. David himself was devastated. On hearing the news, he cried out: "I have lost my pride, my antagonist!" A corner of his Paris garden was set aside in memory of his much-loved pupil.

Though David was neither professor nor assistant at the Académie, increasing numbers of students wanted to study with him. His colleagues Devosges and Fragonard both entrusted their sons to him. The energy that he put into supporting his students, before and during the competition, infuriated other entrants: "We want to compete against one another, not against Monsieur David, who will always have a protégé to support." And indeed, the favou-

François-Xavier Fabre
THE DEATH OF ABEL
1790, oil on canvas,
144 × 196 cm
(56 3/4 × 77 1/8 in).
Musée Fabre, Montpellier.

Anne-Louis Girodet-Trioson |
STUDY FOR
THE SLEEP OF ENDYMION
Undated, oil on canvas,
49 × 62 cm
(19 1/4 × 24 3/8 in).
Musée du Louvre, Paris.

rites for the Grand Prix that year were Fabre, Girodet, Gros and Gérard. Fabre won, and in 1791, sent back to the Salon a *Death of Abel*, inspired by one of the idylls of the Swiss writer Gessner. David introduced him to Alfieri and the Countess of Albany, whose portrait he painted in 1793. He went to live near them, in Florence, and was adopted as their heir, returning to France only at the end of his life.

In 1789, it was Girodet's turn. The painting that he sent to the 1791 Salon was *The Sleep of Endymion*; its 'pre-Romantic' treatment of 'ideal beauty' was found astonishing, and it displayed an expansive eroticism entirely foreign to David. But his second submission, *Hippocrates Refusing the Gifts of Artaxerxes*, was rigorously Davidian in its neo-classicism. Girodet returned to France only in 1795, having been forced to flee to Naples in 1793. Gérard made a journey to Rome in 1790; on his return to Paris, he found David increasingly absorbed by politics.

David often attended political debates in the clubs and the assemblies with his closest collaborator, Gros, but in early 1793 he encouraged him to leave for Italy, fearing that his moderate views were unacceptable. The most republican of his students, Topino-Lebrun, was in Florence, and David, hoping that he would soon return, wrote to him there: "Giroust is in the army and his opinions have changed. Gérard himself steers clear of us." A slight tone of disillusionment is perceptible. David's political commitments were beginning to come between him and his friends.

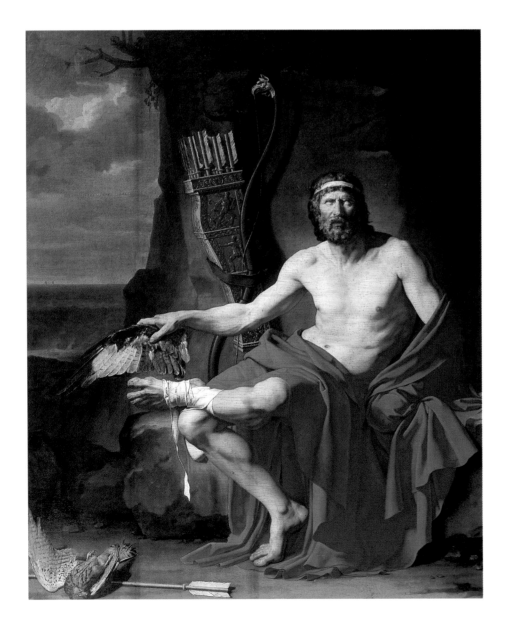

Jean-Germain Drouais
PHILOCTETES AT LEMNOS
1788, oil on canvas,
225 × 176 cm
(88 5/8 × 69 1/4 in).
Musée des Beaux-Arts, Chartres.

3. At the Heart of the Revolution

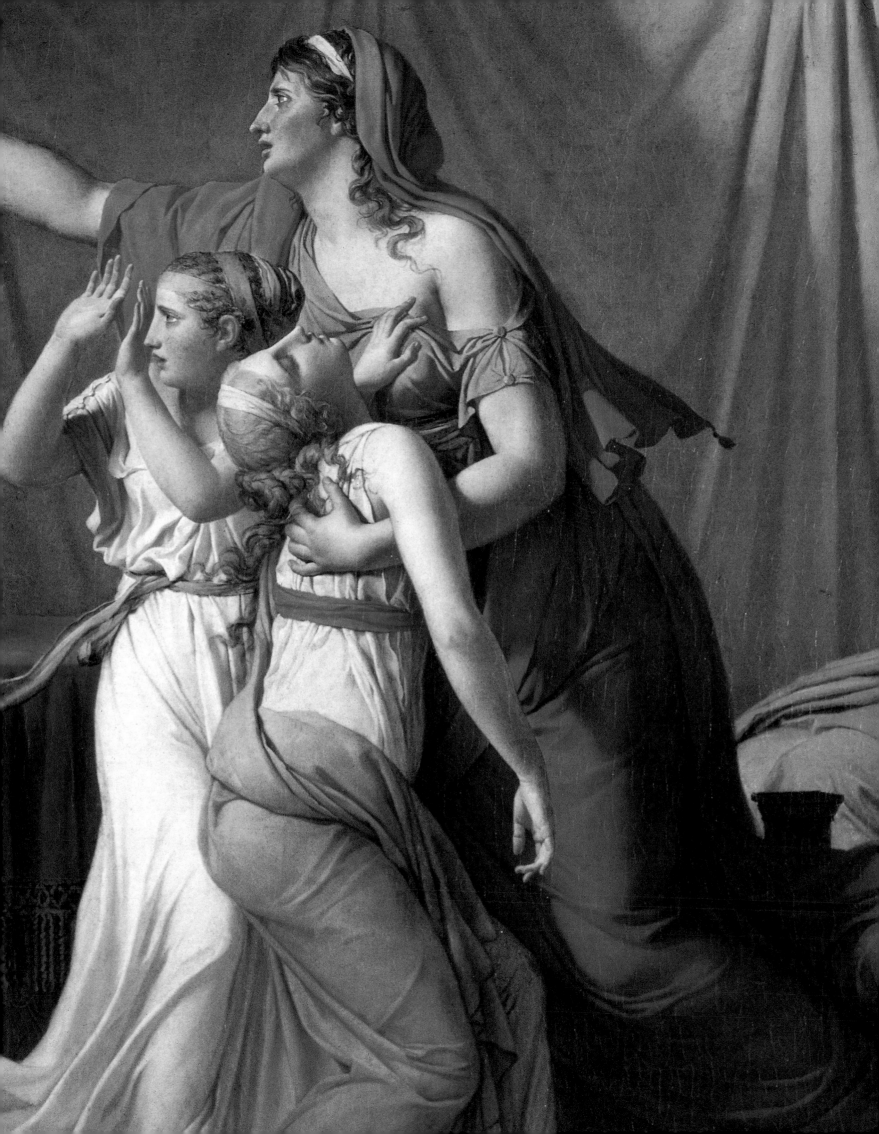

As early as 1751, the marquis d'Argenson had observed: "There is a philosophical breeze blowing from England, a breeze of free and antimonarchical government, which makes its way into people's minds, and we know how the world is governed by opinion."

Thirty years later, this breeze had become a gale. The American War had drained the treasury of the French State. The court's sumptuary expenses exasperated a people worn down by the terrible winter of 1788-1789. But the convocation of the Estates General brought a glimmer of hope. On 20 June 1789, the deputies of the Third Estate swore not to disperse until they had given France a constitution. The storming of the Bastille on 14 July was followed by riots. David and Girodet may have been present: sketches of the severed heads of Launay, the governor of the Bastille, Foulon, who had been appointed Chief Inspector of Finances only two days before, and Bertier de Sauvigny, mounted on pikes, have been attributed to them. The enclosed society inhabited by the artists of the Louvre was riven by conflicts of opinion. Following the example of the women of Rome, a female delegation went to offer their jewelry to the National Assembly in October 1789: among their number were the wives of David, Moitte, Fragonard, Gérard and Regnault. Regnault's wife numbered among her pupils the daughter of Duplay, a carpenter who, in October 1791, gained an important lodger: Robespierre. Boze, who had made portraits of Louis XVI and Marie Antoinette, now turned his talents to Mirabeau and Robespierre, before David had him expelled from the Jacobin Club in 1793. Hubert Robert had been a guard of the Royal Museum since 1784; he now painted *The Demolition of the Bastille* and *The Festival of Federation*, and in 1792 drew *The Sleep of Marat*.

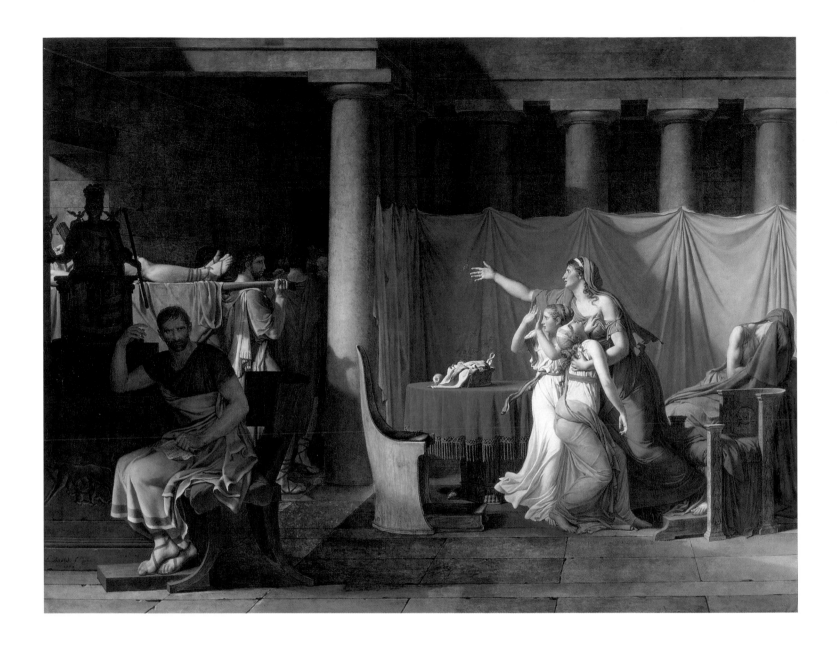

The march of the Revolution

In early 1789, David was still dreaming of Italy, and seemed remote from the political turbulence that had engulfed Paris. But the picture that he was working on, *The Lictors Bringing Brutus the Bodies of his Sons*, dovetailed perfectly with the concerns of the time. It was a heroic subject, in the same vein as his preceding works on classical themes, and a royal commission. To judge by the surviving sketches, the project was already under way in 1787. "I am painting a subject I have invented myself", David wrote to his pupil Wicar. The story of Brutus had formed the basis of tragedies by Voltaire (premiered 1730) and Alfieri, and David's version is a kind of summation. It shows the founder of the Republic pent up in his grief as the lictors bring him the bodies of his sons, one of them killed trying to reestablish the Tarquin monarchy, the other condemned to death by his father for having failed to denounce the plot.

For the philosophers of the Enlightenment, Brutus was a heroic exemplar of republican liberty, who had placed the interests of the nation above the life of

| Jacques-Louis David
THE LICTORS BRINGING BRUTUS THE BODIES OF HIS SONS
1789, oil on canvas,
323 × 422 cm
(127 1/8 × 166 1/8 in).
Musée du Louvre, Paris.

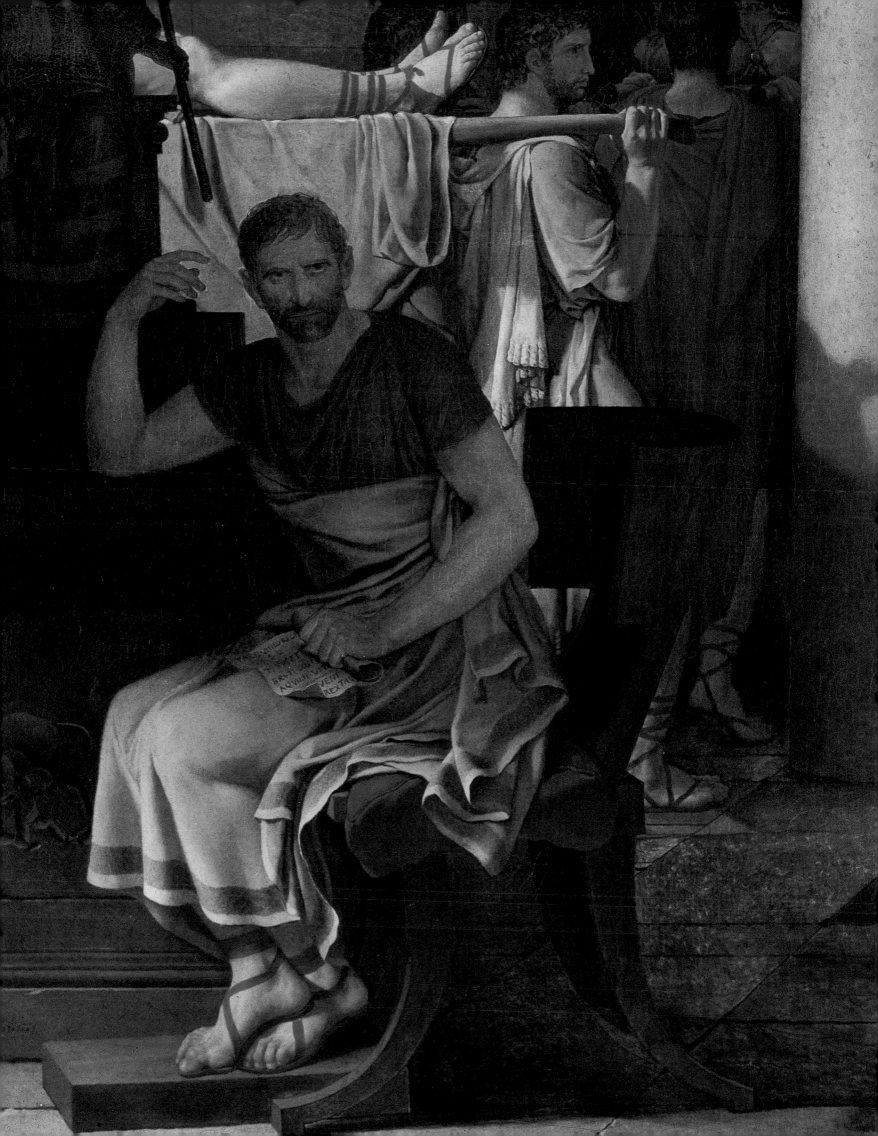

his sons. David's stroke of genius, which the critics unanimously hailed, was to envelop Brutus in shadow – the dark night of inner conflict. The statue of Rome, to which Brutus' sons have been sacrificed, is also wreathed in shadow. The light touches on the corpse borne on the lictors' shoulders before haloing the women in their extremity of grief, while at the centre of the painting, unexpected and overlooked, a workbasket stands symbolically between the brutal world of men and the tenderness and compassion of women.

In the Autumn Salon of 1789, as if to point a moral lesson, David showed the stoicism of *Brutus* alongside the adultery of *Paris and Helen*, which had brought the war of Troy in its wake. But he withdrew the portrait of Lavoisier on the advice of his cousin Cuvillier; Lavoisier had narrowly escaped lynching on 6 August, when a crowd discovered him carrying gunpowder through the streets. By contrast, David ignored d'Angiviller's fears that a parallel might be drawn between the behaviour of Brutus and the failure of Louis XVI to act against "his brother and others among his relatives who had similarly conspired against their country's liberty". The summer's events meant that the *Brutus* was appreciated rather for its political content than its artistic merit.

Dining with the Countess of Albany after the 'Flight to Varenne' (20-21 June 1791: Louis XVI and Marie Antoinette, attempting to flee Paris, were apprehended and forced to return), David apparently expressed his regret that the market women "had not torn the old bitch [Marie Antoinette] to pieces". Our source for this remark is his friend Filippo Mazzei, who had just obtained for him a commission from the King of Poland to copy a number of celebrated portraits. David's contempt for the Queen was a common one. In 1783-1784, an adventuress called Jeanne de Valois had persuaded the Cardinal de Rohan that he was acting as the Queen's intermediary in buying a diamond necklace; she forged the Queen's approval of the purchase, then purloined and sold the diamonds. Though de Valois was caught, the Queen's innocence was not established till long after her death, and her reputation for extravagance and anti-democratic sentiment was exacerbated with a taint of dishonesty. With this exception, David kept his political opinions in check till the end of the year, devoting himself to his art. Indeed, when he painted the portraits of two sisters, the marquise d'Orvilliers and the comtesse Thélusson de Sorcy, it was at the request of relatives of the minister Necker.

In late 1789, the city of Nantes approached David for a picture to commemorate its part in the Revolution; their spokesman, the architect Mathurin Crucy, had studied with David in Rome. On 9 December, David replied, proposing an allegory: "We must imagine France as it was, at the mercy of every depredator; I shall therefore show the figure of France on a throne, torn to shreds by corrupt practices; false merit will be shown triumphant and truth neglected in the shadows, trade languishing, the farmer stretched out on his sheaves of corn as he starves to death, the clergy and the nobility fighting over the rewards of their success – and then the Bretons, led by their mayor, revolted by this spectacle, swoop down upon these vampires and grateful France places herself under their protection." David visited Nantes in March and April 1790, but the municipality failed to confirm the commission.

Jacques-Louis David |
PORTRAIT OF ANNE-MARIE-LOUISE THÉLUSSON, COMTESSE DE SORCY
1790, oil on canvas,
129 × 97 cm
(50 3/4 × 38 1/8 in).
Alte Pinakothek, Munich.

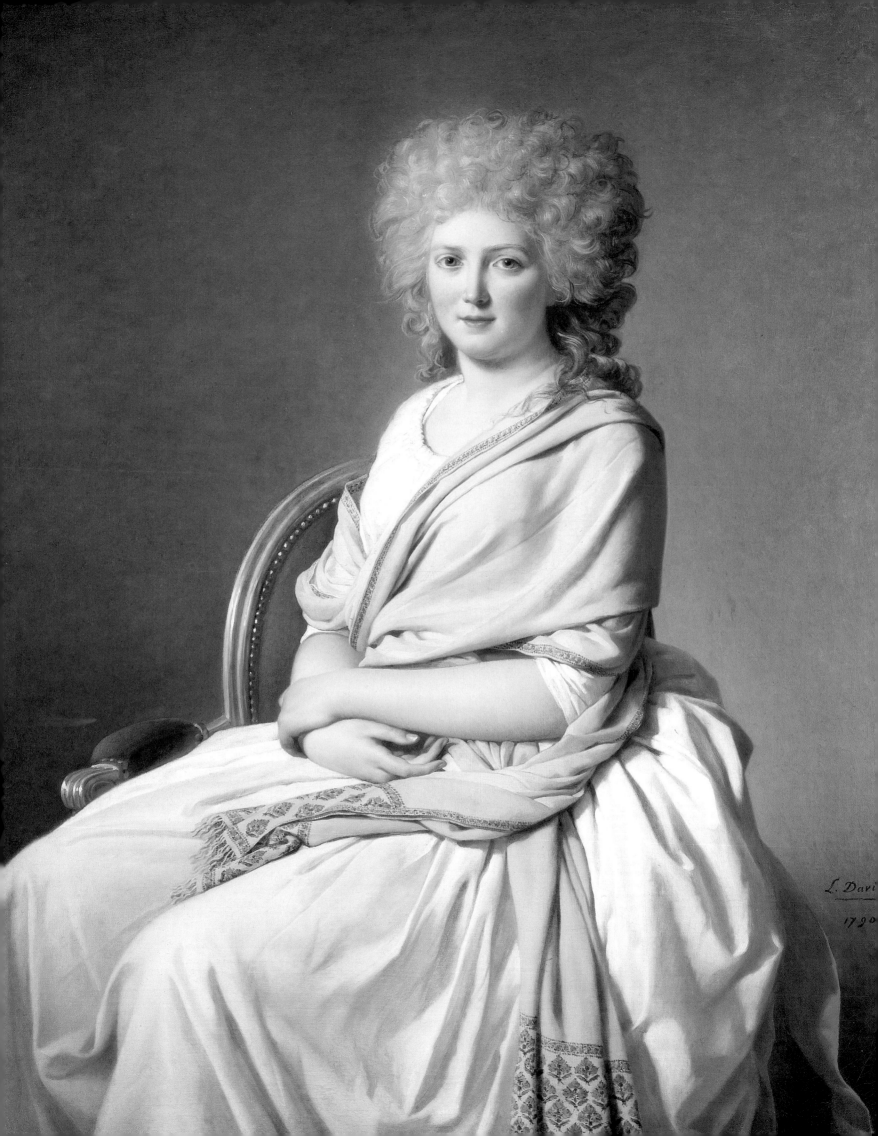

A few sketches for the project survive. They constitute David's first overt expression of hostility to the privileged castes of the *ancien régime*.

He nevertheless began a portrait of Louis XVI. After the flight to Varennes, few people any longer trusted the King, and in September 1791, the Constituent Assembly asked him to commission a painting as an official record of the oath of allegiance he had just sworn to the new constitution. The monarch would be depicted drawing the attention of his son to the founding text of the new regime. Louis XVI commissioned two such paintings: one for the National Assembly, from Mme Labille-Guyard, and one for the Council Room, from David. The project did not long occupy David, who had something of much greater consequence in mind.

Painting as manifesto: The Tennis Court Oath

On 20 June 1789, the members of the Third Estate, together with a part of the Second (the clergy), gathered in the Tennis Court at Versailles. There they swore "never to separate and to meet wherever circumstances required, until the constitution of the kingdom was established and shored on solid foundations". The historic significance of this event had not escaped the French people, and in June 1790 a solemn ceremony initiated a tradition of commemoration. The Society of Friends of the Constitution had been formed at the very beginning of the Estates General in Versailles, and subsequently transferred its meetings to the former Jacobin convent in Paris. In October 1790, the Jacobin Club, as it was now known, launched a subscription "to perpetuate the most fruitful monument of courage and patriotism that any century has ever produced". The funds were to cover the commission of a painting for the National Assembly; this would be reproduced by engraving and a mosaic copy would be installed in the Tennis Court itself. The picture was to be thirty feet long and twenty feet high (approximately ten by six metres). The deputy Dubois-Crancé persuaded his colleagues to call on the services of David: "To realise our conception in paint, we have chosen the author of *Brutus* and the *Horatii*, that patriotic Frenchman whose genius anticipated the Revolution." "You have deprived me of my sleep for many nights to come", David declared to general applause when he mounted the rostrum on 28 October 1790 to accept this commemorative commission. He felt himself invested with the role of painter of the Revolution. The great master of classical history had now to find a way of depicting history in the making: "O my country! O my dear country!" he cried. "Now we shall no longer be compelled to seek subjects for our canvases in the history of ancient peoples. Artists lacked subjects, and were forced to repeat themselves; now subjects are wasted for lack of artists. There is, I say, no people whose history offers anything so great and sublime as *The Tennis Court Oath* that I must now paint. I shall not need to invoke the gods of fable to excite my genius. Nation of France, it is your glory that I wish to promote."

The idea for the painting probably arose in early 1790, in conversations between David and André Chénier, who had been present when the oath was sworn. In 1791, Chénier wrote *The Tennis Court*, a hymn "to sacred liberty,

Jacques-Louis David |
THE TENNIS COURT OATH
Detail from the preparatory drawing, 1791, brown ink, brown wash and white highlights, 66 × 101.2 cm (26 × 39 7/8 in).
Musée National du Château, Versailles.

In the centre are Bailly (standing on the table), Sieyès (sitting at his feet); in the foreground, taking the oath, the abbé Grégoire (centre), the pastor Rabaut-Saint-Etienne (right) and the Carthusian Dom Gerle (left).

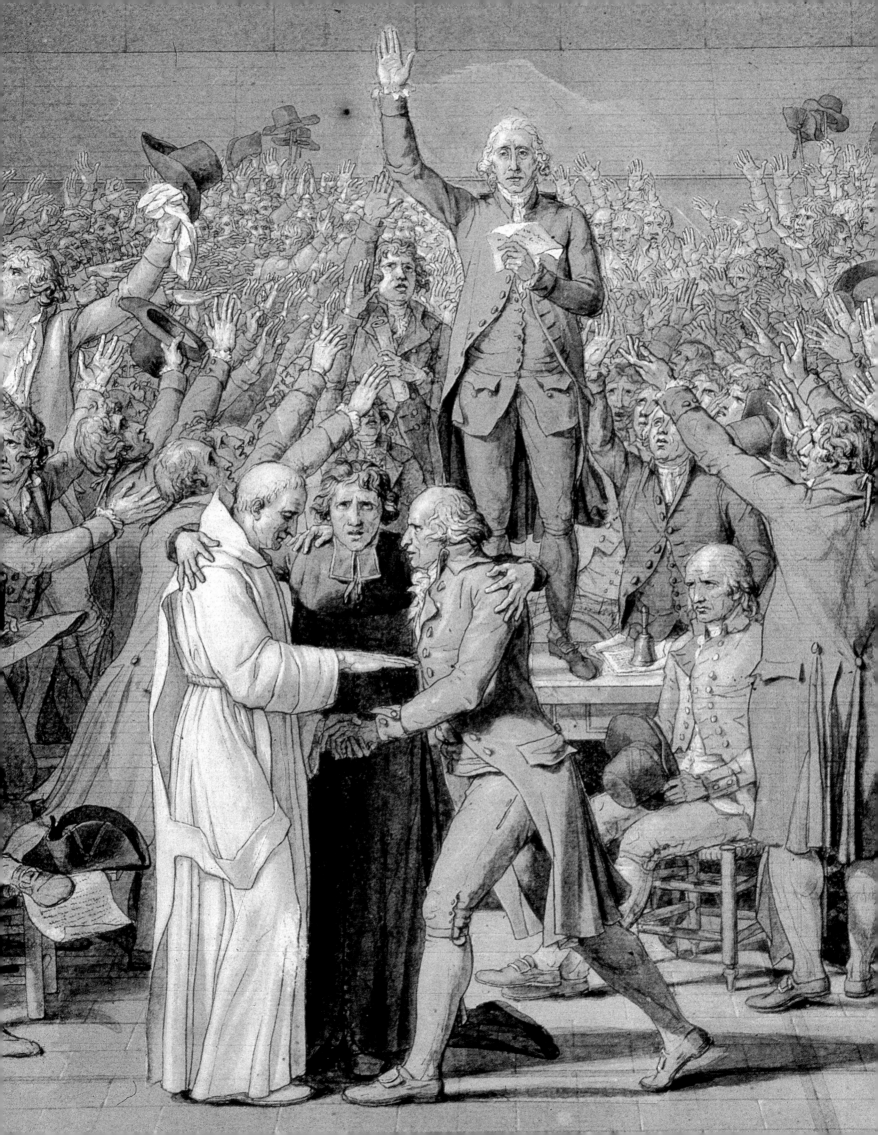

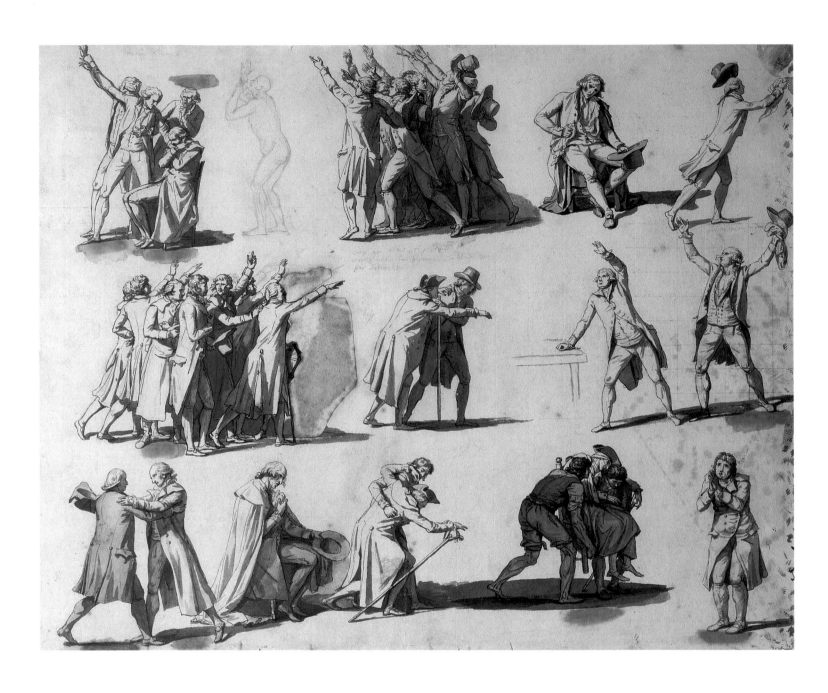

| Jacques-Louis David
**STUDIES OF FIGURES FOR THE OATH
OF THE TENNIS COURT OATH**
Circa 1791, black ink,
grey wash over pencil,
49 × 60 cm (19 1/4 × 23 5/8 in).
Musée National du Château, Versailles.

daughter of the French soil", dedicating it "to Louis David" with the observation that "no talent was ever born of the favours of kings". In sketches and notes, David recorded gestures, faces, the space, the spectators looking down into the room, the great storm wind, and the lightning playing around the roof of the Royal Chapel. In addition to the six hundred and thirty signatories to the oath, national guards and members of the people had rushed to witness the historic event; David thought he would have to depict around a thousand figures. Each was to be treated individually, as the numerous studies for individual heads show. David envisaged nude and clothed studies to ensure the coordination of the gestures. The attitudes struck by the representatives were to contrast with the curiosity of the onlookers. There was a tender realism in the treatment of the children exhorted by their parents to take note of this historic moment. But only a few of the deputies had posed in person before work on the project was halted. Four fully painted heads stand out against the

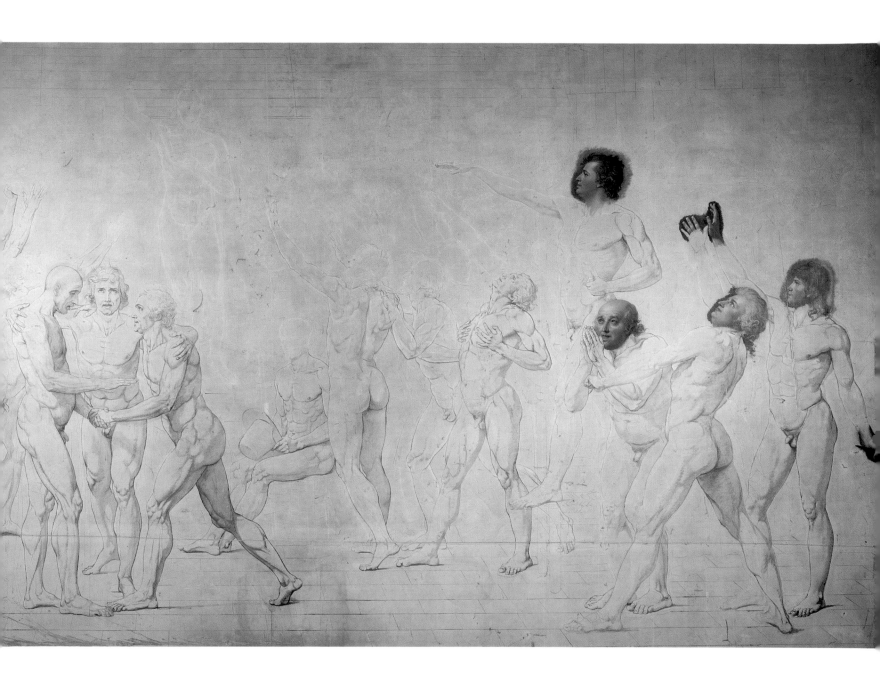

enormous expanse of white ground: the abbé Grégoire, the author of tracts in defence of Jews and Blacks; Mirabeau, the celebrated orator; Barnave, a jurist from Grenoble; and Dubois-Crancé. Other figures are sketched in, but as yet unclothed, forming an assembly of nudes worthy of Michelangelo.

The subscription launched by the Jacobins was not a success. However, many people came to the 1791 Salon to see the large preparatory drawing, which was to serve for the engraving. It was hung beneath *The Oath of the Horatii*, now exhibited for the second time; the analogies of gesture and meaning were inescapable. The first viewers divided along political lines: some were frightened by this eulogy of the Third Estate, while others praised the "intense patriotism" of the drawing. Others again regretted its moderation, wanting a more explicit declaration of war on despotism. But all were struck by the audacity and freedom of the drawing.

In spring 1792, after several months of unremitting work, David abandoned

Jacques-Louis David |
THE TENNIS COURT OATH
Fragment of the unfinished
painting. 1791-1792,
oil on canvas,
358 × 648 cm (141 × 255 1/8 in).
Musée National du Château, Versailles.

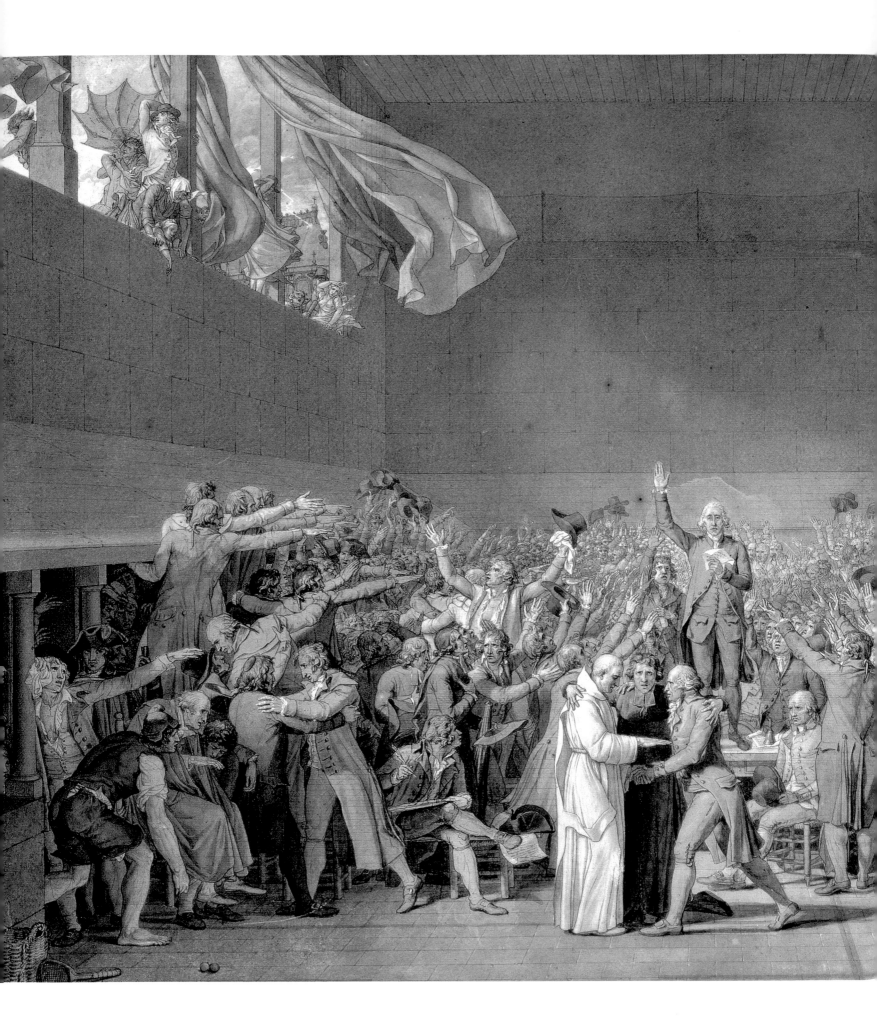

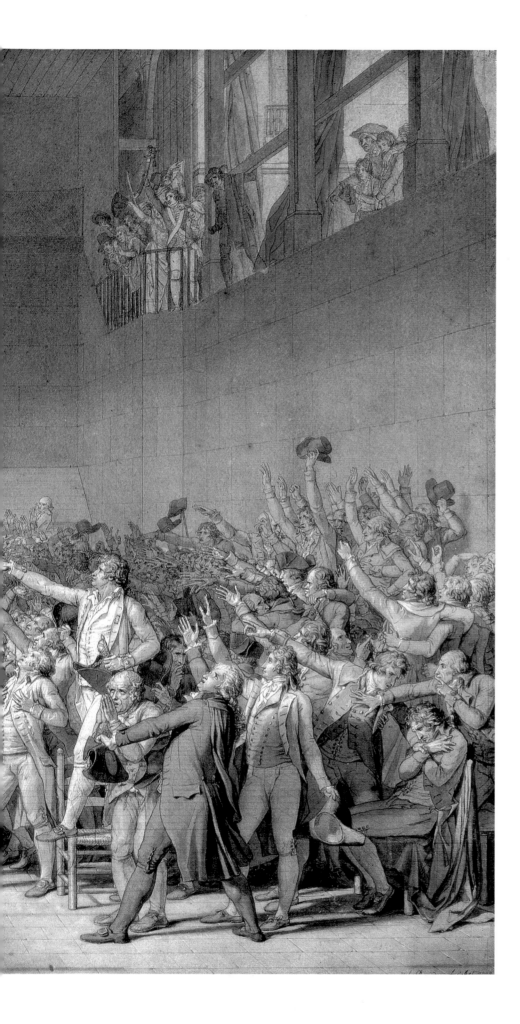

Jacques-Louis David
THE TENNIS COURT OATH
1791, brown ink, brown wash
and white highlights,
66 × 101.2 cm (26 × 39 7/8 in).
Musée National du Château, Versailles.

Jacques-Louis David
NUDE STUDY FOR THE TENNIS
COURT OATH: MIRABEAU
Circa 1791, graphite.
Musée Bonnat, Bayonne.

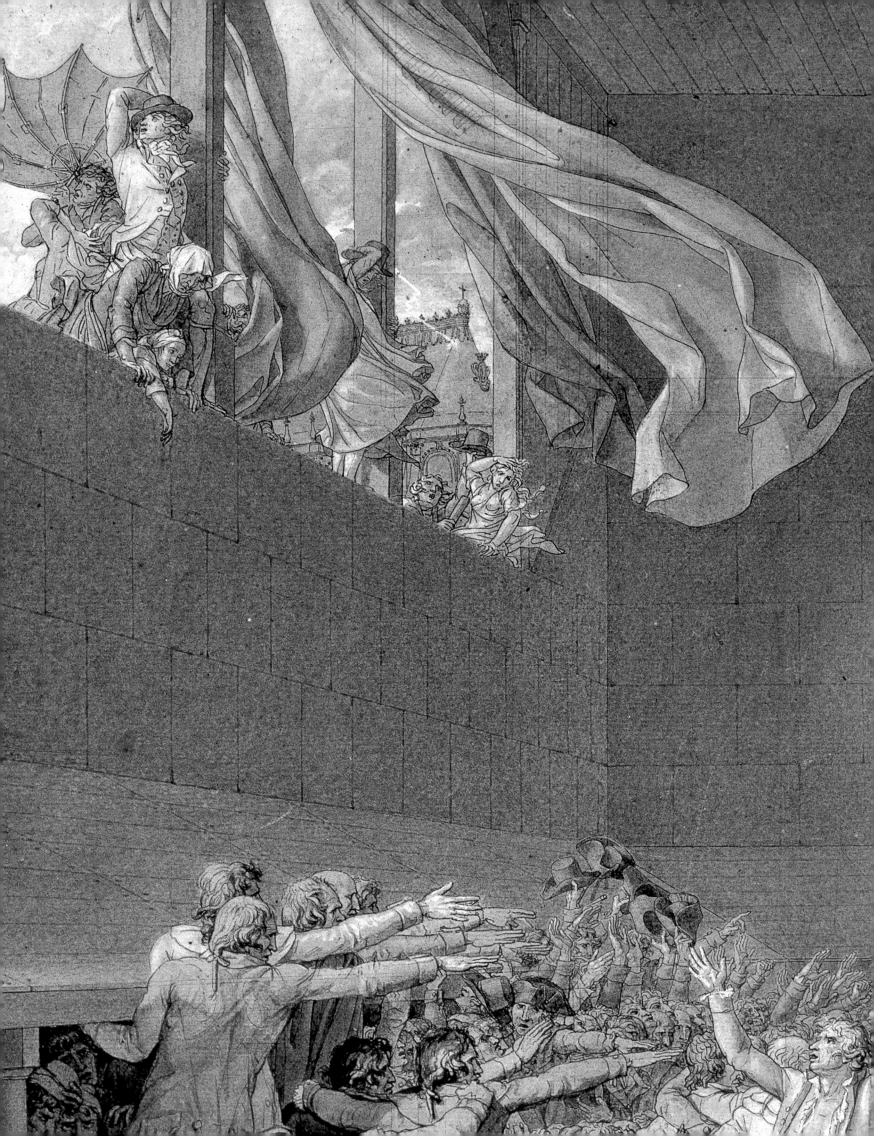

Jacques-Louis David |
**STUDY FOR
THE TENNIS COURT OATH**
Circa 1791, graphite, |
18.2 × 11.3 cm
(7 1/8 × 4 1/2 in). |
Musée du Louvre, Département
des Arts Graphiques, Paris. |

| Jacques-Louis David
THE TENNIS COURT OATH
| Detail.

the unfinished canvas. The painting for which the Chapelle des Feuillants had become a studio was never completed. The hectic pace of political events quickly rendered the project obsolete. Certain of the painting's heroes had fallen from favour; Mirabeau had died just in time, his collaboration with the court having just been discovered. Barnave was gradually sliding over to the monarchist camp, and Bailly was a confirmed moderate. The Revolution had begun to devour its children, and it was no longer possible to remain a spectator. Moreover, David was no longer a mere Jacobin activist; he was serving, with increasingly frequency, on the various commissions for the arts, and preparing to stand in the legislative elections. The *Oath* thus became, in the words of Jean-Jacques Lévêque, a "ghost-painting", and one of the rare works of art to attain mythical status.

A revolution in the arts

David's long-standing resentment of the Académie, born of his own defeats, had grown ever more bitter. The decision not to appoint him as Rector of the Académie de France in Rome, a post he had set his heart on, underlay his conduct toward the institution. His sudden passions and whims had counted against him, as had his speech impediment, which continued to afflict him despite his efforts to overcome it. (In their caricatures of him, his enemies highlighted the exostosis on his jaw.) On his election to the Convention, David persuaded the Assembly to undertake a complete reorganisation of the Académie.

As early as 1789, he had zealously sought reform. The disorderly students of the Académie supported him in his attempt to have Drouais admitted posthumously. When the Secretary of the Académie, the painter Renou, refused, David and Restout began a campaign of dissidence within the institution, contesting the authority of the Director and officers who decided such questions, and criticising the distinction between full and associate members. Soon the associates had joined the rebels, to "work to revise the statutes and reform any abuses which may exist". The group appointed a secretary, the engraver Miger, and five commissioners – Houdon, Jollain, Le Barbier, Pasquier and Restout – to coordinate their activities. David was named president. Vien proposed a compromise with the rebels, assuring the hierarchy that "from David alone of his party we have nothing to fear." Once their president had returned from Nantes, the dissidents submitted their proposals for a new set of statutes. In September 1790, a Commune of the Arts was formed, in whose name, six months later, David demanded the dissolution of the Académie. Its members petitioned for non-Academicians to be allowed to exhibit at the next Salon, and David threatened not to take part in the exhibition "planned by that privileged society, the so-called Académie de Peinture". He won the support of Barère in the Assembly and Talleyrand in the Paris administration, and on 21 August 1791, the Salon de la Liberté opened to the public. David had helped select the featured works, together with Pajou, Vincent and Quatremère de Quincy. He was also one of the commissioners elected by the exhibiting artists to award the main prize, which the

Constituent Assembly, conscious that State commissions were now few and far between, had endowed with one hundred thousand francs. The jury was composed of an equal number of Academicians and non-Academicians, together with five public figures – one of whom was Quatremère de Quincy, a deputy of the newly-elected Legislative Assembly. During their stay in Nantes, the Winckelmannian Quatremère had persuaded David that the Académie's educational work should be separated from its honorific function. David also denounced the disparate teachings of the twelve masters, the imposition of themes, and the authorisations required by artists going abroad.

Though he accepted a post as assistant professor at the Académie in July 1792, David continued to campaign for the abolition of both Académies (painting and architecture). On 27 November 1792, he contrived the abolition of the post of Rector in Rome. Roland, the minister in question, had been about to appoint Suvée, who had won the Grand Prix, beating David, in 1771 – "Suvée, that aristocrat!" To frustrate his rival, David did all in his power to abolish the post that they had both coveted. Responsibility for supervising the students now fell to Basseville, France's new 'agent' in Rome. It was the wrong decision; the increasing politicisation of the Palazzo Mancini students – given expression in Girodet's monumental representation of the Republic – culminated in an anti-French riot during which Basseville was murdered.

In spring 1793, when Renou asked David to resume his teaching at the Academy, the painter refused outright: "for me, the Académie is history". On 8 August 1793, won over by David and the abbé Grégoire, the Convention decreed the abolition of the Académie. David's contempt for these institutions was still apparent in November 1794, when he wrote to Boissy d'Anglas from his prison cell: "Only half-talented artists ever emerged from the Académie." As a member of the Convention, David exercised a sort of artistic dictatorship. Among the countless committees on which he sat was the one responsible for the inventory and conservation of nationalised church property and for the royal collections. Through the Committee for Public Education, he created a "jury of the arts", whose fifty members awarded prizes and initiated projects to immortalise the Revolution. The jury proposed a giant allegory on the Pont-Neuf, using the statues of kings removed from Notre-Dame, and a competition for a monumental statue of the French people, to stand on the tip of the île Saint-Louis.

Establishing a museum in the Louvre had been the dream of La Font de Saint-Yenne and Diderot; now d'Angiviller began the process. On 27 July 1793, the Convention voted to create a National Museum, to be housed in the Grande Galerie. In a speech to the Convention in January 1794, David insisted on the dual – cognitive and educational – purpose of the museum. To this end, drawings should be exhibited alongside paintings and sculpture. At the same time, a new Conservator was appointed, the incumbent having been deemed insufficiently patriotic. David nominated Jean-Honoré Fragonard. When Coustou's celebrated horses were moved to the Place de la Concorde (then Place de la Révolution), it was at David's behest, and he frequently interceded

Attributed to David |
PIERRE-LOUIS PRIEUR DE LA MARNE
Undated, oil on canvas,
38 × 31.5 cm (15 × 12 3/8 in).
Musée de la Révolution Française, Vizille.

Page 106 |
Jacques-Louis David |
PORTRAIT OF LOUISE TRUDAINE
1792, oil on canvas,
130 × 98 cm (51 1/8 × 38 5/8 in).
Musée du Louvre, Paris.

Page 107 |
Jacques-Louis David |
PORTRAIT OF LOUISE PASTORET
1792, oil on canvas,
130 × 97 cm (51 1/8 × 38 1/8 in).
The Art Institute of Chicago.

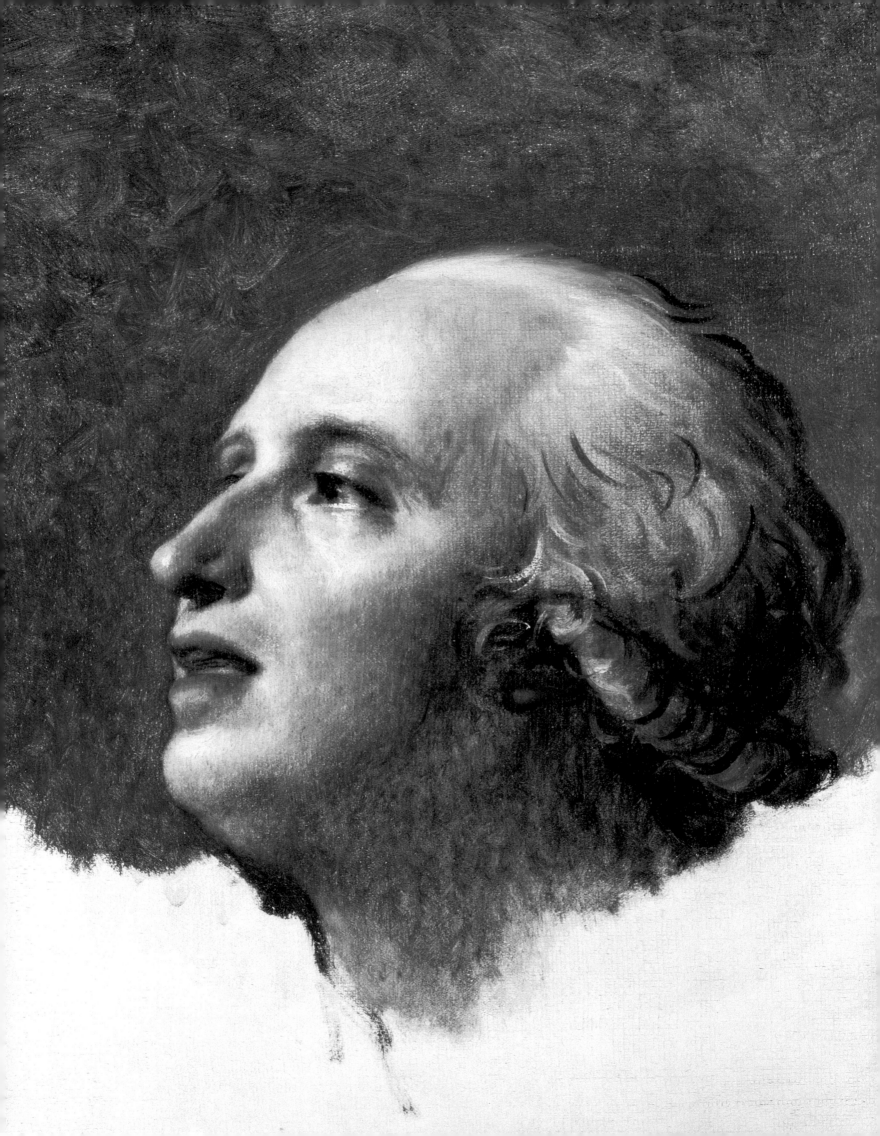

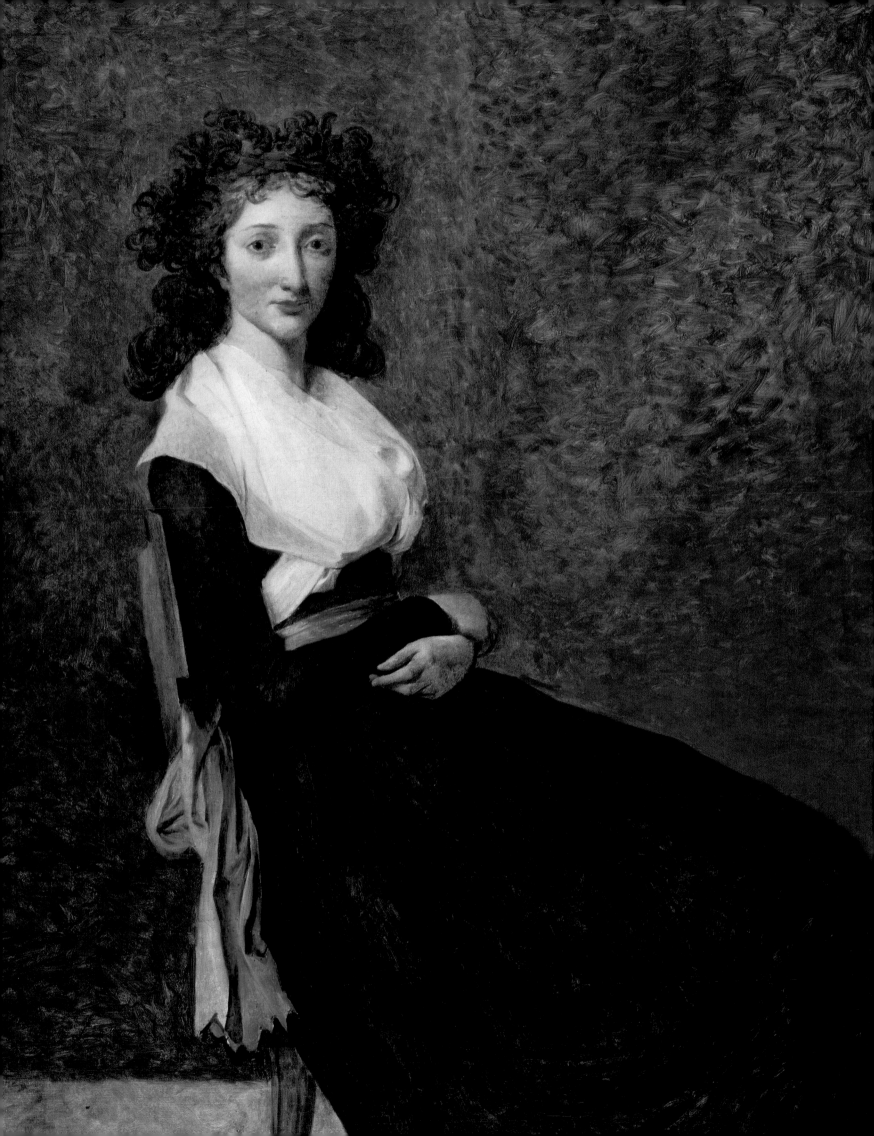

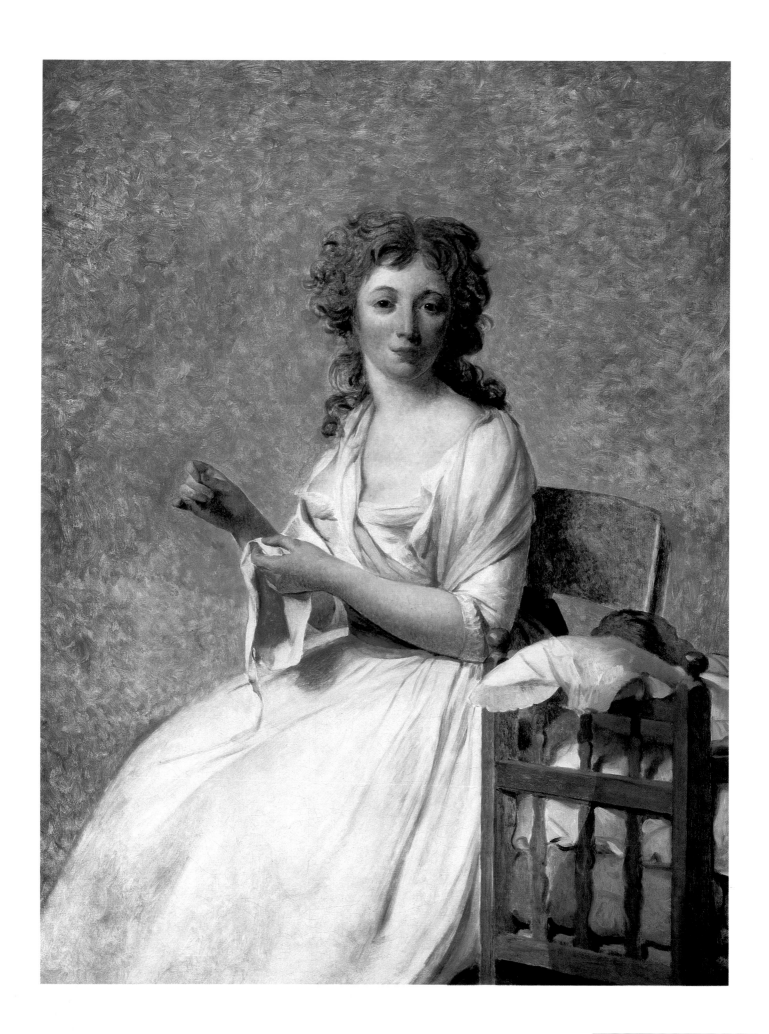

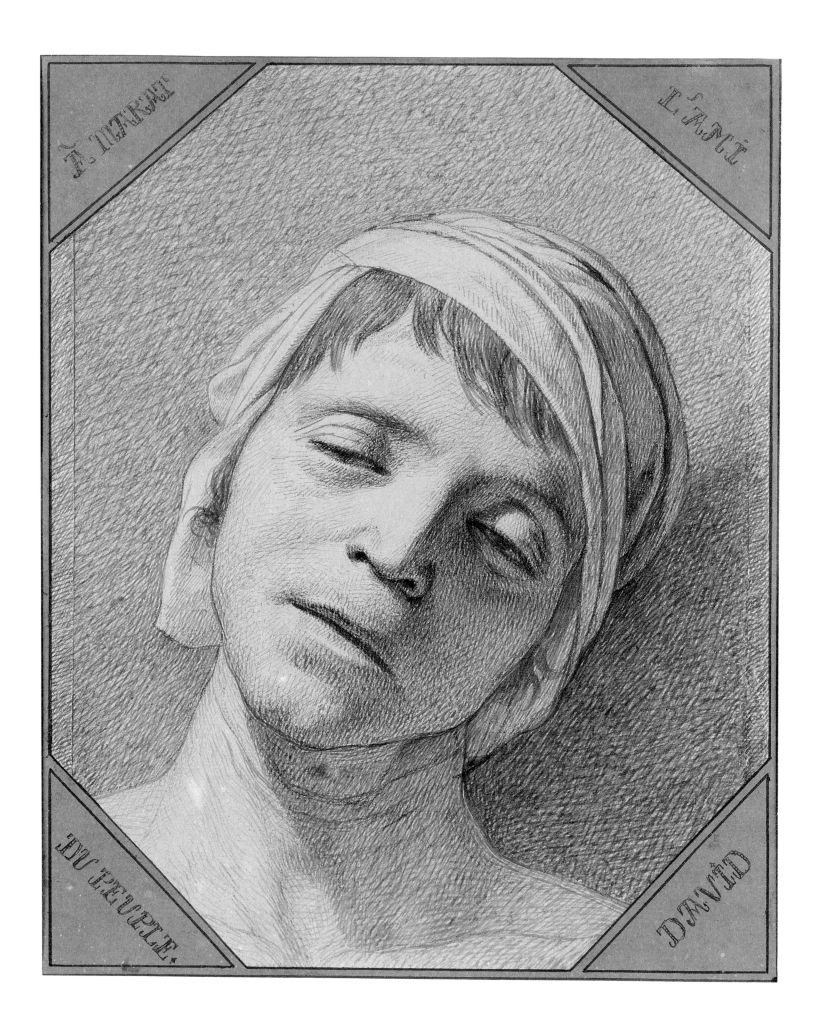

on behalf of his friends. In one such case, he certified the *civisme* of Vivant Denon, who was given the task of engraving *The Tennis Court Oath* and designing various costumes for the new regime. David also recommended his pupil Wicar for the post of Director of the Sèvres Porcelain Factory.

Icons of the nation

David's political involvement increased his isolation. His royalist wife was estranged from him, and in 1790 was permitted to retire to a convent, though her stay was brief, since the religious communities were themselves swept away shortly afterwards. Civil divorce had recently been instituted, and they separated on 16 March 1794. Along with the 'amazon of liberty', Théroigne de Méricourt, and Marie-Joseph Chénier, David had signed a manifesto proposing a triumphal reception for the Swiss Guards of the Châteauvieux regiment (see p.114). This was too much for André Chénier, who dissociated himself from the painter and friend he had so admired. David's vote for the execution of Louis XVI had alienated his liberal acquaintances, among them many Girondins. As President of the Convention, a title held by rotation for two weeks, David signed a warrant for the arrest of Fabre d'Églantine, one of the instigators of the September massacres of prisoners; the massacres were a factor in the fall of Danton and his friends. Since September 1793, he had sat on the Comité de Sûreté générale, the body responsible for policing the Terror. Throughout this period, David adhered to the hardline republicanism of Robespierre and his disciples. He signed almost three hundred arrest warrants and about fifty summonses to appear before the Revolutionary Tribunal. Almost all the accused were guillotined. Among the victims were some who had fostered his career, notably Philippe Égalité, former duc d'Orléans, and the maréchal and duchesse of Noailles, who had commissioned a *Christ on the Cross* from him. He was a regular attender at both the Jacobin Club and the Convention. His intense political activity meant that he had less time for painting. He produced a few portraits: those of Mme Trudaine de Montigny (long mistaken by art historians for Mme Chalgrin), and Mme Pastoret, whose husband, a deputy of the Legislative Assembly, had fled to Provence, where he was active for the monarchists. Their features betray helpless amazement, as if they had just been apprized of their imminent arrest. The unfinished state of the two works makes them all the more moving; they have a sort of timeless modernity. Their faces, limned with the simplicity of David's revolutionary style, stand out on a background of nervous brushwork. He used a similar economy of style in his paintings of "the martyrs of liberty".

On 20 January 1793, in a restaurant in the Palais-Royal, a guardsman by the name of Pâris stabbed to death Le Peletier de Saint-Fargeau, one of the leading Conventionnels. It was not a sophisticated crime; Pâris simply wished to strike down one of the men responsible for the sentencing of the King, who was to be guillotined the following day. The murder stunned the revolutionary party. Le Peletier, a former counsellor to the Parlement de Paris and deputy for the Yonne, had died like a Roman Tribune, and David decided

François Desvosge |
LE PELETIER DE SAINT-FARGEAU ON HIS DEATH BED
Before 1793, graphite on paper, 46 × 40 cm (18 1/8 × 15 3/4 in).
Musée des Beaux-Arts, Dijon.

| Jacques-Louis David
HEAD OF MARAT IN DEATH
1793, brown and black ink over black chalk, 27 × 21 cm (10 5/8 × 8 1/4 in).
Musée National du Château, Versailles.

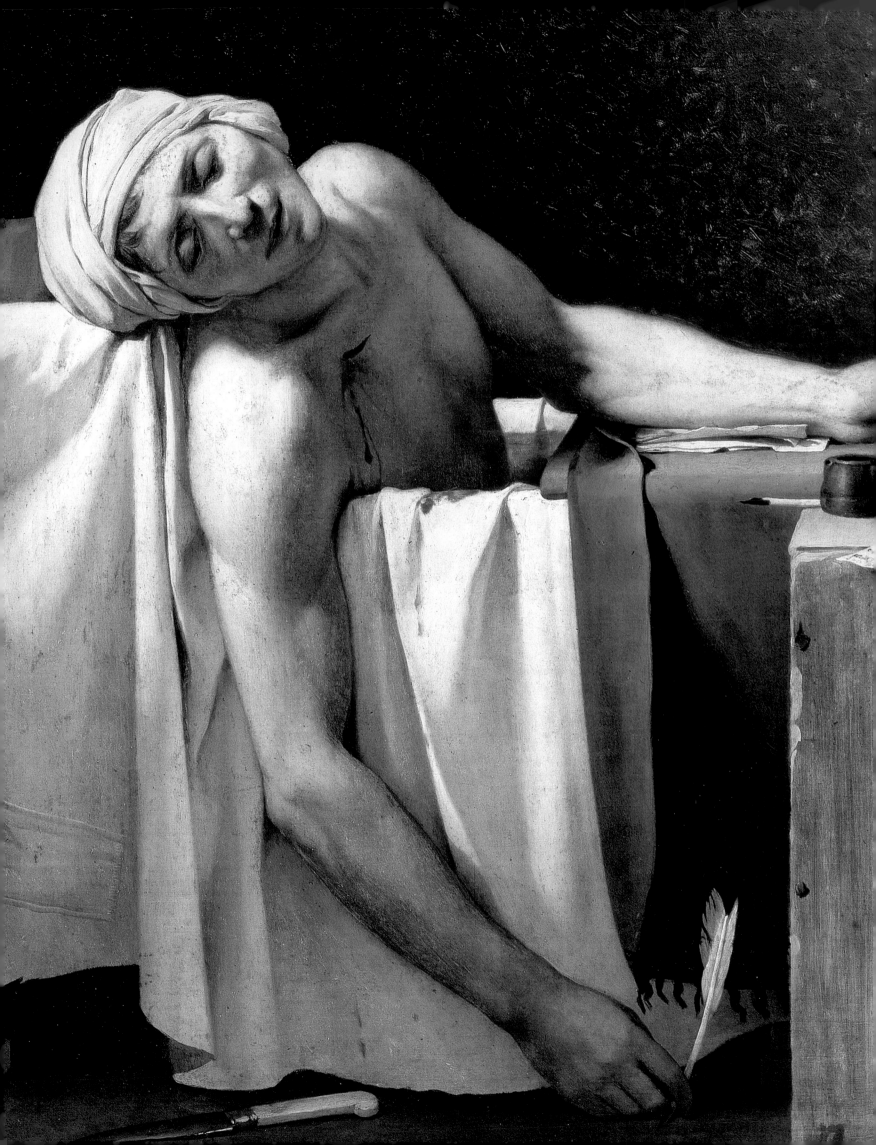

to paint his corpse. In late March 1793, he offered his painting to the Convention, where it was immediately hung above the President's chair. Then David mounted the rostrum to declare: "Citizens, each of us is responsible to our homeland for the talents we have received from nature... The true patriot must seize on every means he can to enlighten his fellow citizens and keep before their eyes the sublime lineaments of heroism and virtue." The painting has, alas, disappeared, and its austere lines survive only in a drawing made by Desvosge from an engraving.

On 13 July 1793, came the murder of Marat. The following day, a Constitutionnel exclaimed "David, one more painting awaits your hand!" David was laconic: "It shall be done." He set to work on the very day when André Chénier composed his impassioned ode to Charlotte Corday.

An admirable drawing of Marat's head, presumably made just before his corpse was exhibited, shows us a timeless figure; the embalmed features of the martyr seem younger and more serene. For the painting itself, destined to hang next to the portrait of Le Peletier in the Convention, David surpassed himself. He worked alone, with only his memories to help him. "The day before Marat died," he wrote, "the Jacobin Society sent us to fetch news of him. I was struck by the attitude in which I found him. He had a block of wood by his side, on which stood paper and ink, and his hand, emerging from his bathtub, was writing his thoughts about the salvation of the people." Marat suffered from a skin disease, and spent most of his time in the bath to soothe his pain. David maintained this realistic setting, but idealised the martyr in every way; wounded in the chest, head turbanned in linen, he rests in his bath like a Christ from a deposition. Remote from Marat's violent rhetoric, his face seems almost serene. The austerity of the composition, testifying to the republican poverty of the "the People's Friend", appealed strongly to the Parisian *sans-culottes*, who worshipped Marat.

The work was quite without precedent. After *The Death of Marat*, painting was never the same again – the work's influence extends to Seurat and the Cubists. Baudelaire is admirably exact: "The drama is there, alive in all its deplorable horror, and by a bizarre feat of virtuosity, which makes this painting David's masterpiece and one of the great curiosities of modern art, there is nothing trivial or ignoble about it. Most astonishing of all, this unwonted poem was painted with extreme rapidity; when you consider the beauty of the drawing, the fact is altogether bewildering. This is food for the strong and the triumph of spiritualism; cruel as nature, the picture breathes the life of the ideal. (...) In this work there is something at once tender and poignant; in the cold air of the room, on these cold walls, around this cold, funereal bath tub, hovers a soul."

| Jacques-Louis David
THE DEATH OF MARAT
Detail. 1793, oil on canvas,
165 × 128 cm (65 × 50 3/8 in).
Musées Royaux des Beaux-Arts de Belgique, Brussels.

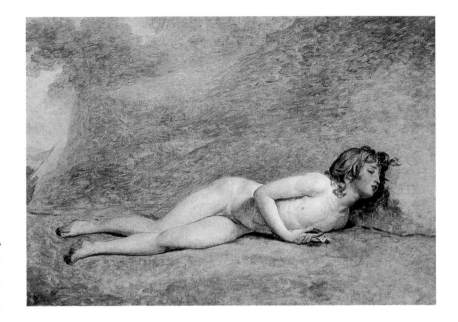

Jacques-Louis David |
THE DEATH OF BARA
1794, oil on canvas,
119 × 156 cm
(46 7/8 × 61 3/8 in).
Musée Calvet, Avignon.

On 12 September 1793, the Comité de Salut public invited "the citizen David to employ the talents and means at his disposal to multiply engravings and caricatures that will reawaken the public spirit, and demonstrate how repugnant and ridiculous are the enemies of liberty and of the Republic". Five hundred copies of *The Death of Marat* in colour and five hundred in black and white were planned, and dozens of other engravers received identical orders. The following year, the heroes of the day were children. David was asked to paint Joseph Bara, the drummer who chose to die rather than shout 'Vive le roi!', and the young Provençal Agricol Viala. Of these two projects, one unfinished canvas survives. It is known as *The Death of Bara*, though there are some indications that the subject is actually Viala, who was shot dead while cutting a cable used by the royalist troops to cross the river Durance. The royalists can just be made out on the left, while the cable snakes across the ground beside his body. He still holds the tricolour cockade and the message entrusting him with the mission. He is shown naked; child spies stripped to slip behind the enemy lines. But his nudity is also a homage to 'ideal beauty', like Girodet's *Endymion* or Prud'hon's illustrations for the publisher Didot. Indeed, the movement of the body is curiously reminiscent of the Villa Borghese *Hermaphrodite*. This vision of languid exhaustion was painted as the violence of the Revolution attained its climax.

Festival magnificence

"Hold festivals to fire the people with enthusiasm for liberty." Thus Robespierre. David was the painter-propagandist of republican virtue; his work as a member of the Comité de Sûreté générale and as deputy, and his ongoing vendetta against the Academy, were combined with 'parade' duties. He designed costumes for the representatives of the Republic and, with André Chénier's brother, Marie-Joseph, organised the revolutionary festivals. The role was a traditional one; under the old system of trade guilds, painters

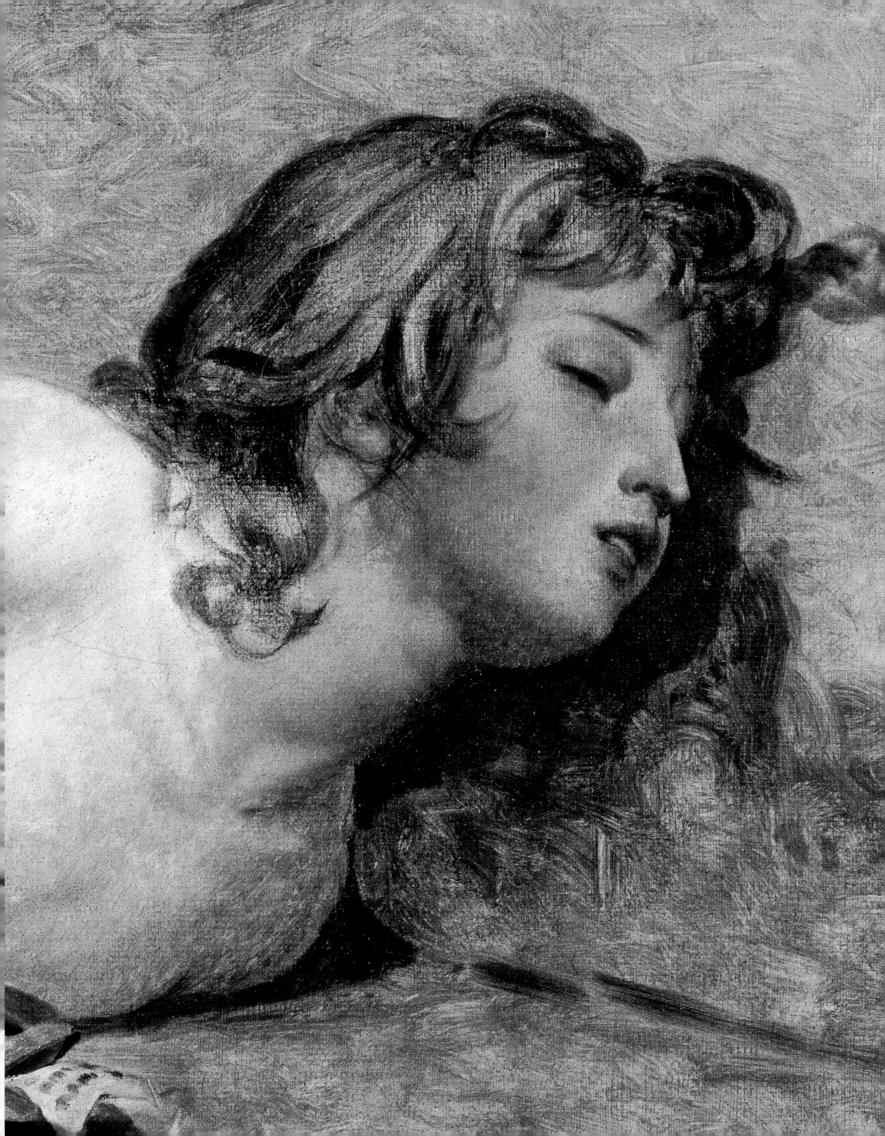

| Jacques-Louis David
THE FRENCH CITIZEN
| 1794, black ink
and watercolour,
30 × 20 cm
(11 7/8 × 7 7/8 in).
Musée National du Château,
| Versailles.

Jacques-Louis David |
**THE REPRESENTATIVE
OF THE PEOPLE PERFORMING
HIS DUTIES**
1794, black ink
and watercolour,
31.5 × 22 cm
(12 3/8 × 8 5/8 in).
Musée Carnavalet, Paris.

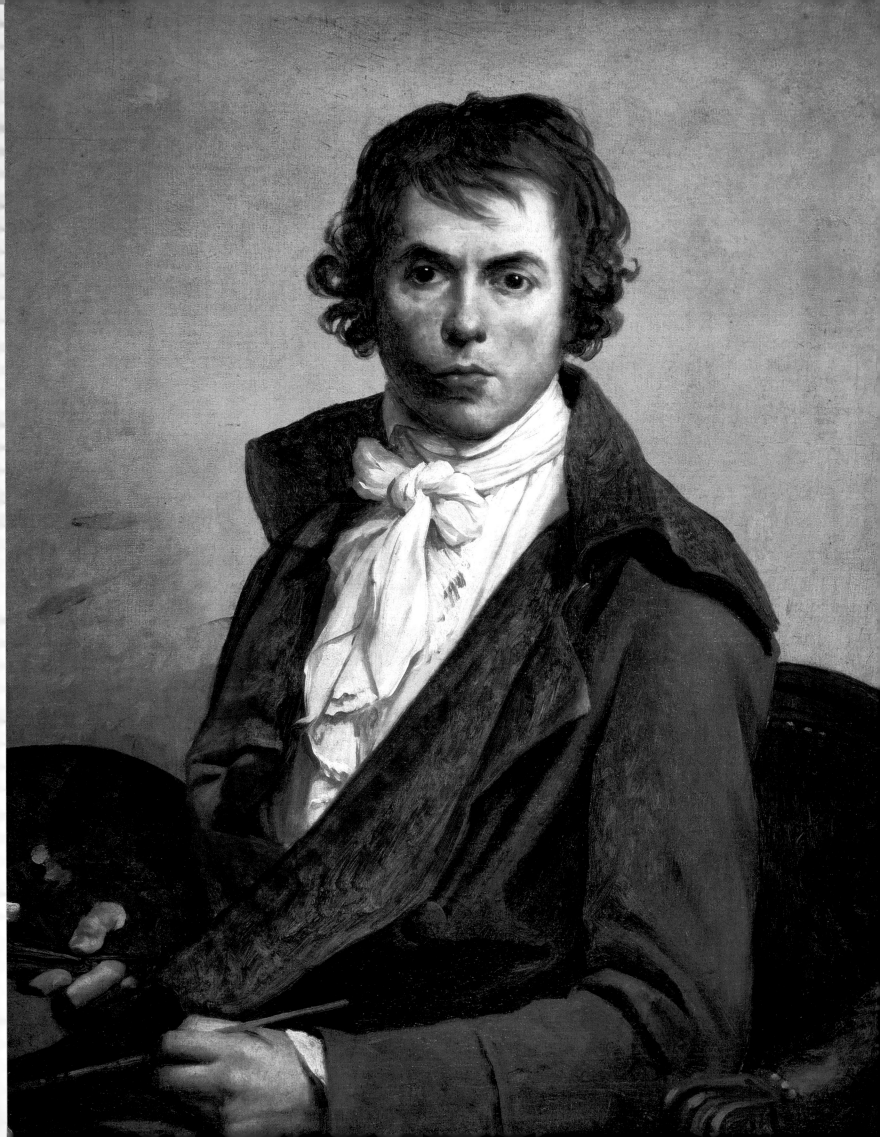

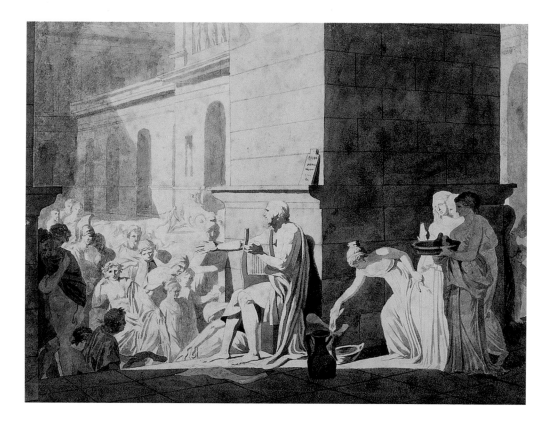

Jacques-Louis David |
**HOMER RECITING HIS POETRY
TO THE GREEKS**
1794, sanguine and ink,
27.2 × 34.5 cm (10 3/4 × 13 5/8 in).
Musée du Louvre, Département
des Arts Graphiques, Paris.

| Jacques-Louis David
SELF-PORTRAIT
1794, oil on canvas,
81 × 64 cm (31 7/8 × 25 1/4 in).
Musée du Louvre, Paris.

Page 122 |
Jacques-Louis David |
**PORTRAIT OF EMILIE SÉRIZIAT
AND HER SON**
1795, oil on canvas,
131 × 96 cm (51 5/8 × 37 3/4 in).
Musée du Louvre, Paris.

Page 123 |
Jacques-Louis David |
PORTRAIT OF PIERRE SÉRIZIAT
1795, oil on canvas,
129 × 95 cm (50 3/4 × 37 3/8 in).
Musée du Louvre, Paris.

David did not attend the Convention that day, having perhaps been warned by a friend among the deputies. "He stayed at home, having taken an emetic." He was arrested three days after Robespierre and his allies had been executed. When accused, he claimed to have been misled. His claims were not eloquent: "If the false virtues of Robespierre led my patriotism astray, this mistake was due less to any personal attachment to him than to the universal esteem by which I always saw him surrounded." He added "he was not the only one to have been deceived. Moreover, Robespierre had courted him, rather than the other way round." Incarcerated for a fortnight at the Prison des Fermes, in the rue de Grenelle Saint-Honoré, he encountered several Girondin deputies, who greeted him sarcastically. But David had a pupil, Pierre Maximilien Delafontaine, bring him his painting equipment, and, with the aid of a small mirror, serenely painted the second self-portrait of his career. He was in due course transferred to the Luxembourg gaol. While in prison, he was reconciled with his wife, in a scene worthy of Greuze. Visiting with their four children, she fell tearfully into David's arms, after admonishing the gaoler: "Citizen, do not imagine you are guarding a scoundrel. This is the most honest man I have ever known..."

In his prison cell, David conceived the idea for a painting: *Homer Reciting his Poetry to the Greeks*. Was he thinking of himself or of André Chénier when he drew the figure of Homer? The misfortunes of Troy and the fratricidal wars of Greece offered clear analogies with the course of the Revolution. The painting was never completed, and we know it only from a drawing. The women on the right have the graceful lines of vase paintings, and present an idealised

| Jacques-Louis David
VIEW ASSUMED TO BE
OF THE LUXEMBOURG GARDENS
| 1794, oil on canvas,
| 55 × 65 cm (21 5/8 × 25 5/8 in).
| Musée du Louvre, Paris.

view of the female attendants who catered for the prisoners. During this period, David made his only known landscape painting, the *View Assumed to be of the Luxembourg Gardens*. Does it represent Diderot's *La Promenade du sceptique*? The enigmatic figures here might be those who drew in the sand of the "chestnut-lined path" "circles, triangles and other mathematical figures". Or does it merely express a prisoner's nostalgia for country landscapes?

Thanks to the ardent support of his pupils and of Boissy d'Anglas, David was released on 28 December 1794, and the charges dismissed. On his release, he went to his appartment in the Louvre, then to stay with the Sériziat family in Saint-Ouen. There, remote from public life, he seemed to regain his peace of mind: "I am leading a life that I like a great deal. I am surrounded by nature, working at rural tasks and at my art." The freshness and serenity of his portraits of Emilie Pécoul, his sister-in-law, and her husband, the barrister Pierre Sériziat, contrast with his experience of the time, when he was assailed with accusations and denunciations.

In March and May 1795, the starving Parisians rose against the government. But the so-called riots of Germinal and Prairial were brutally repressed. The Convention was determined to dispose of the last of the Montagnards, and on 30 May, David was again arrested. He was incarcerated in the Collège des Quatre-Nations, now serving as a prison, until the end of July. There he made a portrait (and a friend) of his fellow-painter Jeanbon Saint-André, who had been detained for the same reasons as himself. Released on bail, David now returned to his family. He completed the portraits of the Sériziats, and, encouraged by his pupil Serangeli, exhibited them at the Salon. The amnesty of revolutionary acts, voted on 26 October 1795, finally left him a free man. The day before, the Assembly had approved Daunou's proposal to establish the Institut de France; less than a month later, the Directory appointed David as a member, inaugurating a new stage in his existence. It was to last twenty years.

4. The Heights of Fame

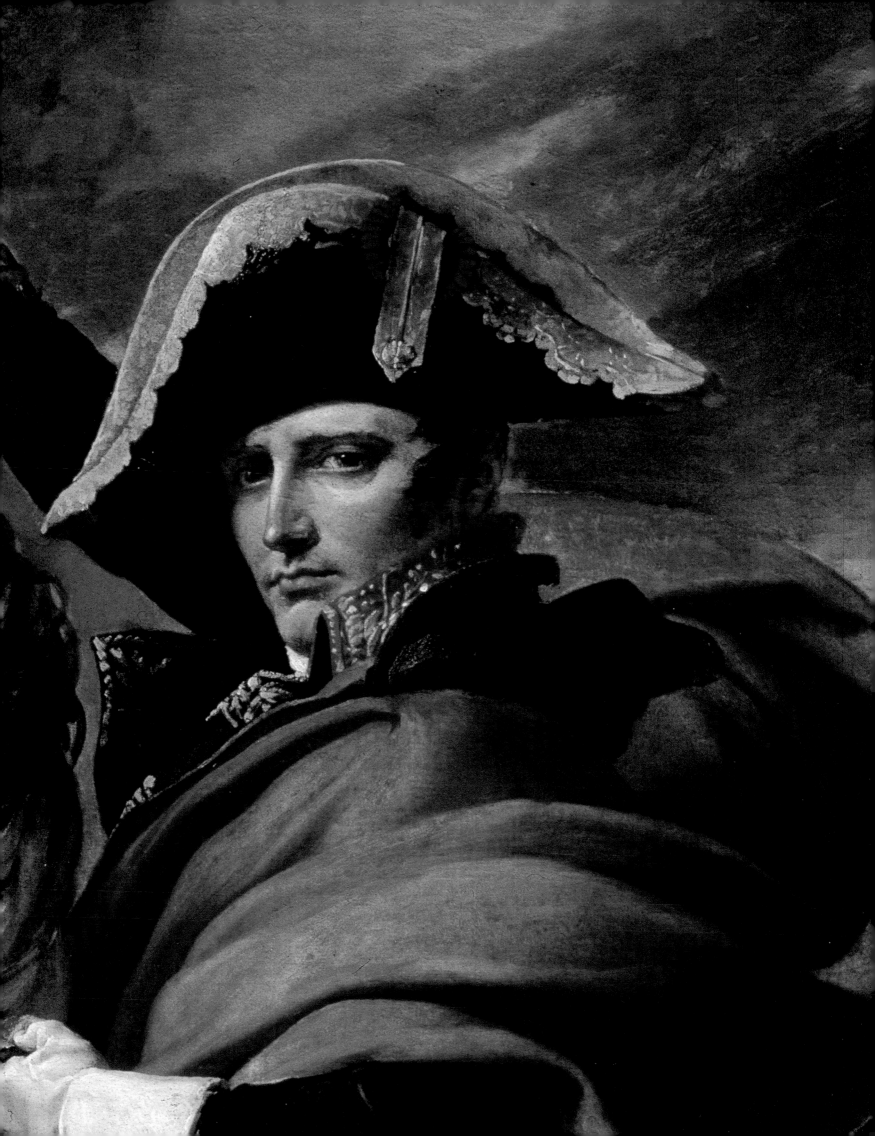

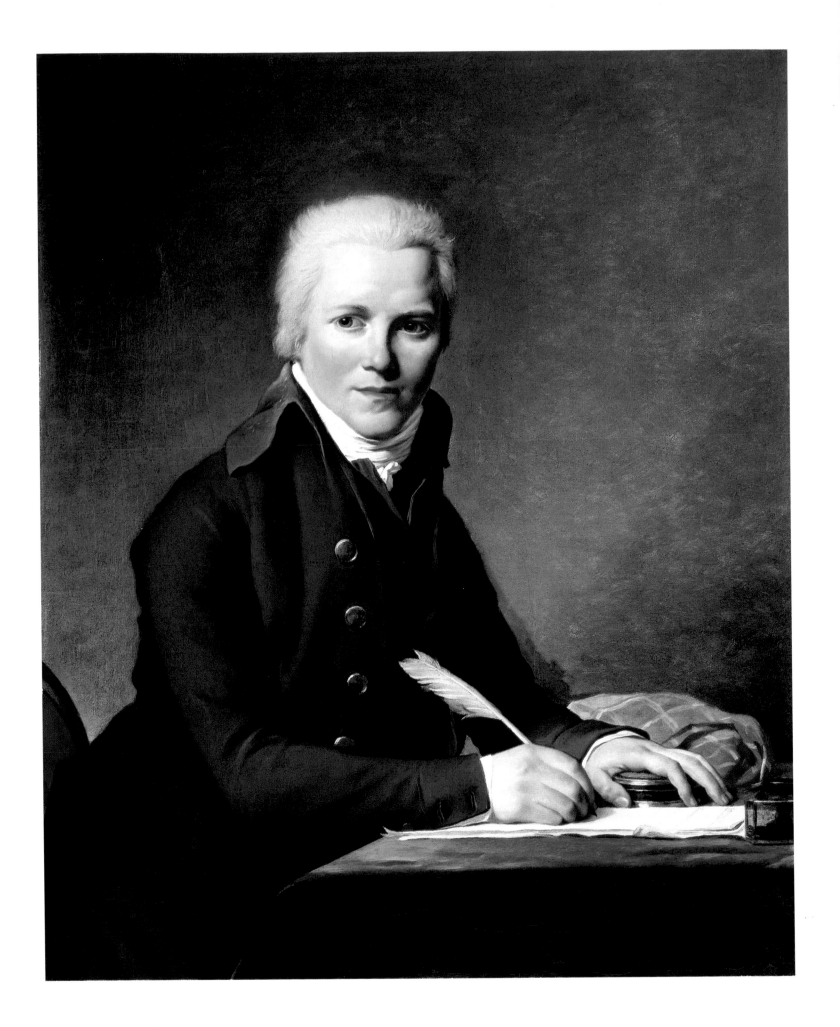

The fury of the nation had made scapegoats of Robespierre and his friends without lancing the accumulated resentments and hatreds. Blood continued to flow. The aftermath of Thermidor was a series of chain reactions; the massacres of the Terror were followed by a cull of former patriots. In September 1794, Gracchus Babeuf began to publish his *Journal de la Liberté*, demanding agrarian reform. In June 1795, the death of the young Louis XVII only aggravated the existing confusion. Former Girondins, Jacobins and Royalists all manoeuvred to seize power. The Palais-Royal was the scene of frequent clashes between Royalist dandies and revolutionary *sans-culottes*.

The peace-making gesture of the Sabines Women

Having withdrawn from politics, David set about rebuilding his life, not without resentment. He was harrassed by Boze and targeted by a petition in which the commissaries of the Museum accused him of being "a terrorist, a disorganiser and a faction leader". Blows such as these were not easy to forget. In a letter of 1800 to Verninac de Saint-Maur, he wrote: "I no longer exhibit at the Salon (...). You know well enough how I was treated by my fellow artists during my misfortunes." In its last session, in October 1795, the Convention allowed David to recover *The Death of Marat* and *Le Peletier on his Death Bed*; he hung them beside *Brutus* and the *Horatii* in his apartments in the Louvre. When in prison, he had observed that he "should never have left his studio"; now he returned to it and settled down to work.

In the first days after he regained his freedom, he painted two portraits: *Jacobus Blauw* (1795) and *Gaspar Meyer*. The two men were representatives in Paris of the Batavian Republic, which had been established in Holland that same year with the support of the French army. Blauw's sober attitude is lit up by a camaieu of blues; his suit is in the splendid shade invented by the dyer Werbrouk for the drapers of Flanders. In the same year, David painted one of his most touching portraits, that of *Catherine Tallard*. Shortly after leaving prison, he went to recover at her family's house in Burgundy. At the time of the painting, she was twenty-two years old. Her face, rendered in extraordinarily delicate brushwork, reflects a multitude of feelings – shyness, modesty, and a slight anxiety. The shrinking Burgundian lass forms a striking contrast with the solid, cheerful *Citoyenne Crouzet*, a typically austere representative of the First Republic, whom David also portrayed in 1795.

David was nonetheless intent on returning to the tradition of history painting. He had not completed a work of this genre since *Brutus*. While in prison, he had scrawled a first sketch of another Roman subject, *The Sabine Women*. "The moment of the rape," he later wrote, "has been given a stern and moving treatment by Poussin, whom the modern Romans have honoured with the epithet Divine. I dared to treat the following episode, the moment when the Sabine women come to separate the armies of the Sabines and the Romans. (...) Romulus still holds aloft the javelin he is about to hurl at Tatius. The cavalry general is restoring his sword to its scabbard. Soldiers raise their helmets in a sign of peace. Feelings of conjugal, paternal and

Pages 126-127
Jacques-Louis David
BONAPARTE CROSSING THE SAINT-BERNARD PASS
Detail. 1800-1801,
oil on canvas, 267 × 223 cm
(105 1/8 × 87 3/4 in).
Musée National du Château, Versailles.

Jacques-Louis David
PORTRAIT OF JACOBUS BLAUW
1795, oil on canvas,
92 × 73 cm
(36 1/4 × 28 3/4 in).
The National Gallery, London.

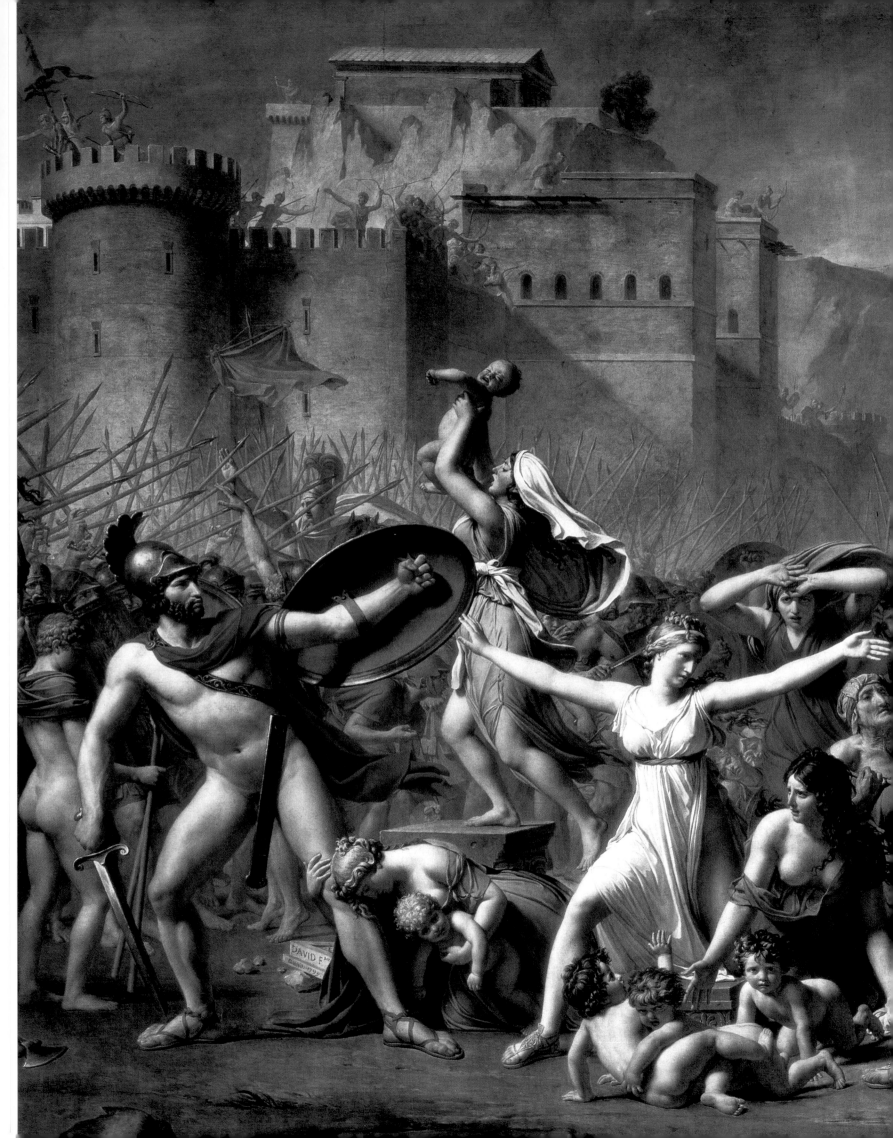

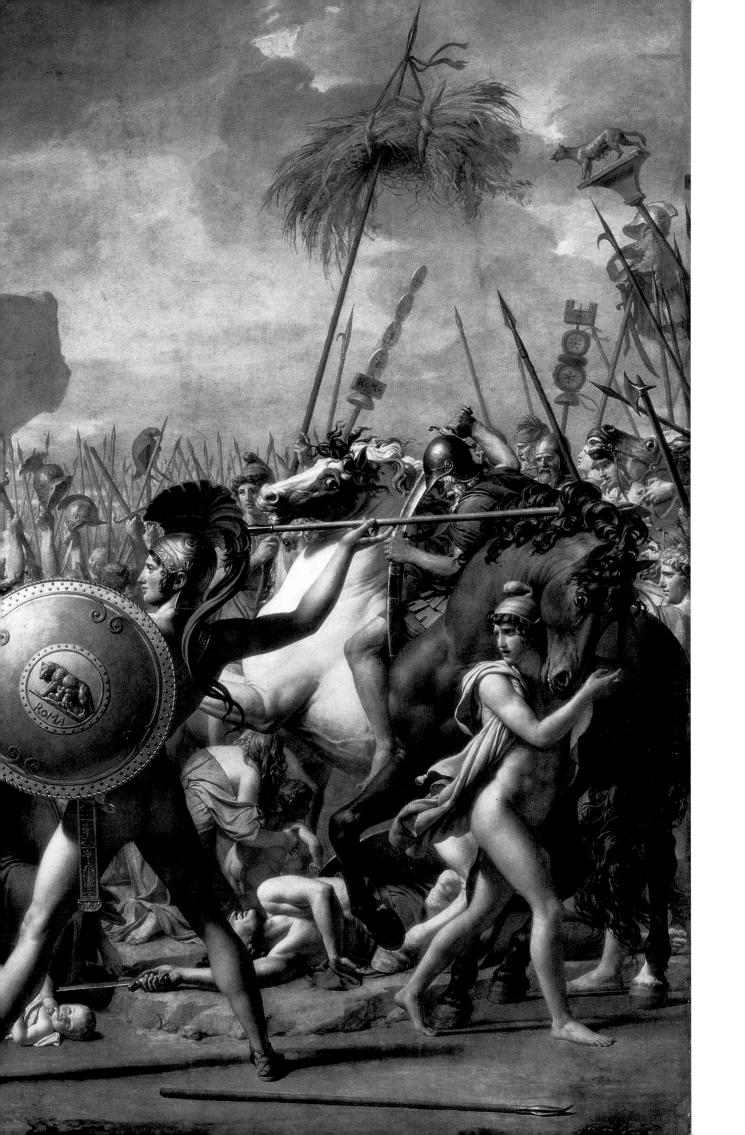

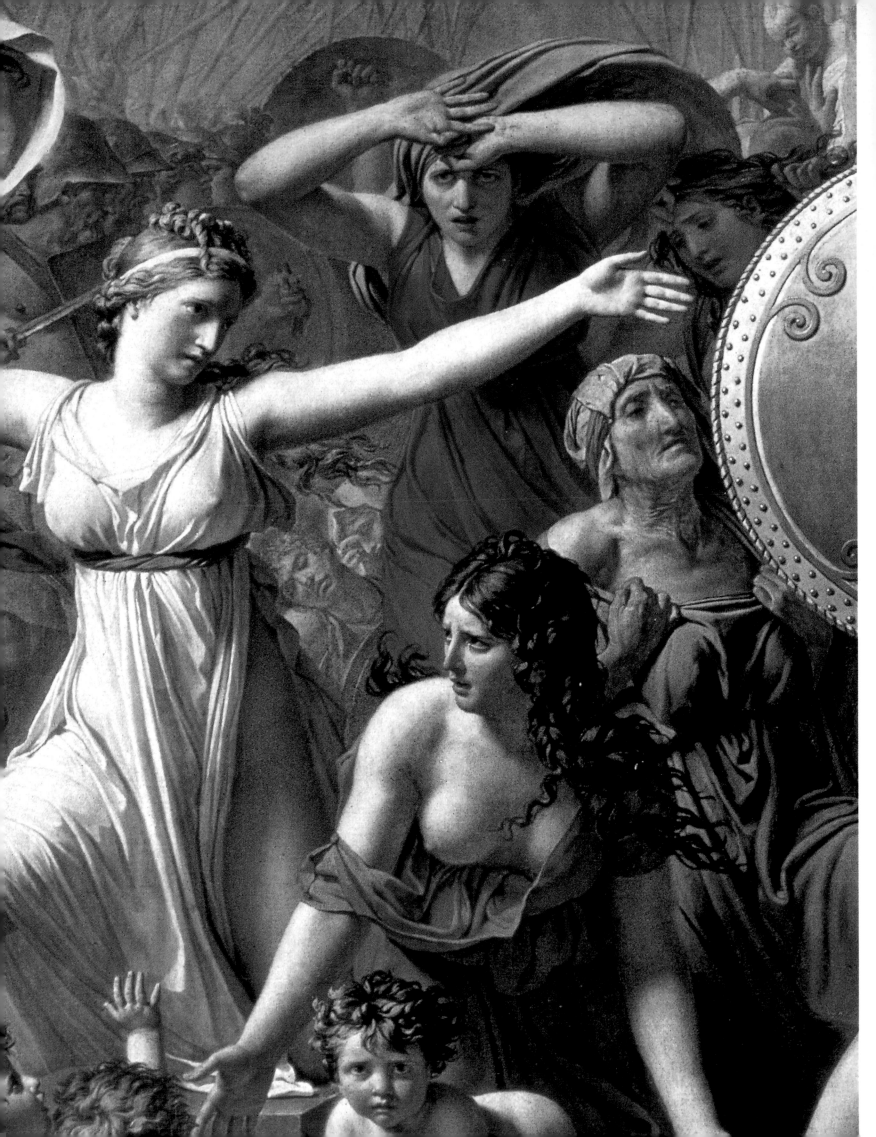

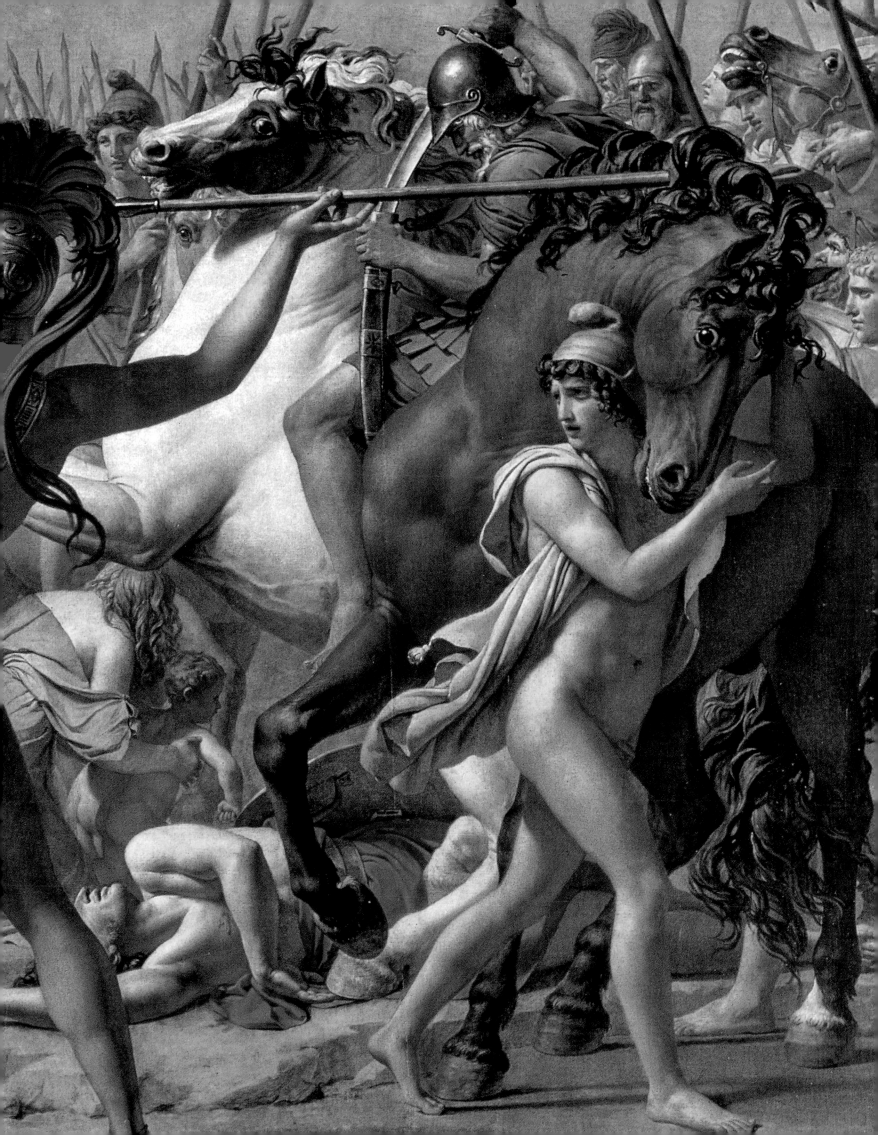

beautiful women in Paris; the rumour contributed to the success of the exhibition, which continued until 1805, and received in all around fifty thousand visitors. The proceeds amounted to sixty-five thousand francs, enough for David to buy himself a farm in the Brie.

Although *The Sabine Women* kept him busy for three long years, David had not forgotten his great work of historical witness, *The Tennis Court Oath*. The unfinished canvas had been entrusted to Topino-Lebrun, who had a studio in the Feuillants convent. "Every time I wanted to continue with *The Oath*," David observed, "I was thrown into prison." That did not prevent him proposing to the Directory that he should resume work on it. Some deputies were now "highly insignificant to posterity", and he would replace them with "all those who have since distinguished themselves, and are therefore of more interest to our nephews". However, his financial conditions for completing the project – fifty thousand francs a year for three years – proved unacceptable.

David had returned to his art with renewed ardour. The delirium of the Revolution put firmly behind him, he also came to occupy the role of artistic adviser that he had always coveted. In addition to his membership of the Institut de France, he was made responsible for evaluating nationalised works. But in 1796, when, in the wake of the victorious campaigns of the French army, convoys arrived in Paris bearing works confiscated in Holland and Italy, some French artists voiced concern at the extent of these 'levies'.

Quatremère de Quincy composed a brave letter to the 'Citizen-Directors'; he asked them "whether it is to the advantage of the arts and artists in general to remove from Rome the monuments of Antiquity and the masterpieces of painting and sculpture that comprise the galleries and museums of this capital of the arts". David signed the letter, but the effect was nugatory. On 27 July 1798, while Napoleon was in Cairo, the Directory marked the arrival of plundered Italian masterpieces with specially organised festivities. Napoleon's military victories were the condition of this depredation. He was shortly to appoint David First Painter.

Portrait painter to a new society

These were the heady days of the Directory; society was light-hearted, and women were prominent. The aristocratic Joséphine de Beauharnais was the widow of one of the first aristocrats to side with the Third Estate; he had risen to become chief of staff of the Republican army, and been guillotined in 1794. When she married Napoleon Bonaparte, the former protégé of the brothers Robespierre, their union exemplified the kind of reconciliation David had illustrated in *The Sabine Women*.

Shortly afterwards, one of the prettiest women in Paris asked David to paint her portrait. Her name was Juliette Récamier. The daughter of a Lyon banker, during the Terror she had married her mother's lover, who thus ensured that the adolescent Juliette would be his heir. It was rumoured that her husband was actually her father. Her exemplary virtue, so rare in these troubled times, perhaps stemmed from this extraordinary situation. The receptions that she

Pages 136 and 137
Jacques-Louis David
THE SABINE WOMEN
Details.

Jacques-Louis David
PORTRAIT OF HENRIETTE DE VERNINAC
1799, oil on canvas,
145 × 112 cm (57 × 44 in).
Musée du Louvre, Paris.

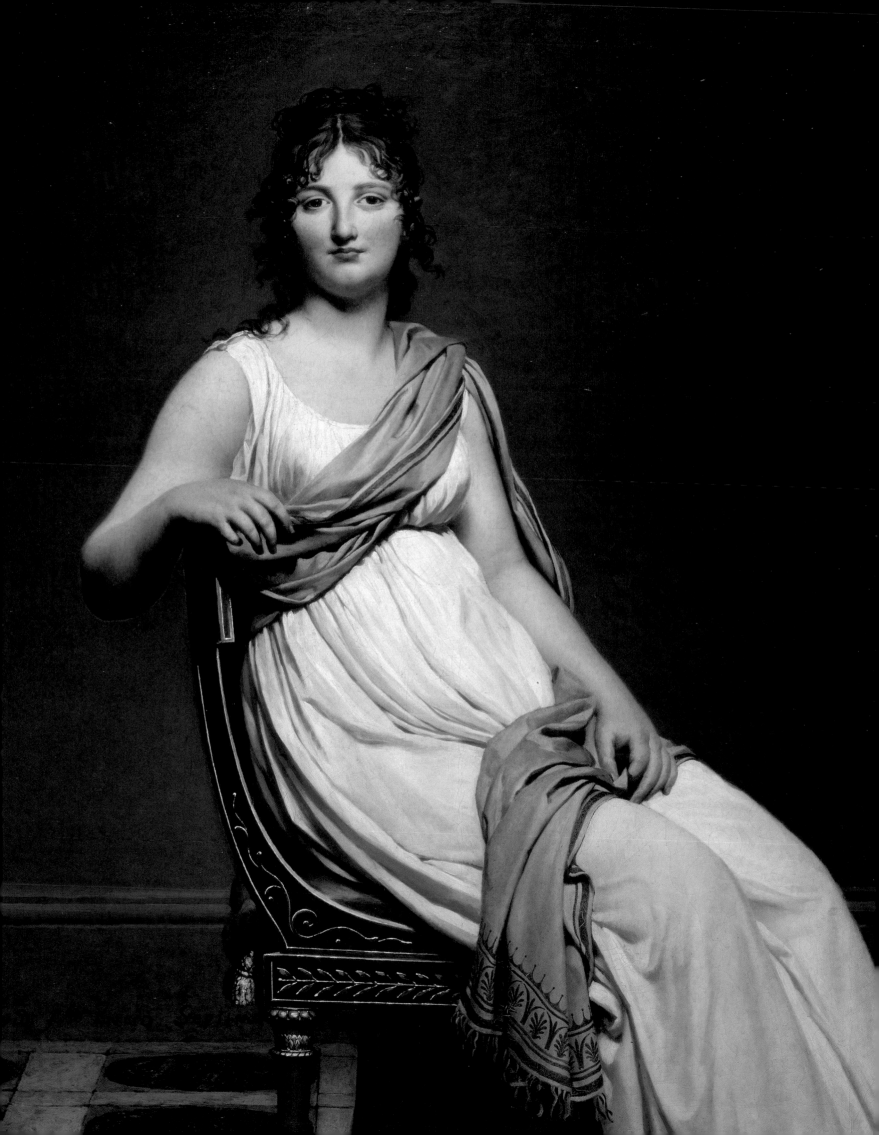

gave – her town house on the Chaussée-d'Antin had formerly belonged to the Necker family – attracted the cream of Parisian society. Lucien Bonaparte, Bernadotte, and the Montmorency family were regular visitors to her salon, and those hostile to the First Consul were also represented, notably by Mme de Staël. During the pre-Restoration years, Mme Récamier had countless admirers, among them Chateaubriand, the great love of her adult life. These platonic relationships – she was reputed to be frigid – were the subject of much speculation.

Ready to accept his demands, she wrote: "You do not, I hope, doubt the value I place upon a portrait by your hand. As for the sittings, I am at your command." But, once again, the painting was left unfinished. The working conditions left much to be desired: "the room is too dark", and then "the light comes from too high up". David was not happy with his work: "We will start again somewhere else." He worked so slowly that the model's patience was exhausted. She sounded out Gérard: would he undertake a portrait? David, exasperated, advised his colleague to accept. When Mme Récamier returned to the Louvre for the next sitting, David informed her: "Women have their caprices; so do artists. Allow me to satisfy mine: I will keep your

François Gérard |
PORTRAIT OF MADAME RÉCAMIER
1805, oil on canvas,
225 × 148 cm
(88 5/8 × 58 1/4 in).
Musée Carnavalet, Paris.

portrait in its present state." He regretted his decision for the rest of his life. Despite this sudden interruption – or perhaps because of it – the *Portrait of Madame Récamier*, with its subtle geometry of successive planes and its sober palette of yellows and greys, exemplifies David's genius for synthesis. His painting has the simplicity that he so admired in Greek art. Mme Récamier is barefoot and wears a modest white dress whose folds spill onto the ground. Her head-band presses a few isolated curls against her brow. In the pose of a lascivious odalisque, she has the virginal purity of a vestal. The horizontals and verticals counterpoint the arabesque of her body and harmoniously fill the empty space conjured by a vibrant scumbled background, like that of *The Death of Marat*. The décor of the completed painting would probably have included a collection of fashionable objects, but was confined under the circumstances to the candelabra sketched in by Ingres, a footstool and the couch on which Mme Récamier reclines. This austerity makes her graceful presence all the more disturbing. She was twenty-three when the sessions ended.

The previous year, David had painted another beautiful woman, Henriette de Verninac, wife of the Prefect of Lyon and sister of the romantic painter,

| Jacques-Louis David
Portrait of Madame Récamier
1800, oil on canvas,
173 × 243 cm
(68 1/8 × 95 5/8 in).
| Musée du Louvre, Paris.

| Jacques-Louis David
**PORTRAIT OF ANTOINE MONGEZ
AND HIS WIFE**
| 1812, oil on canvas,
74 × 87 cm (29 1/8 × 34 1/4 in).
| Musée du Louvre, Paris.

Eugène Delacroix. The portrait's icy majesty exemplifies the form of ideal beauty with which neo-classicism countered the mannered grace of the rococo. The model wears a white dress in the Greek style, like Hersilia in *The Sabine Women*. She poses in an empty space, a surprising choice, given that Mme de Verninac came from a family of great cabinet-makers, the Oebens and Rieseners. The mahogany chair, carved with tracery and palmettes and covered with red cloth, was part of David's studio furniture. This austerity, combined with the young woman's Spartan self-assurance, disturbed Delacroix: "Everything is equal; the interest is no more in the face than in the drapery or seat; complete enslavement to what the model represented for him is the cause of this coldness." Yet this neutrality is precisely David's strength.

The elegant simplicity of *Henriette de Verninac* and *Madame Récamier* has become severity in the *Portrait of Suzanne Le Peletier de Saint-Fargeau*. After her father's assassination, Suzanne had been adopted by the Convention and renamed 'Liberty'. She herself asked David to paint her portrait. There is nothing symbolic or affected here; material density alone counts, in a manner that anticipates Courbet. In the apparent placidity of this face, David marvellously captures the inward nature of Suzanne's gaze, seemingly haunted by some unbearable vision.

Under the Empire, David painted portraits not only of senior officials whom he met through his profession, but of his own extended family. The discreet charm of his earlier models gave way to the pomp and circumstance of a class of notables and newly created aristocrats. Beyond their detailed rendering of immaculate toilet and sumptuous dress, these works are remarkable for their

Jacques-Louis David |
**PORTRAIT OF SUZANNE LE PELETIER
DE SAINT-FARGEAU**
1804, oil on canvas,
60.5 × 49.5 cm (23 3/4 × 19 1/2 in).
The J. Paul Getty Museum, Los Angeles. |

Page 144 |
Jacques-Louis David |
PORTRAIT OF THE COUNTESS DARU
1810, oil on canvas,
73 × 60 cm (28 3/4 × 23 5/8 in).
The Frick Collection, New York. |

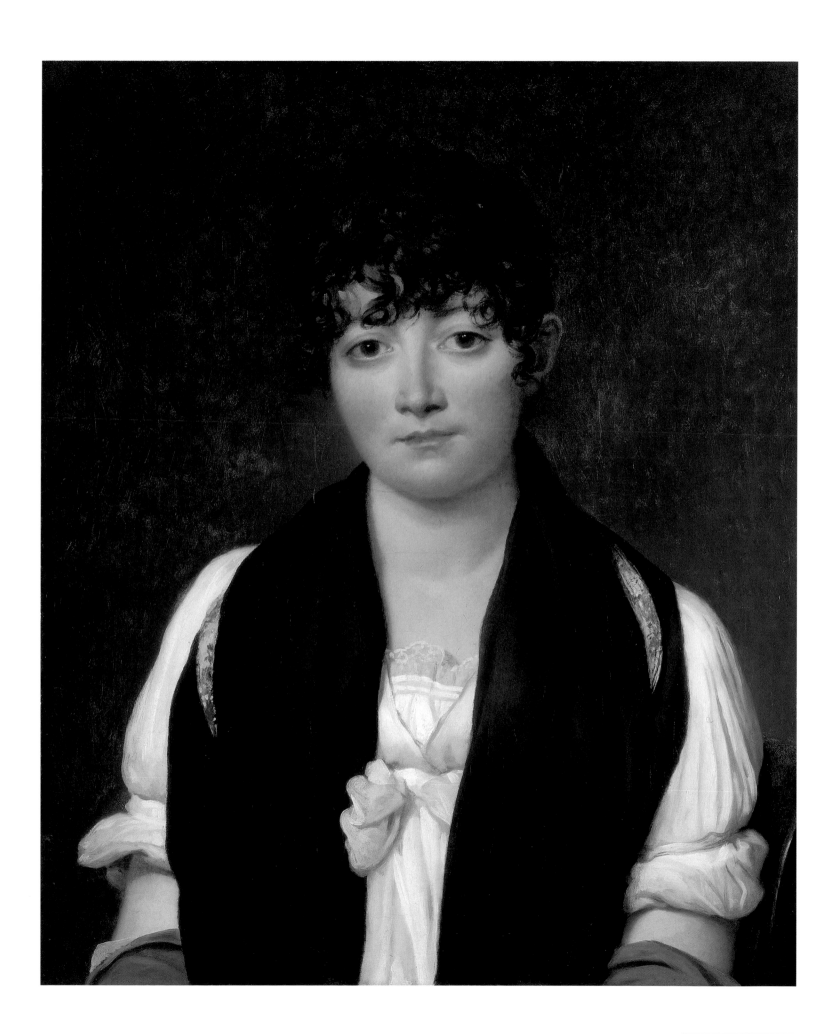

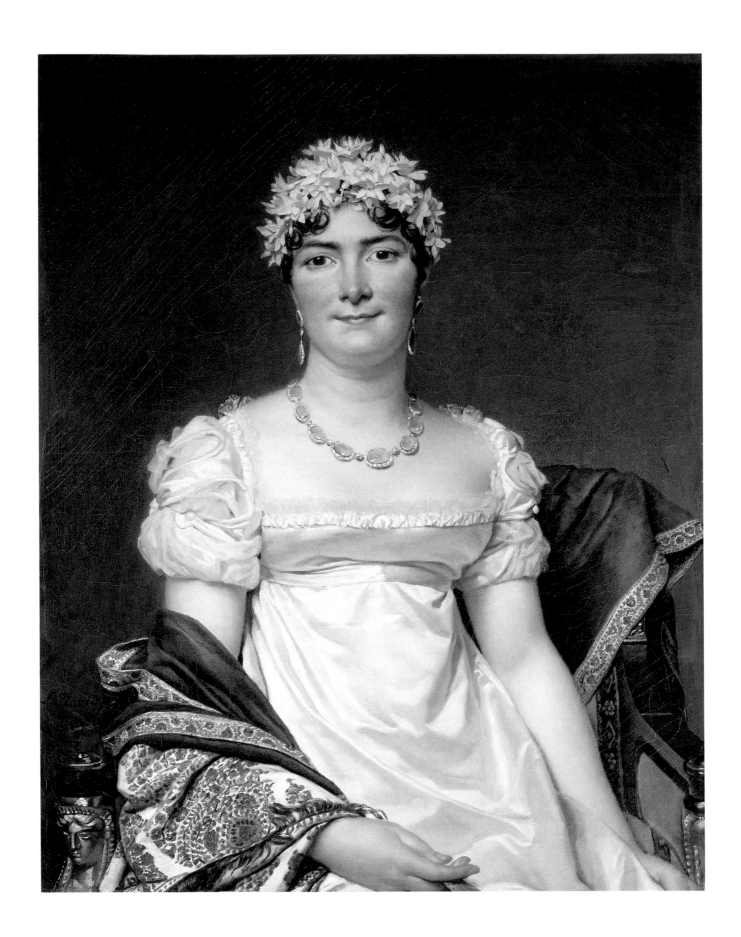

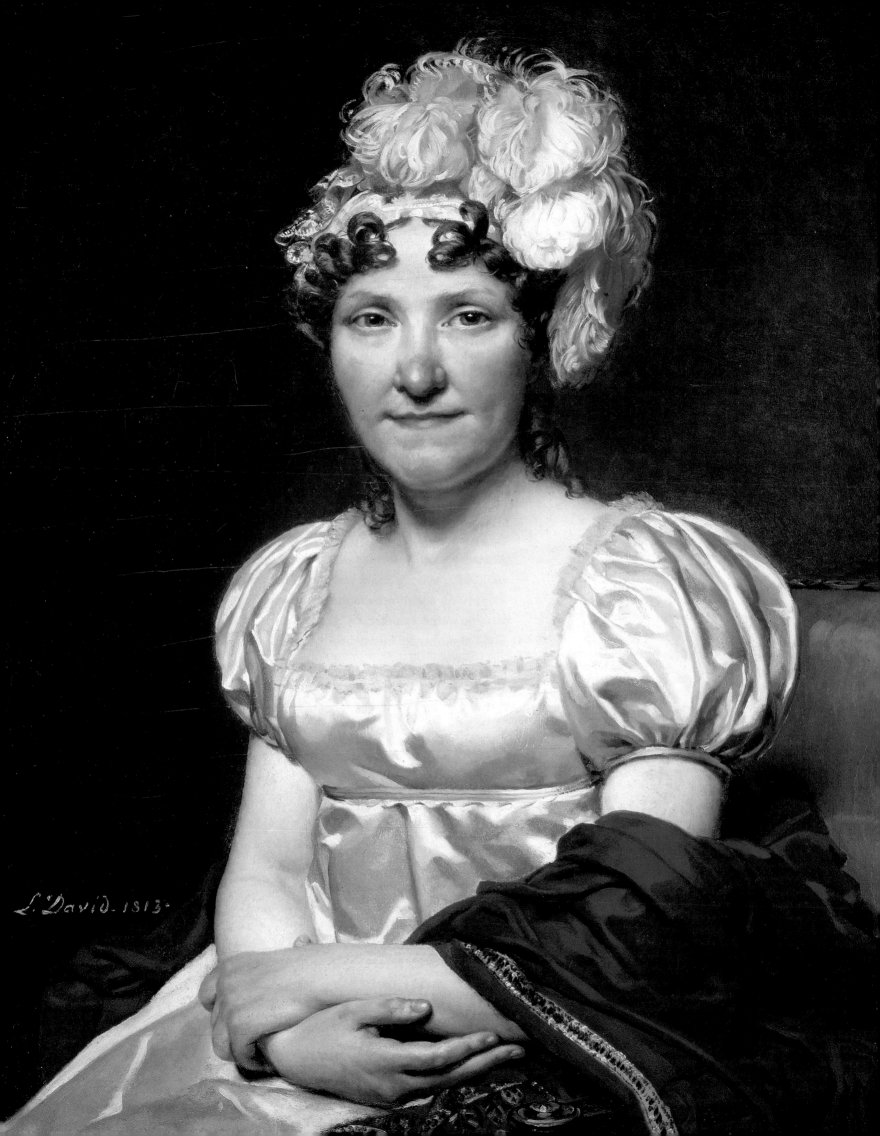

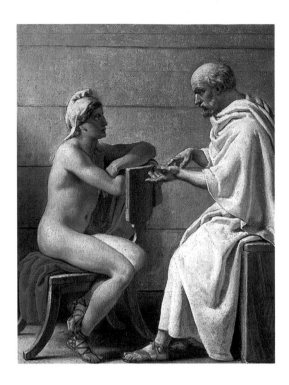

Christoffer Wilhelm Eckersberg
SOCRATES AND ALCIBIADES
1813-1816, oil on canvas,
32.7 × 24.1 cm
(12 7/8 × 9 1/2 in).
Thorvaldsens Museum, Copenhagen.

David's liberal teaching allowed his pupils to express their different personalities, and the most diverse talents emerged from his studio. They included Granet, who specialised in cloisters and churches, and James Audubon, who was born in Santo Domingo, brought up in Nantes, and made his reputation in the United States with his exquisite *The Birds of America*. Many foreigners came to study with David, and helped to disseminate his teaching; they included the German sculptor Tieck, brother of the poet, and the Spaniards Madrazo and Aparicio. Some worked only briefly with David; one such was the young American Vanderlyn, who was a student of Vincent's. "There's nowhere but Paris in the whole wide world," he exclaimed, and pitied compatriots who had "foolishly chosen London... and would no doubt [have regretted] the fact if they had known Paris better"; he spent the years 1796-1801 in France. In 1812, the Danish artist Eckersberg described David's teaching: "He is extraordinarily severe and precise and goes to great lengths to encourage and stimulate his pupils (…); they paint from life and in his studio have access to the most wonderful models."

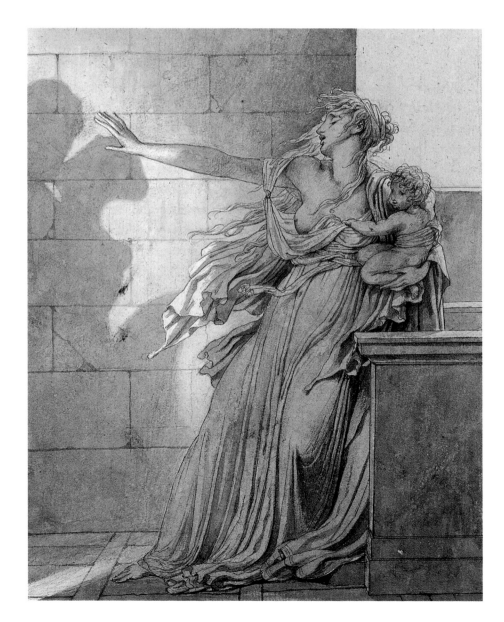

Pierre-Narcisse Guérin
PHAEDRA AND HIPPOLYTUS
Undated, graphite,
42.1 × 26.5 cm
(16 1/2 × 10 3/8 in).
Musée du Louvre, Département
des Arts Graphiques, Paris.

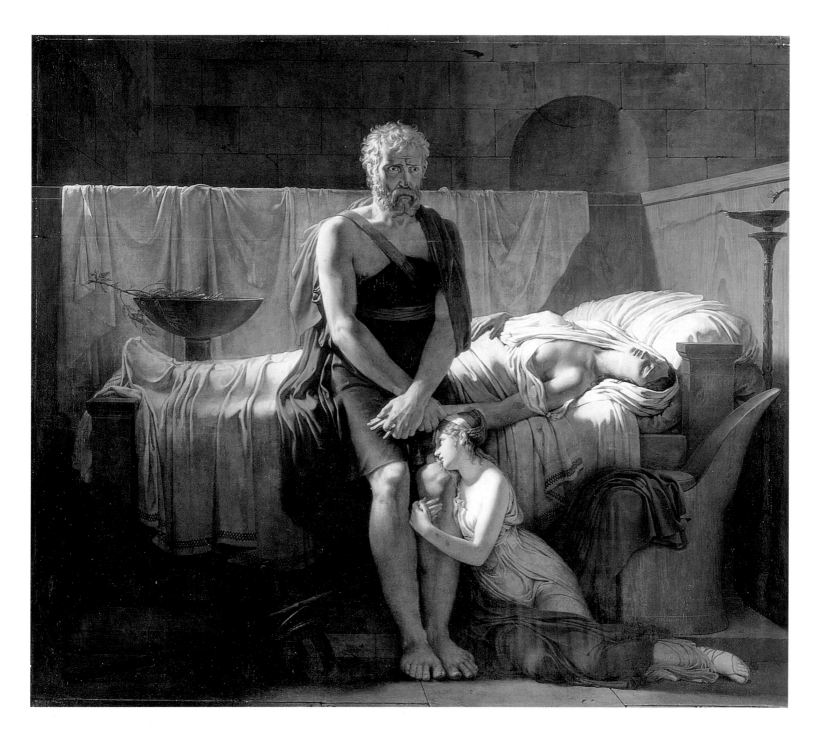

Pierre-Narcisse Guérin |
THE RETURN OF MARCUS SEXTUS
1799, oil on canvas,
217 × 243 cm
(85 1/2 × 95 5/8 in).
Musée du Louvre, Paris.

The first generation of David's students came to prominence under the Directory, and the most talented were soon as famous as their master. Gérard, who spent part of February 1795 in prison, had chosen the theme of *Marius' Return to Rome* for that year's Salon. But the Prairial insurrection (20 May 1795) deterred him; the theme might, under the circumstances, have seemed provocative. Instead, in a mere eighteen days he completed a *Belisarius*. This subject too was far from innocent; in Gérard's version, the blind general is wandering along on a deserted road, when his young guide is bitten by a snake and dies in his arms. The child has the neo-classical langour of the dying Bara, the old man is an energetic Saint Christopher, while the intensely realistic viper is a powerful metaphor for ingratitude and calumny of all kinds. In 1794, both Gérard and Vincent won prizes in the competition of the

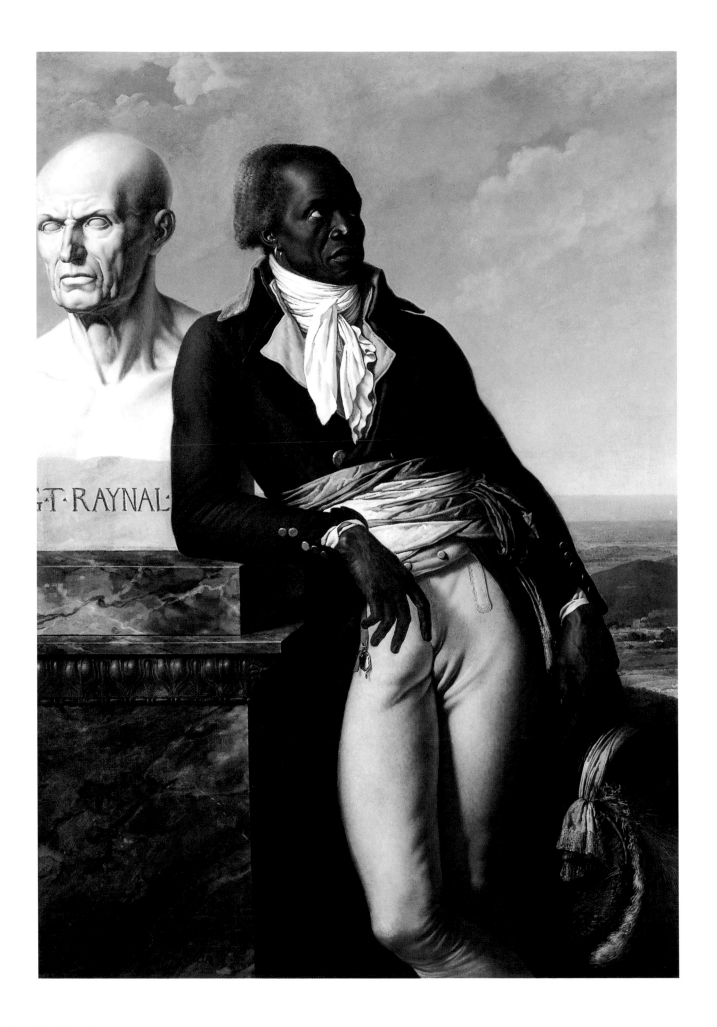

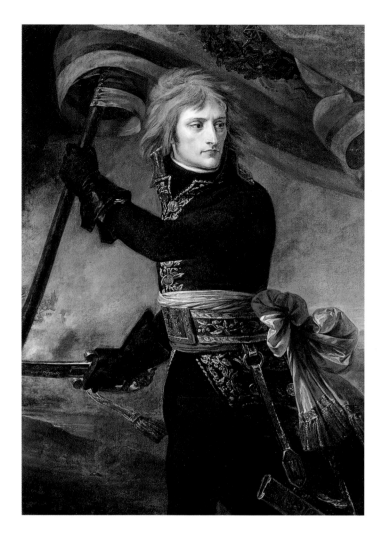

Popular and Republican Society for the Arts. Gérard was given a studio in the Louvre to work on the prescribed subject: *The French People Demanding the Overthrow of the Tyrant, 10 August 1792.* This huge canvas, partly inspired by *The Oath of the Jeu de Paume,* was never finished. In 1798, while Guérin was working on *The Return of Marcus Sextus* as a poignant allegory of the return of the emigrés, Gérard showed his *Cupid and Psyche* at the Salon to great acclaim. Having painted an exceedingly charming portrait of Joséphine, he went on to paint almost every member of the Imperial court. Girodet enhanced his reputation with the *Portrait of Jean-Baptiste Belley,* painted shortly after his return from Italy in 1797. The former Senegalese slave now represented Santo Domingo at the Convention. He leans against the plinth of a Roman-style bust of the abbé Raynal, whose writings had been instrumental in the abolition of slavery. (Bonaparte promptly restored the practice in 1802.) For the private residence of the imperial couple at Malmaison, Girodet painted *The Apotheosis of French Heroes who Died for their Country during the War of Liberty.* David was amazed by the impression of floating evanescence that Girodet had created, exclaiming: "These are figures of crystal."

As for Gros, his magisterial *Bonaparte on the Bridge at Arcole, 17 November 1796* inaugurated the era of hagiographic portraits. He excelled in the role

imposed by Napoleon, that of painter of battles, from the *Battle of Mount Tabor* to the blood-stained snow of *Eylau*. His *Bonaparte Visiting the Plague House at Jaffa* placed Napoleon in a tradition of miracle-working sovereigns and was widely acclaimed. David had remained close to his pupil and was thrilled by his success.

1808 marked the consecration of a school and a style. David and his three most talented pupils, Gros, Gérard and Girodet were awarded the Legion of Honour by the Emperor. Vanderlyn won the Salon Gold Medal for his *Caius Marius among the Ruins of Carthage*. In 1810, the Emperor established a competition for holders of national prizes, and the master thus entered into competition with his disciples and their competitors. Girodet's *Deluge*, inspired by the catastrophic landslip and flooding at Goldau, still fresh in people's memories, took first prize for history painting. *The Sabine Women* was highly commended, as were Guérin's *Phaedra* and Prud'hon's *Justice in*

| John Vanderlyn
CAIUS MARIUS AMONG THE RUINS OF CARTHAGE
1807, oil on canvas,
221 × 174 cm (87 × 68 1/2 in).
The Fine Arts Museums of San Francisco.

Antoine-Jean Gros |
BONAPARTE VISITING THE PLAGUE HOUSE AT JAFFA
1804, oil on canvas,
532 × 720 cm (209 1/2 × 283 1/2 in).
Musée du Louvre, Paris.

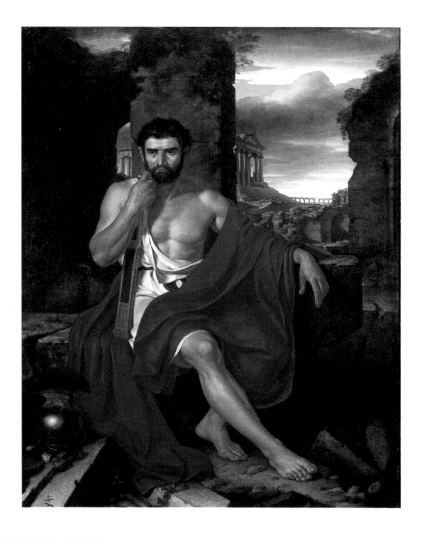

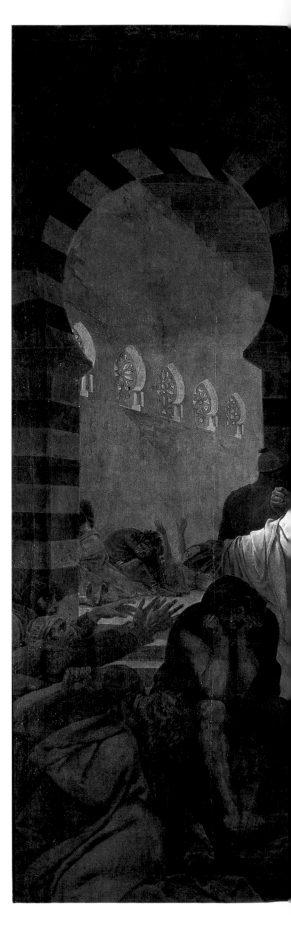

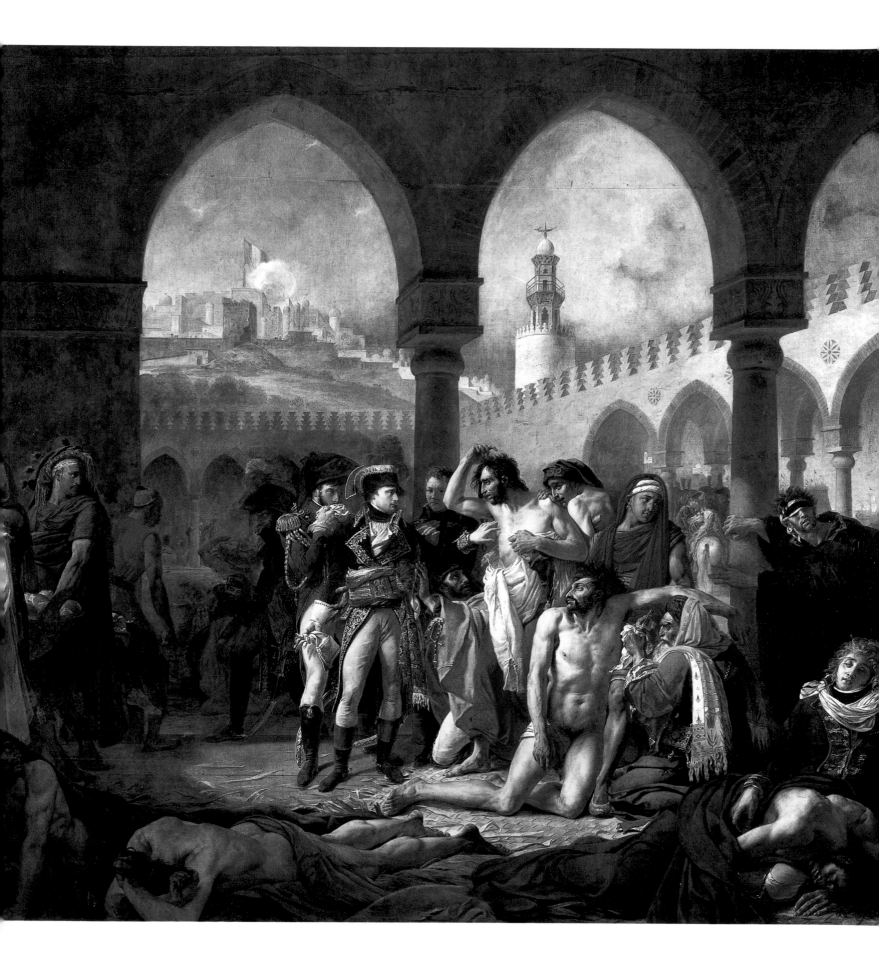

Pursuit of Crime. In the category of "pictures representing a subject which does honour to the national character", David's *Coronation of Napoleon* took first prize, while *The Plague House at Jaffa* was highly commended. Henceforth, different personalities began to emerge within the school of David, some of them gradually moving towards a Romantic style. In 1810, Napoleon commissioned Ingres to paint a *Dream of Ossian* on the ceiling of the Palazzo di Monte Cavallo; the result was a work bordering on Romanticism. Two years later, the vigorous brushstrokes of the young Géricault's *Charging Chasseur* claimed everyone's attention. David was obliged to admit, "I do not recognise this manner."

By then, he was no longer working in the Louvre. After a long stay in the church of Cluny, on the place de la Sorbonne, he was moved in 1811 to the Collège des Quatre-Nations. Taking a stroll through the Louvre one evening in 1801, the First Consul was alarmed by the anarchic alterations that the artists had made to their living quarters. "Those buggers are going to burn my museum down", he exclaimed. The decision to expel the occupants was taken immediately. Shortly before, an attempt had been made to requisition one of David's studio for the Académie school. "I am myself an Académie", was the haughty reply.

Anne-Louis Girodet-Trioson |
THE APOTHEOSIS OF FRENCH HEROES WHO DIED FOR THEIR COUNTRY DURING THE WAR OF LIBERTY
1802, oil on canvas,
192.5 × 184 cm
(75 3/4 × 72 1/2 in).
Musée National du Château de Malmaison,
Rueil-Malmaison.

Anne-Louis Girodet-Trioson |
THE DELUGE
1806, oil on canvas,
67 × 47 cm
(26 3/8 × 18 1/2 in).
Musée Magnin, Dijon.

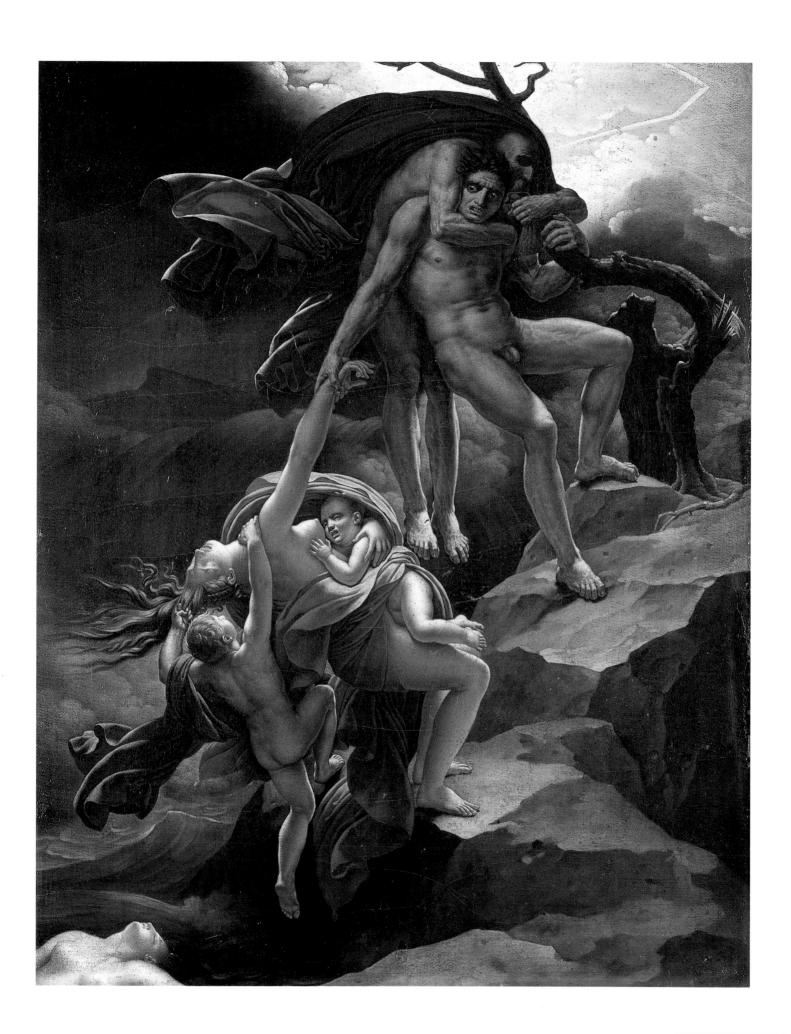

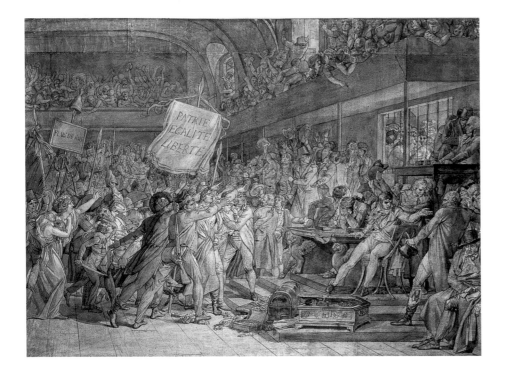

Jacques-Louis David |
PORTRAIT OF GENERAL BONAPARTE
1798, oil on canvas,
81 × 65 cm
(31 7/8 × 25 5/8 in).
Musée du Louvre, Paris. |

| François Gérard
THE FRENCH PEOPLE DEMANDING
THE OVERTHROW OF THE TYRANT,
10 AUGUST 1792
1794-1795, pen and ink,
bistre wash, 67 × 91 cm
(26 3/8 × 35 7/8 in).
Musée du Louvre, Département
des Arts Graphiques, Paris.

On the Emperor's orders

An almost hysterical enthusiasm greeted Bonaparte on his return to Paris. His Italian victories were still fresh in every mind, and he brought with him the peace treaty with Austria signed at Campoformio. On 10 December 1797, The Legislative Assembly hosted a gigantic banquet in his honour in the galleries of the Museum. In the spring of the previous year, Bonaparte had proposed that David join him in Italy; Gros, who had followed the Bonapartes first to Milan, then to Genoa, probably acted as Napoleon's intermediary. But David was unwilling to leave Paris, his reunited family, his students and *The Sabine Women*.

This was the period of Napoleon's great speeches to the French army in Italy: "Soldiers (...) you have won battles without cannons, crossed rivers without bridges, performed forced marches without boots, bivouacked without brandy and often without food. Only the phalanx of the Republic, only the soldiers of liberty could have endured all that you have suffered." These fiery words could not fail to strike a chord with the painter of *The Oath*. In late 1797, David and Bonaparte finally met, at a dinner hosted by Lagarde, Secretary of the Directory. On that occasion or at the Institute, they agreed on a portrait. As a long-standing Jacobin, David could not help but admire the young man who had saved Toulon and unhesitatingly quashed the Royalist uprising on the steps of the church of Saint-Roch.

Bonaparte, pushing through a crowd of lookers-on, posed very briefly for David in the studio where the *Horatii* hung. As usual with David, the planned composition related to a feat accomplished by the sitter. Bonaparte was to appear with the recently-signed Treaty of Campoformio in his hand, while his officers and horse waited in the background. Only the face was finished, and the canvas was later cut down. It registers Bonaparte's sombre, reflective mood and the familiar, slightly expressionless gaze. Napoleon had

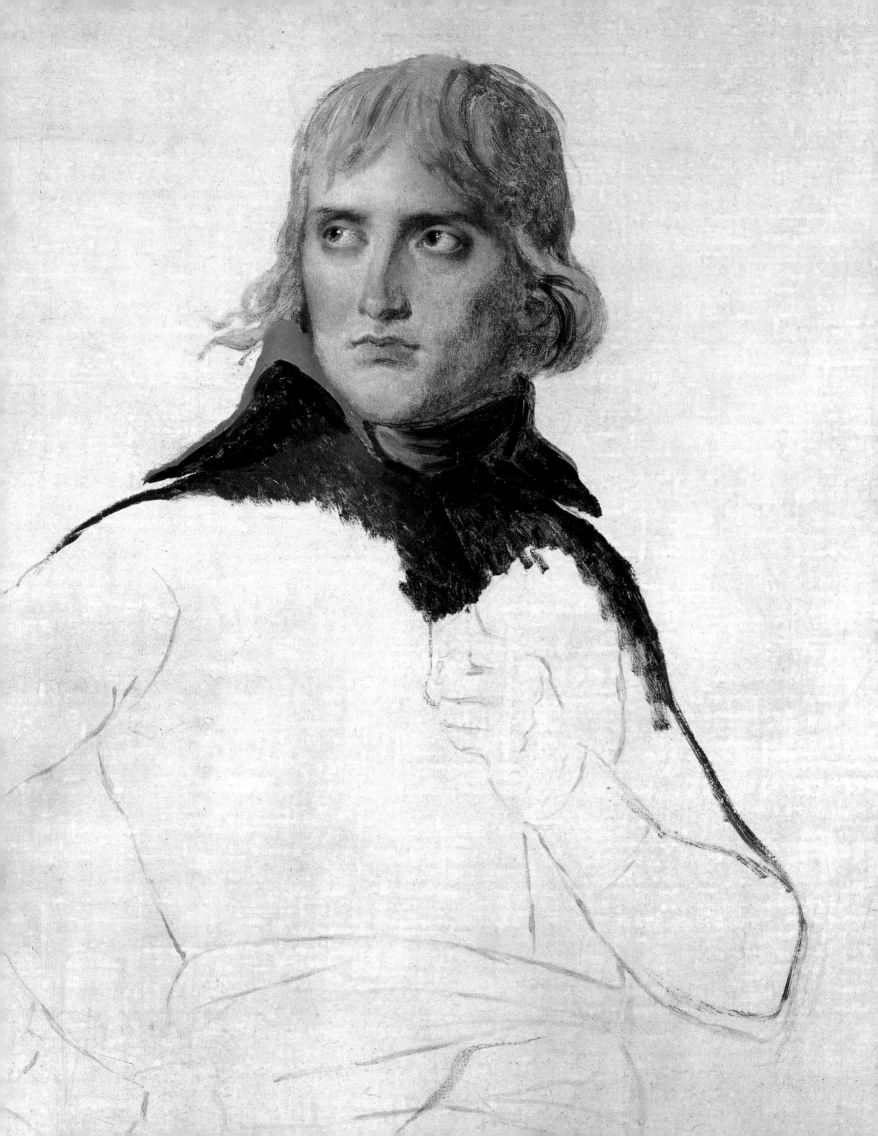

hardly left the studio before David was confiding in his students; he was thrilled to find a face so close to the classical ideal and marvelled at the severe perfection of the features. "What a head he has! It's pure, it's noble, it's as handsome as anything in Antiquity! In classical times, they would have raised altars to this man. Yes, my friends! Bonaparte is my hero."

At the time, there was much talk of new theatres of war, either in England or the Near East. David was willing to follow Bonaparte to London, but not to Egypt: his health would not allow it. Instead it was Denon who went with the scholars and scientists. In the wake of the Egyptian campaign and the Brumaire *coup d'état*, the First Consul inspired delirious enthusiasm in France. After the battle of Marengo, an urgent need was felt to commemorate Napoleon's military genius with an official portrait. Moreover, Charles IV of Spain, anxious for a rapprochement after the war waged against Spain by the Convention, sought to add the young general's portrait to the gallery of great military leaders that he had assembled in his palace in Madrid.

David started work on the portrait in September 1800, without obtaining a sitting. Napoleon remarked that "Alexander certainly never sat for Apelles. No one inquires whether portraits of great men are likenesses. It is enough if their genius lives on in them." His commission was very specific: "I want to be painted sitting calmly on a spirited horse." David's *Bonaparte Crossing the Saint-Bernard Pass* is indeed the image of a conqueror. Napoleon had crossed the Alps in May 1800, at the start of the second Italian campaign, but he did so riding on a mule. Here, mounted on an extravagantly Rubensian charger, he occupies almost the entire surface of the painting, while his troops file past in the background. The mountain landscape and stormy atmosphere are purely imaginary, but the uniform, sword and hat, painted with scrupulous realism, are those that Bonaparte wore at Marengo. They were lent to David, who arranged them on one of the dummies in his studio. The diagonal composition enhances the sense of vertigo, while the terrified whinnying of the horse contrasts with the impassivity of its rider, who points toward a glorious future. Everything combines to create a modern demi-god, a worthy successor to the great heroes of the past. The names of Hannibal and Charlemagne, heroes who crossed the Alps before him, are engraved on the rocks beside his own.

David and his studio made five copies of this work. The original was intended for Charles IV; a first copy was for Bonaparte himself (now in the Charlottenburg Museum), another was hung in the Invalides, a fourth was destined for the palace of the Italian Republic (now in the Kunsthistorisches Museum, Vienna), and the last remained in the artist's studio (it now hangs in the Museum at Versailles). As soon as they were finished, the first two versions went on show beside *The Sabine Women*, so that France's new idol could show the public this sublime image of himself. But the critics quite properly perceived the extreme idealisation of the portrait.

In 1802, the Peace of Amiens brought an interlude of peace. Foreigners flocked to Paris to see the astounding collections in the Museum (renamed

Jacques-Louis David |
BONAPARTE CROSSING THE SAINT-BERNARD PASS
1800-1801, oil on canvas, 271 × 232 cm (106 5/8 × 91 3/8 in). Musée National du Château de Malmaison, Rueil-Malmaison.

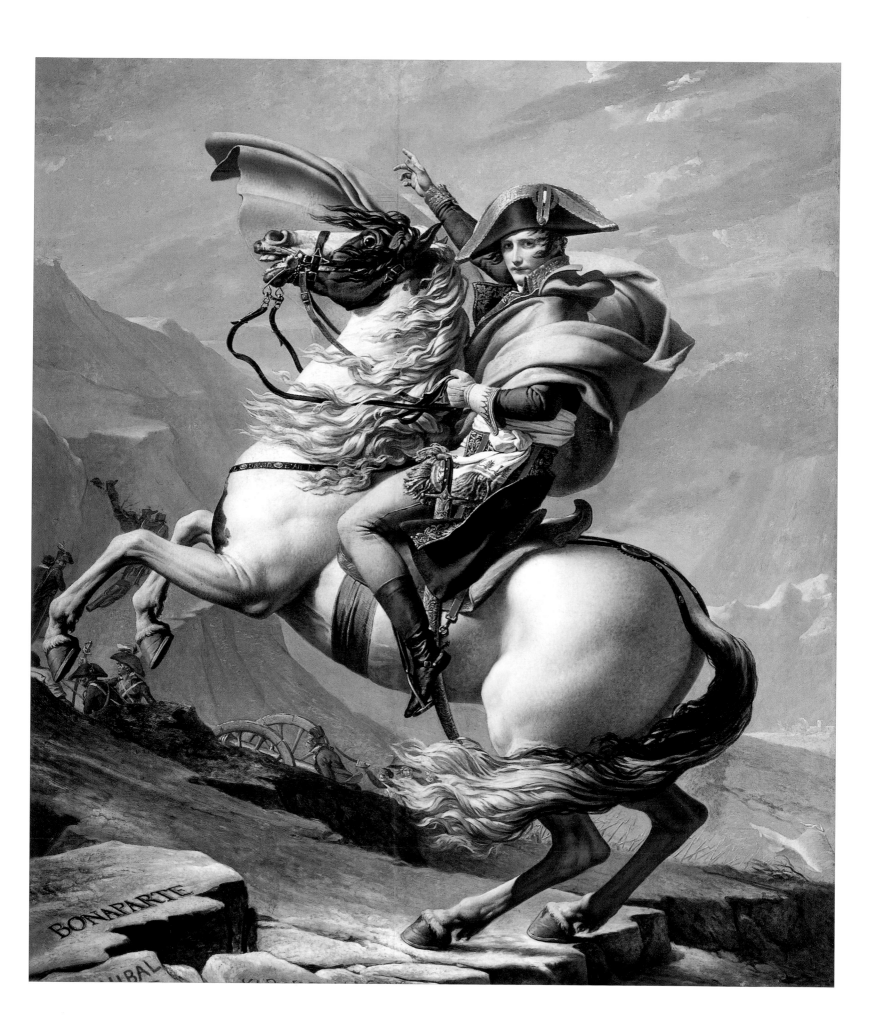

the Musée Napoleon a year later). They explored the studios of the city and visited David's *Bonaparte* and *The Sabine Women*. Fuseli, an admirer of the Revolution, was moved to wonder by David's "incomparable strength" which, he said "elicits universal sympathy". But times had changed, and others execrated David as a regicide. A group of artists in the company of the landscape painter Farington met Gérard, Guérin and Girodet, but arranged to inspect the master's work in his absence.

Nor were David's relations with Napoleon easy. The ambitions of the one did not always coincide with the will of the other. "He would have liked to be declared Minister for the Arts, First Painter of France, Superintendent of buildings, etc., or rather, under any title at all, be the supreme arbiter", wrote Moriez to Ducis. Both men had once been David's pupils. Napoleon, now Emperor, preferred to leave David free to paint rather than honour him with an official function. In 1806, in a fit of rage, Napoleon rejected the full-length portrait David had made for the Law Courts of the Genovese Republic, dismissing it as execrable. He also demanded to know why David had painted three portraits of Pius VII without being expressly ordered to. Moreover, David was at odds with the imperial administration over the allocation of studios and apartments, remuneration for his pictures (payment been reduced, delayed, or even cancelled, despite the enormous expenses incurred), and their relocation. Thus, in 1803, the Senate reclaimed *Brutus* and the *Horatii* for the Luxembourg Museum; the director of the museum, Naigeon, "would display them in the best possible light, close to Vien's *Hermit*". Meanwhile, Vivant Denon was demanding that *Andromache Mourning Hector* be sent to the Museum of the French School in Versailles. On 18 May 1804, in the aftermath of the Cadoudal conspiracy, Napoleon, though already Consul for life, had himself proclaimed Emperor of the French. Titles and honorary functions were restored. David, who had refused the title 'Government Painter' in 1800, became the Emperor's First Painter, though he had hoped for a wider remit than was granted. He was accorded an annual wage of twelve thousand francs. This was no fortune; in the same period, Mme de Staël offered the same salary to August Wilhelm Schlegel if he followed her to Coppet as tutor to her children. But the commissions that ensued brought David a comfortable income.

As soon as the date and place of the coronation had been fixed, the Emperor summoned his First Painter. He wanted four vast pictures of the coronation festivities for the newly redecorated Throne Room of the Tuileries: *The Coronation of Napoleon, The Enthronement of Napoleon at Notre-Dame, The Distribution of the Eagle Standards,* and *The Reception of the Emperor and Empress at the Hôtel de Ville.* This commission implicitly granted David the exceptional status that Titian had enjoyed at the imperial court of Charles V, or Le Brun at the court of Louis XIV. Within a week, David, as impatient as the new monarch, had sketched out projects for all four works. Only the first and third were completed, though the background architecture of *The Reception* had been sketched in by David's students, and the composition had already been transferred to canvas when the order came to abandon it.

Jacques-Louis David |
HEAD OF NAPOLEON
Undated, oil on wood,
43 × 32 cm
(17 × 12 5/8 in).
Institut de France,
Fondation Dosne-Thiers, Paris.

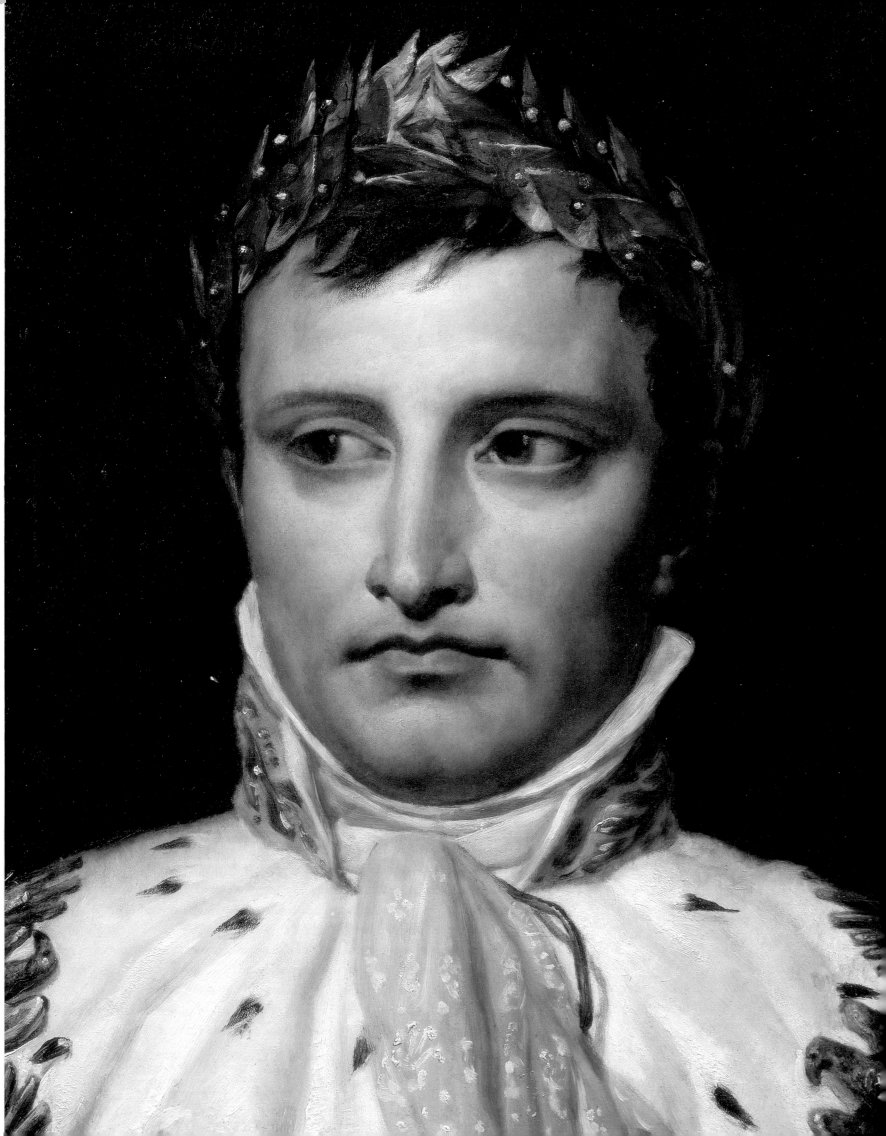

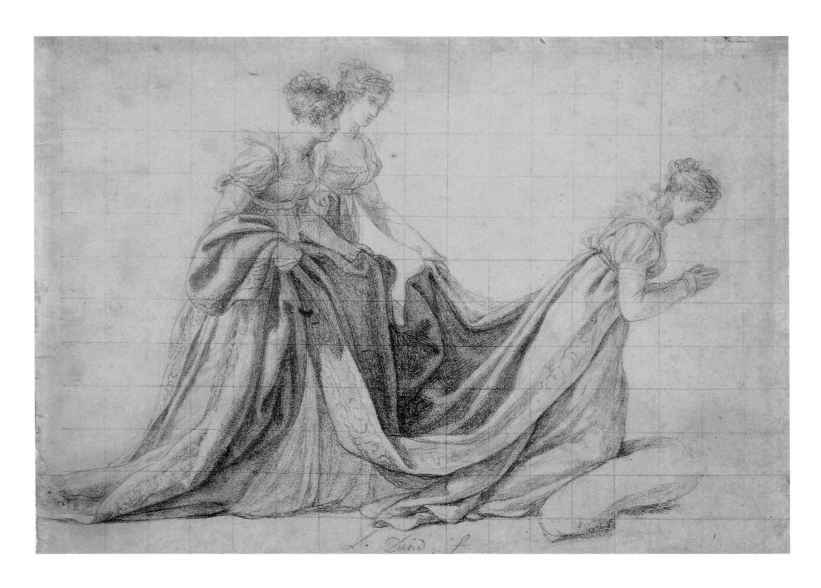

| Jacques-Louis David
**STUDY FOR THE CORONATION
OF NAPOLEON: THE EMPRESS
JOSEPHINE KNEELING**

| Undated, black pencil
and graphite,
27.4 × 39.1 cm
(10 3/4 × 15 3/8 in).
Musée du Louvre, Département
des Arts Graphiques, Paris.

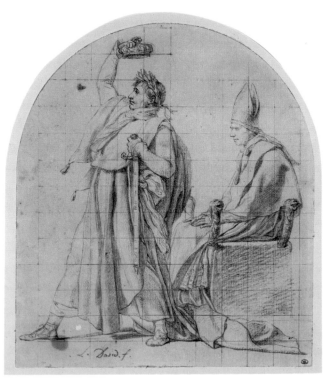

Jacques-Louis David |
**STUDY FOR THE CORONATION
OF NAPOLEON: NAPOLEON
CROWNING HIMSELF**
Undated, graphite, |
29.3 × 25.3 cm |
(11 1/2 × 10 in). |
Musée du Louvre, Département
des Arts Graphiques, Paris.

Jacques-Louis David |
**THE CORONATION OF NAPOLEON
IN NOTRE-DAME**
Detail. |

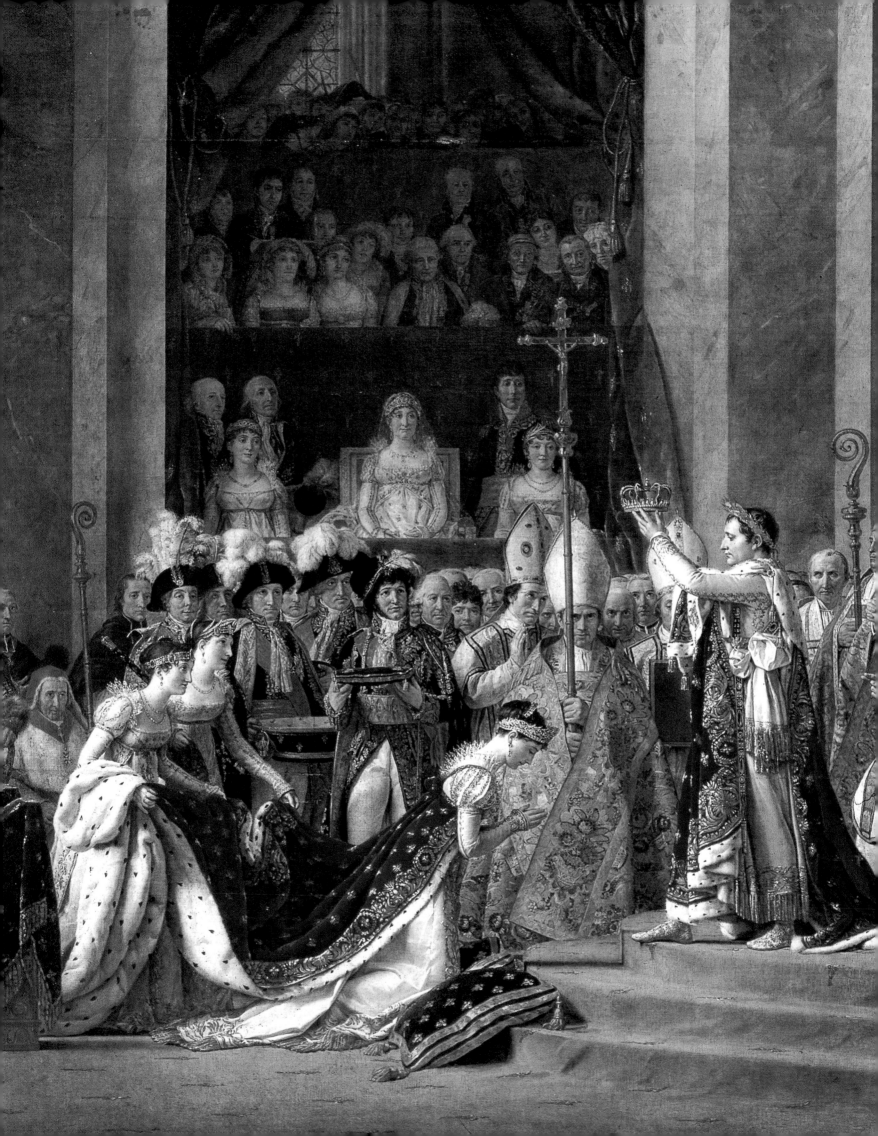

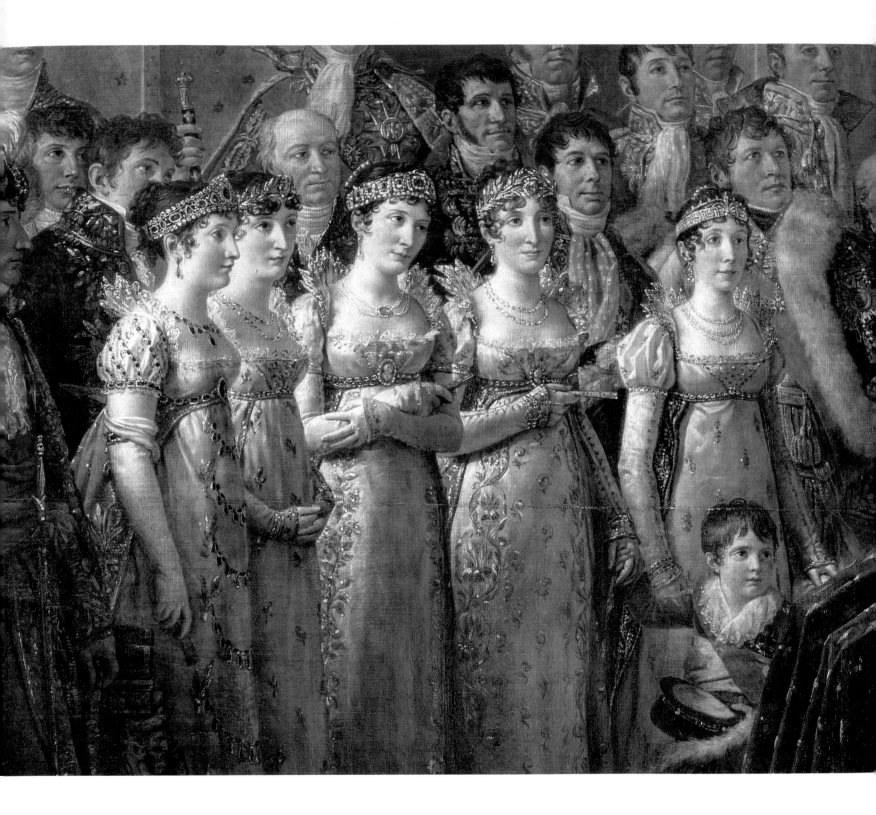

Empress Josephine and one for the Emperor. They capture the discreet, reflective spiritual presence of the man. "He is a true Pope, poor and humble," said David of his model, "whereas Julius II and Innocent X were men of ambition." One of the oil studies for *The Coronation* brings out the contrast between Pius VII and the tough-minded Cardinal Caprara, who had negotiated the conditions of the Pope's presence in France. "I confess," David wrote, "that I long envied the great painters who preceded me for opportunities such as I though I should never have. I should have liked to

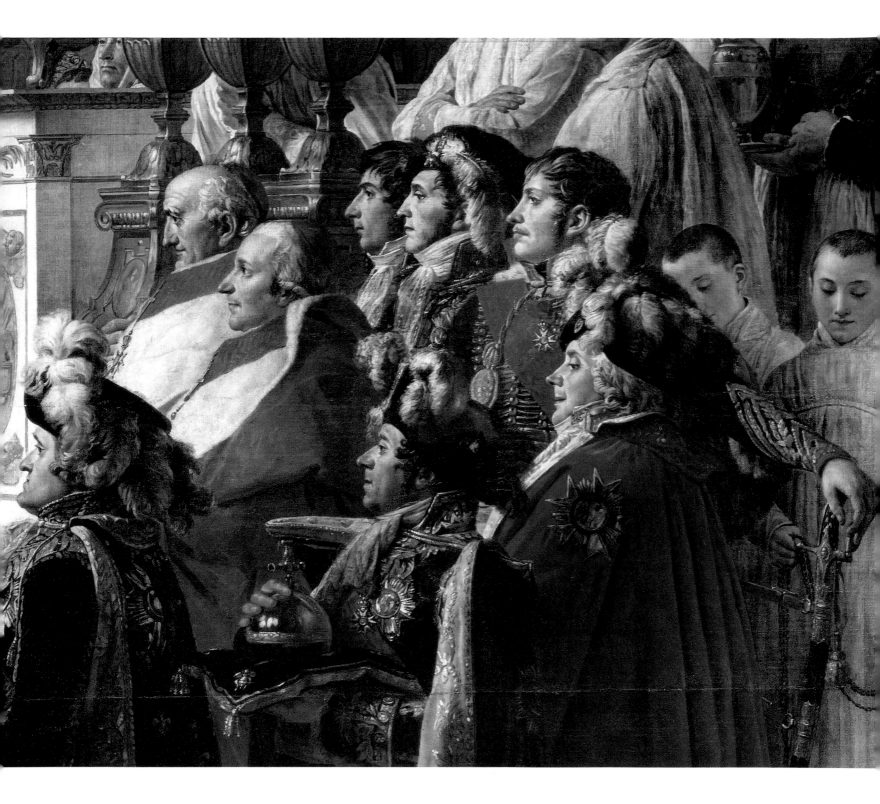

paint an Emperor, and even a Pope" – a Pope like the *Julius II* of Raphael, the *Paul III* of Titian, and the *Innocent X* of Velasquez!

The divorce of Napoleon and Josephine seems to have been the main reason why the *Reception at the Hôtel de Ville* and the *Enthronement in Notre-Dame* were abandoned. In the latter, she was to appear enthroned beside the Emperor. Josephine would also have appeared in the *The Reception*, where the festivities ended with a fireworks display representing the crossing of the Saint-Bernard pass. The purpose of the *The Reception* was, according to

Jacques-Louis David
THE CORONATION OF NAPOLEON IN NOTRE-DAME
Detail: the officers of the Empire.

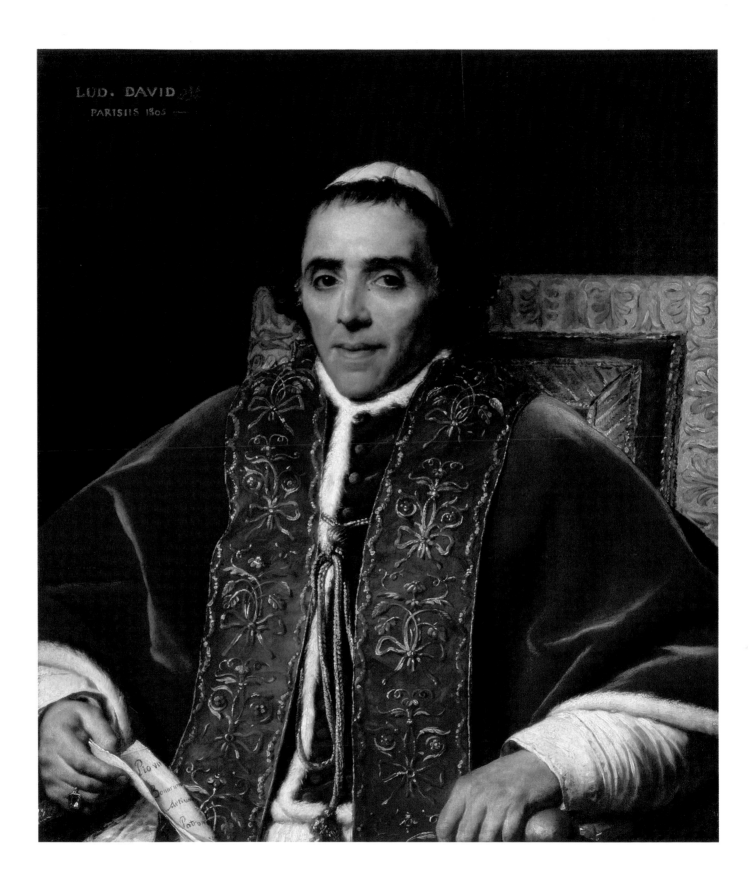

Jacques-Louis David
Portrait of Pope Pius VII
1805, oil on wood,
86 × 71 cm (33 7/8 × 28 in).
Musée du Louvre, Paris.

Jacques-Louis David
Portrait of Pope Pius VII
and Cardinal Caprara
Circa 1805, oil on canvas,
138 × 96 cm (54 3/8 × 37 3/4 in).
Philadelphia Museum of Art, Philadelphia.

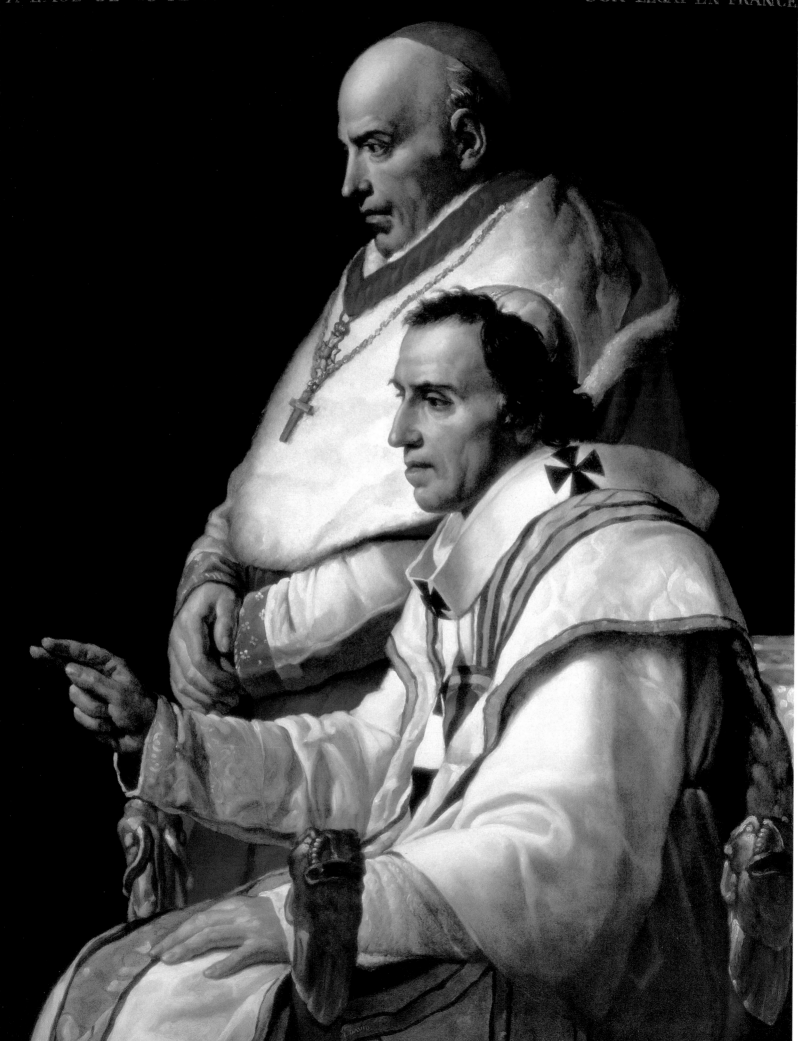

Jacques-Louis David
**STUDY FOR THE DISTRIBUTION
OF THE EAGLE STANDARDS: THE GRENADIER**
Undated, black pencil,
24.9 × 19.2 cm (9 3/4 × 7 1/2 in).
Musée du Louvre, Département
des Arts Graphiques, Paris.

Jacques-Louis David |
**STUDY FOR THE DISTRIBUTION
OF THE EAGLE STANDARDS:
THE STANDARD BEARER**
Undated, black pencil,
23 × 17.7 cm (9 × 7 in).
Musée National du Château, Versailles.

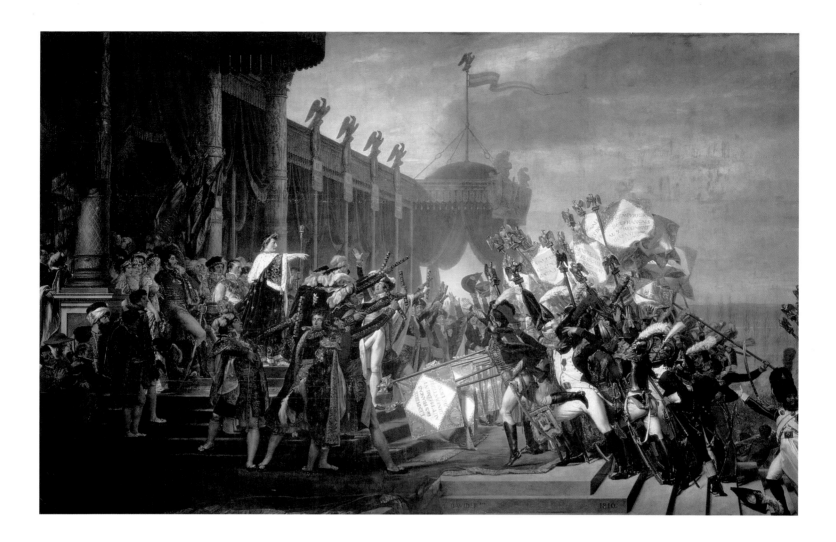

David, to express popular gratitude for the favours granted by the Emperor and the charitable works of the Empress. In the preparatory drawing, Josephine is seen stepping out of the carriage "radiating benevolence like the sun".

Her now undesirable presence also affected the *Distribution of the Eagle Standards at the Champs-de-Mars, 5 December 1804*. David at first proposed replacing her with the Emperor's mother, then simply painted her out. The ceremony was intended to fire the patriotism of the highest ranks of the arm and National Guard, and took place on the Champ de Mars beneath an immense portico designed by the inseparable team of Percier and Fontaine. In the presence of the Emperor, his marshals and the high command, the new colours – carried on eagle standards representing the new Empire – have just been presented to the regimental colonels, who swear to protect them with their lives. As in *The Oath of the Jeu de Paume*, the bracing dynamic of the composition rests on convergent lines of force. The central figure, a colonel balancing on his right leg, was inspired by Giambologna's famous *Mercury*, though the ironic public of the 1810 Salon preferred to identify him with the famous dancer, Vestris. Napoleon's almost disembodied air contrasts with the realism of certain other figures, among them Bernadotte and Berthier. An allegorical Victory was to have floated over the Emperor's

Jacques-Louis David |
**THE DISTRIBUTION
OF THE EAGLE STANDARDS**
1808-1810, oil on canvas,
610 × 931 cm
(240 1/8 × 366 1/2 in).
Musée National du Château, Versailles.

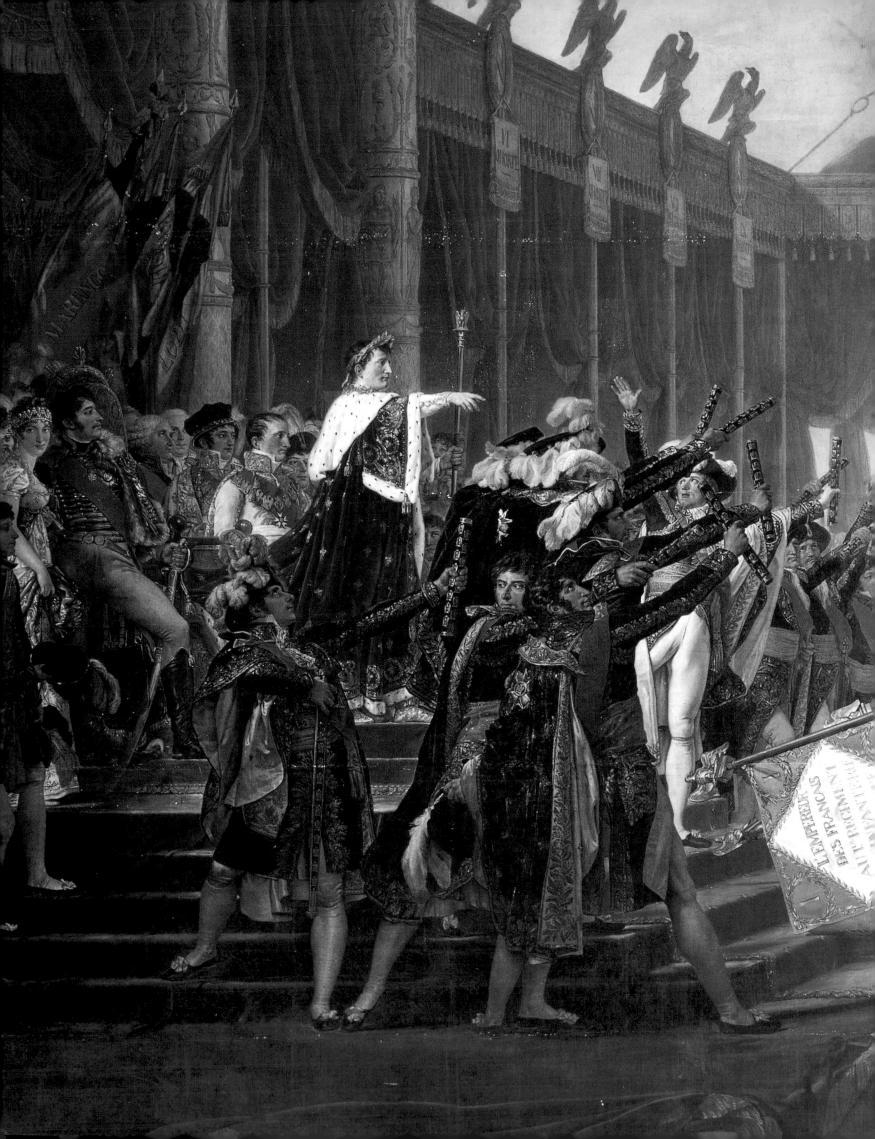

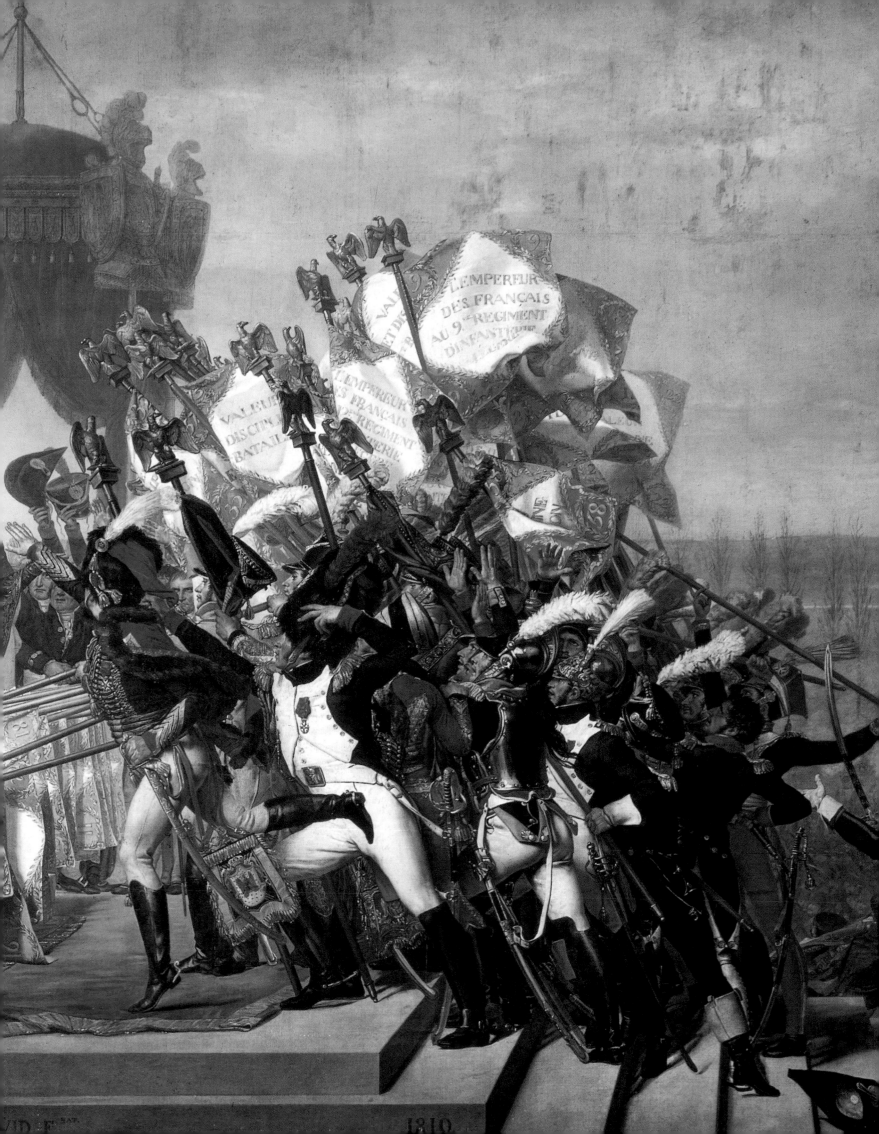

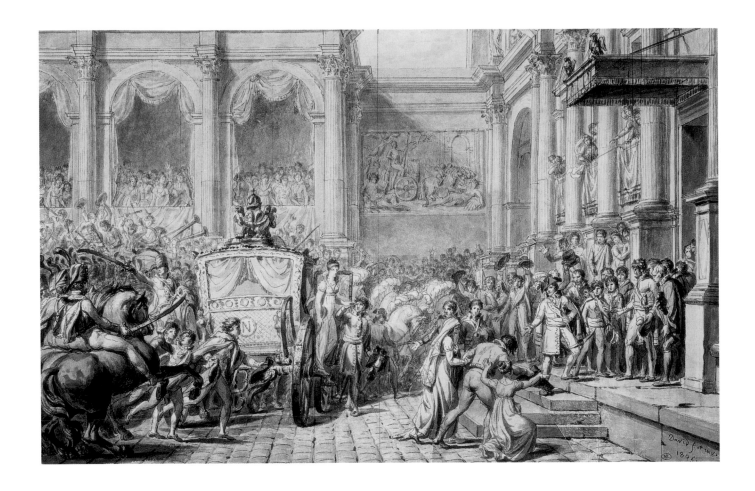

| Jacques-Louis David
THE RECEPTION OF THE EMPEROR
AND EMPRESS AT THE HÔTEL DE VILLE
| 1805, graphite, black ink,
| grey wash and white highlights,
| 26.2 × 40.8 cm (10 1/4 × 16 in).
| Musée du Louvre, Département
| des Arts Graphiques, Paris.

| Pages 172-173
| Jacques-Louis David
THE DISTRIBUTION
OF THE EAGLE STANDARDS
| Detail.

head, but was eventually erased at Napoleon's request. David was forced to rework the composition extensively to restore the sense of balance. The vast painting remains somewhat confused, and was coolly received by the critics. After the 1810 Salon, it was placed in the Guard Room of the Tuileries.

Throughout the Consulate and Empire, David's talents were put to use in the most varied contexts. Many of these projects never came to anything – for example, Lucien Bonaparte's plan to erect 'national columns', like those of ancient Greece, to immortalise the heroism of the soldiers of the Revolution. Napoleon even took an interest in the forms of dress appropriate to high officials. David designed a uniform with a long straight coat for the Consuls, but the First Consul preferred the short breeches of the *ancien régime*. The members of the Institut adopted a costume created by David in 1801 and which, with some adjustments made at the Restoration, continued in use till the Third Republic. It was David who advised Josephine to commission Charles Percier (a friend of Drouais' from their Roman days) and his acolyte Fontaine to design her house at Malmaison. As architects and interior designers, they were the uncontested masters of the Empire style. In 1811, David worked with them to design the furniture for the Emperor's Great Office in the Tuileries; the designs from which Jacob Desmalter constructed his great ebony pieces were also by this trio.

David's official duties left him little time for private clients. He painted a few portraits and, in 1809, a history painting, *Sappho, Phaon and Cupid* (now in

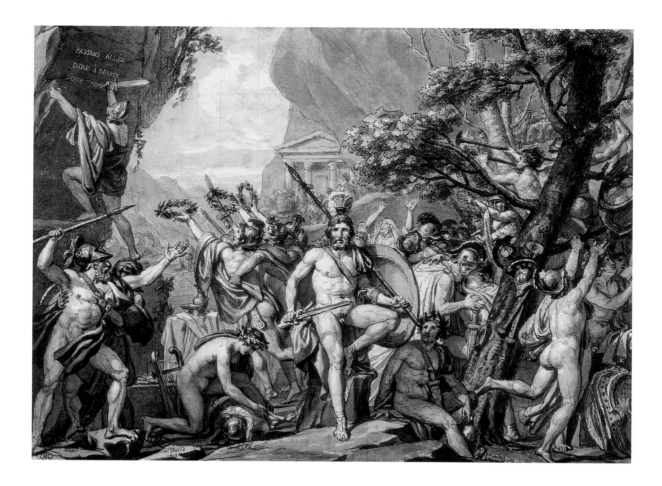

Jacques-Louis David |
**Study for Leonidas
at Thermopylae**
1813, pencil, black ink,
grey wash and white highlights,
21 × 28.1 cm (8 1/4 × 11 in).
Musée du Louvre, Département
des Arts Graphiques, Paris.

the Hermitage, Saint Petersburg), for the great Russian collector, Prince Yusupov. The commission confirmed the extent of his international reputation, though the work itself was thoroughly outmoded.

In 1799, David had in any case begun work on an episode from the persian Wars: *Leonidas at Thermopylae*. The Spartan general and his three hundred hoplites were killed to the last man preventing the passage of the immense Persian army and thus giving the Greek armies time to coordinate their defence. The subsequent defeat of the Persians was owed to their sacrifice. As with *The Sabine Women*, David's originality lay in his choice of the moment to be depicted: not a military engagement, but "something graver, more thoughtful, and more religious." "I want," wrote David, "to paint a general and his soldiers preparing for battle like true Lacedaemonians, knowing that they will not survive." Bonaparte, who saw the painting in 1800 while it was still incomplete, criticised David's decision to paint the defeated. Three young men hold out crowns of flowers towards a soldier who inscribes in the rock: "Passer by, go to Sparta and tell her that her children died for her." At the feet of Leonidas, another soldier is buckling his shoe; on the right, a father embraces his son. The figures painted during the first phase, from 1799 to 1803, have a lyrical tenderness lacking in the later additions. These – the blind man, the other soldiers, and the group in the background – were painted from 1813 onwards, and are distinctly more prosaic. The succession of figures draws the eye from the outside to the

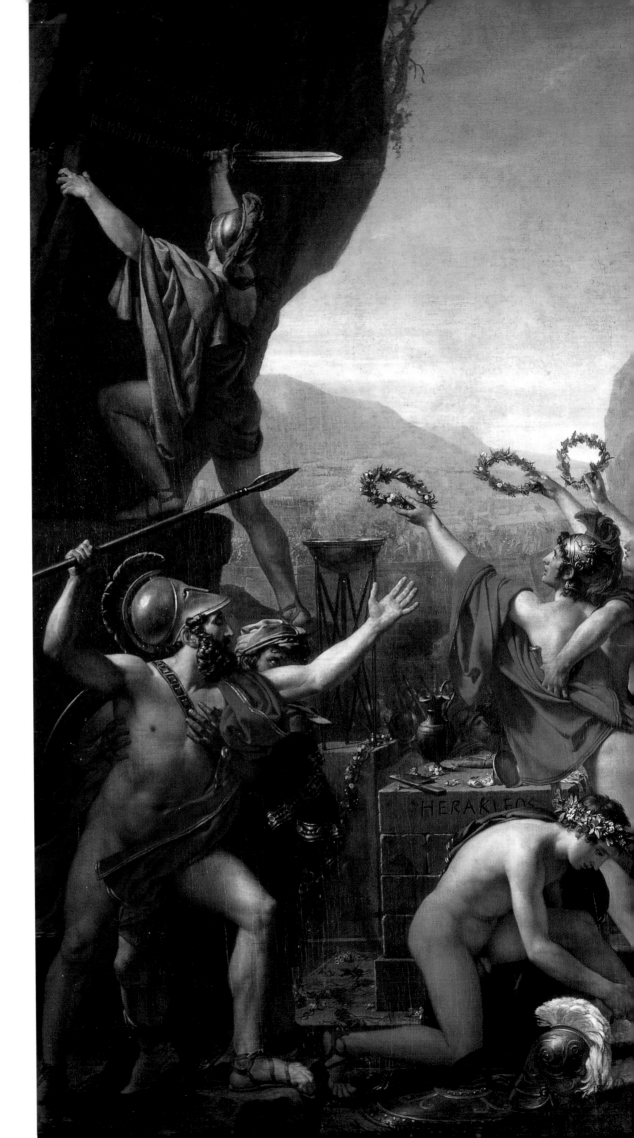

Jacques-Louis David |
LEONIDAS AT THERMOPYLAE
1814, oil on canvas,
395 × 531 cm
(155 1/2 × 209 in).
Musée du Louvre, Paris.

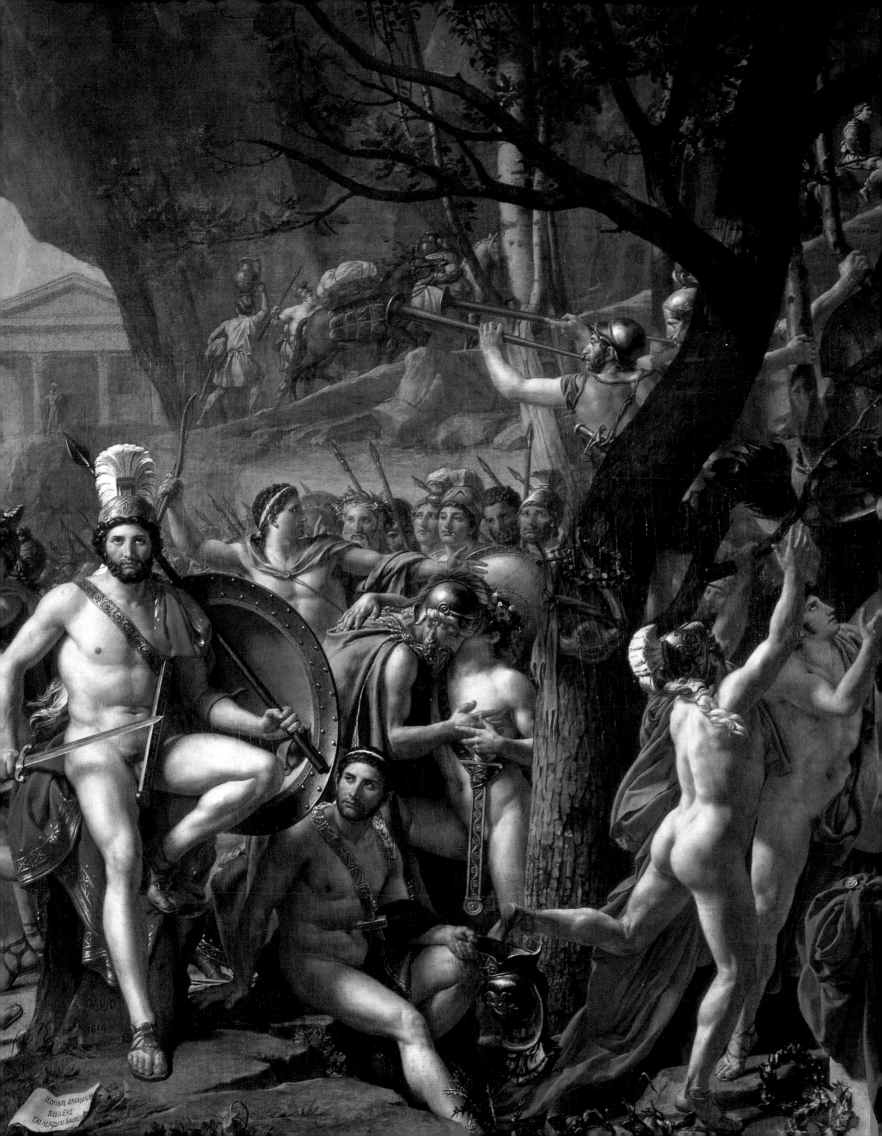

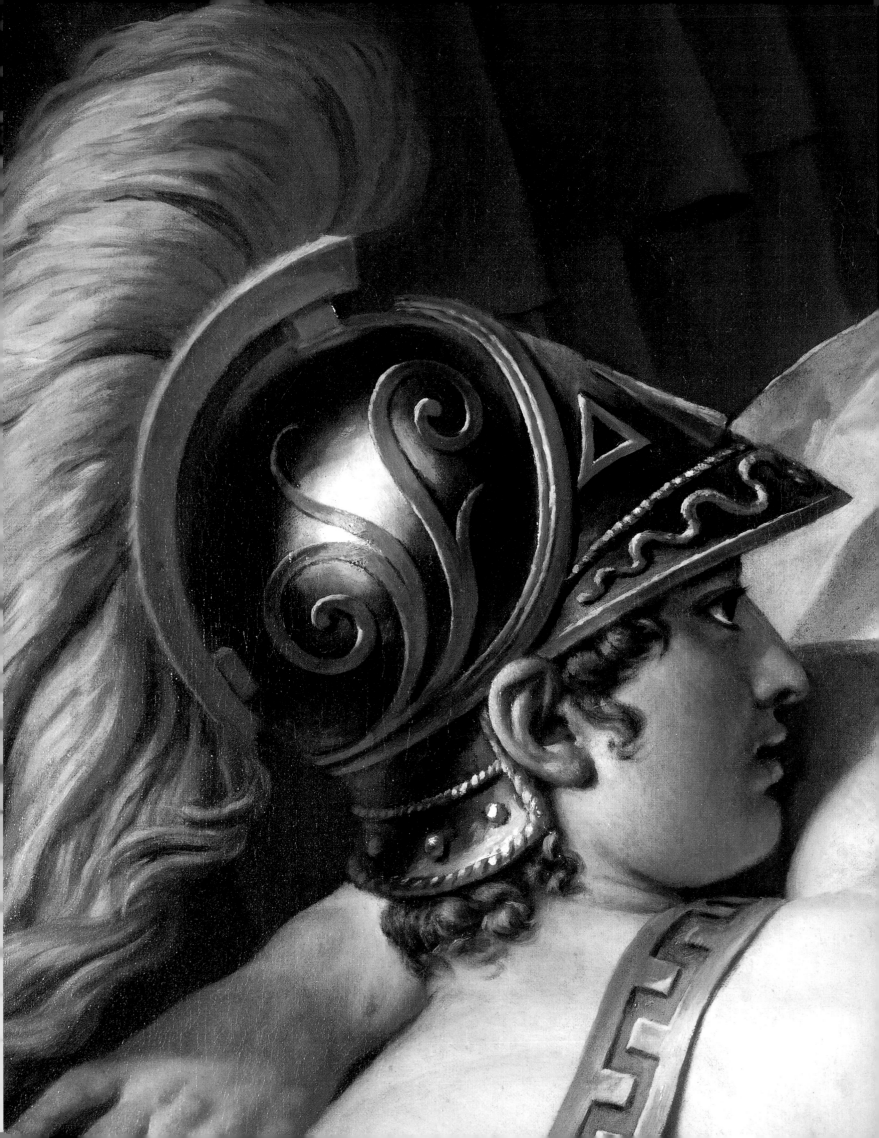

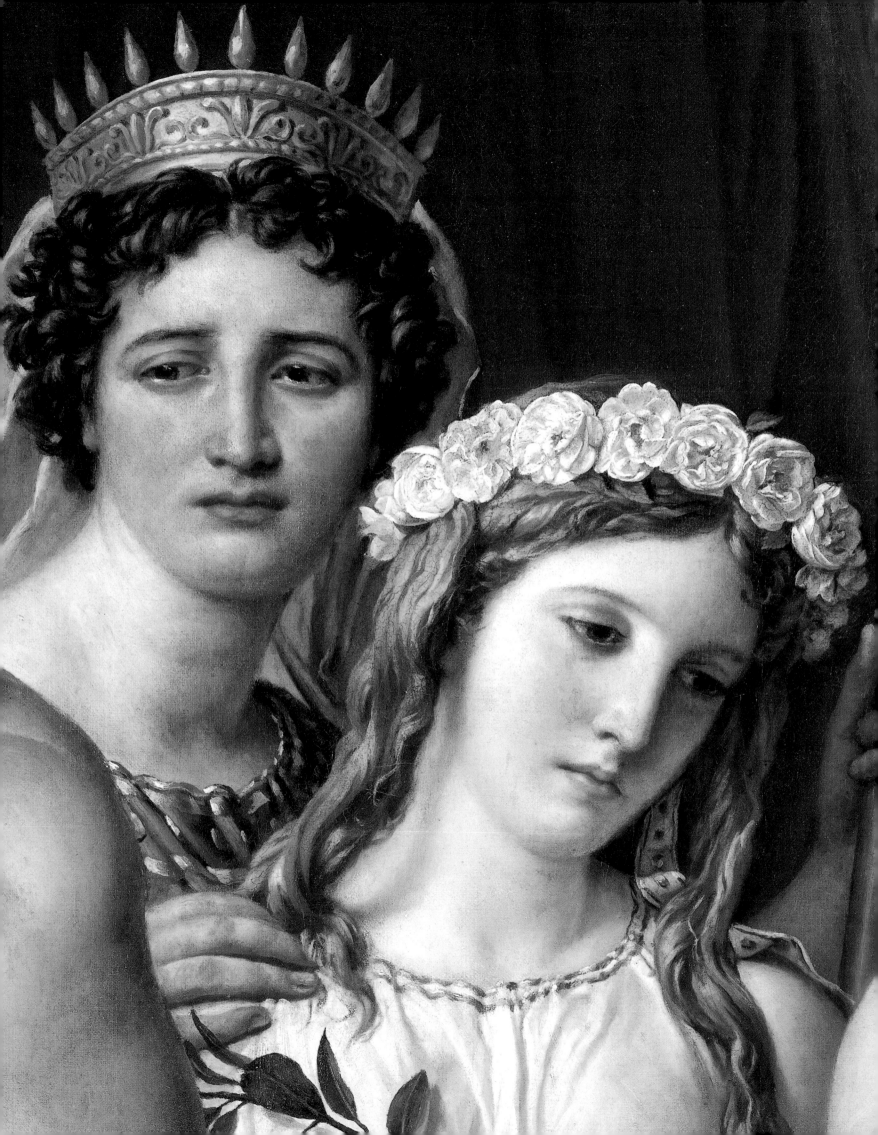

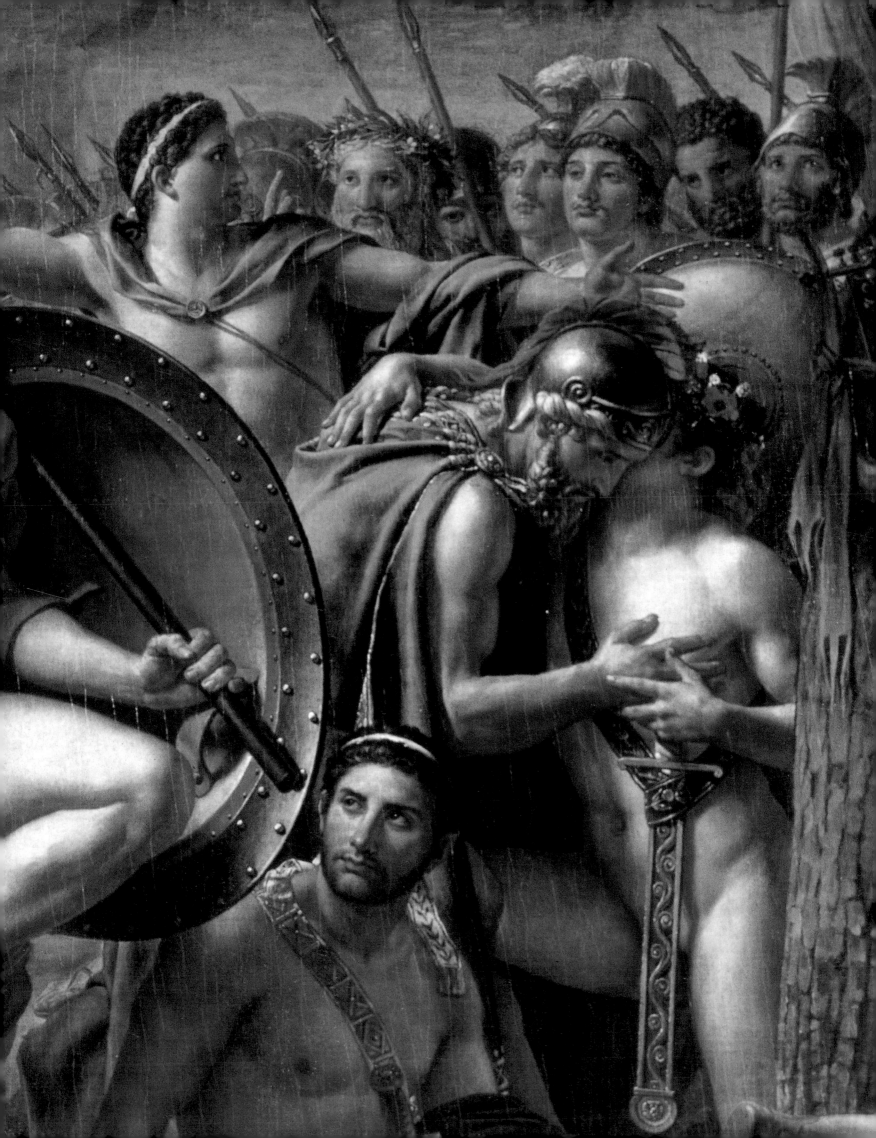

In the early days of the Restoration, the sovereigns foregathered; the King of Prussia and the Austrian and Russian Emperors were all in Paris. The Empress Josephine, soon to be carried off by pneumonia, sold her art collection to the Tsar. Napoleon's Louvre, enriched by a final convoy from Italy in 1814, remained for one last year the finest museum in the world. Foreigners flocked to visit its collections, among them many English painters – landscape artists such as John Crome and history painters such as Benjamin Robert Haydon and David Wilkie. The history painters also visited the Cluny studio to see the works of David. Meanwhile, the allied princes were visiting the Louvre, where the honours of the house were done by Vivant Denon and Auguste de Forbin, a former pupil of David, ex-chamberlain of Pauline Borghese and a future Director of the Museum. The two artists conducted Louis XVIII around the collection in his wheelchair, stopping before the many masterpieces now acknowledged by treaty as French property. "Henceforth they belong to us," Louis declared in his constitutional speech to the Palais Bourbon, "by rights more stable and more sacred than those conferred by victory."

The vicissitudes of fortune

Before the foreign armies reached Paris, Délécluze tells us, David gathered his most overtly political works and placed them in safety on the Atlantic coast, in case he should suddenly have to leave by sea. They included *The Coronation* and the *Distribution of the Eagle Standards* (cut into three pieces), *The Sabine Women*, *Leonidas* and several portraits of the Emperor. Once Tsar Alexander, had obtained honourable conditions of surrender for France, and the situation seemed more stable, he brought them back to the Cluny studio.

The first Salon of the Restoration opened in November 1814. For obvious political reasons, the First Painter to the Emperor did not take part. Louis XVIII had by now relieved David of his post. In 1817, he appointed Gérard to replace him, the rulers and marshals who had passed through Paris during 1814 and 1815 having, almost to a man, already commissioned portraits from Gérard.

However, David had not given up hope of exhibiting the *Leonidas*, which seemed more than ever appropriate to the times. To this end, he opened his studio to the public, where his latest work hung as a companion piece to *The Sabine Women*. The critics were not happy with the pose of the Greek hero, which they considered too academic, but they admired the mastery of the composition. Above all, they could not ignore its powerful implications for the present; indeed, some of them interpreted it as a resounding call to arms. In a pamphlet quoted by Antoine Schapper in his catalogue to the David exhibition of 1989, the comtesse Lenoir-Laroche, a sworn Bonapartist, compared the heroism of the Spartans to the obdurate resistance of the Napoleonic armies in the face of the Allied offensive. She saw the picture as an exhortation to the Imperial soldiery to fight to the death, as their classical forbears had done.

When the epic Hundred Days began, David was living a rather reclusive life, dividing his time between family and studio. News of Napoleon's lightning return from Elba caused the immediate flight of Louis XVIII. He left for Ghent at midnight on 19 March 1815, escorted by the Grey Musketeers, amongst whom was the painter Géricault. A few hours later, Napoleon was in Paris. "On the fifth day after his arrival," wrote Léopold Robert, a Swiss pupil of David's, "the Emperor came to visit Monsieur David." Napoleon deemed the head of Leonidas "sublime". And he added: "David, continue to bring lustre to the name of France by your work. I hope that copies of this picture will be placed in the officer-training schools; they will remind the young of the virtues of their condition."

In another letter, Robert relates that it was Jeanin, David's son-in-law, who had opened the gates of Grenoble to the Emperor: "Our master has now attained the pinnacle of fortune!" he wrote. David was reappointed First Painter and made a Commander of the Légion of Honour. David signed The Act Additional to the Constitutions of the Empire, thus binding himself to oppose the reestablishment of the House of Bourbon. The grandiose ceremony of promulgation was held at the Champ-de-Mars; accompanied by a new distribution of Eagle Standards, it filled the army with wild enthusiasm, and the Parisian bourgeoisie with trepidation. Three weeks later, the Great Army was defeated at Waterloo. On 22 June, Napoleon abdicated and placed his fate in the hands of the English. A few months later, the ex-Emperor was in Saint Helena, and Louis XVIII was in the Tuileries. On 6 July, the Allies again entered Paris. On 7 July, David left for Savoy and Switzerland. This flight to the safety of a neutral country nevertheless bore overtones of pilgrimage; David followed the Bonneville road, which Napoleon had taken in 1800 *en route* for the Great Saint-Bernard pass. He paused at Chamonix, where Josephine had gone to recover after her divorce. Marie-Louise of Austria, Napoleon's second wife, had also made a halt there. David, like Josephine, was a Freemason, and may have found some comfort at Montenvers, in the curious octagonal temple to nature, where Josephine had written in 1810: "Alone for a moment, in such a place as this the heart can rest." A notebook containing a few observations survives from this journey, which David interrupted at Neuchâtel to visit the engraver Charles Girardet; a further delay took place before he was granted a visa to return to Besançon. He finally obtained the visa thanks to Prince Schwarzenberg, whose sponsorship had gained him admittance to the Viennese Academy three years before. In January 1816, the amnesty law for regicides excluded those who "scorning [the King's] almost boundless mercy, voted the additional act or accepted a function or post from the usurper". David immediately set off into exile. Two months later, the Académie des Beaux-Arts erased his name from its registers, replacing it with that of Guérin. Exile would have seemed less harsh to David had he been able to live in Italy. The Empress Marie-Louise was now Duchess of Parma; Fabre was still an important figure in Florence; Wicar, though had made a brilliant career at Napoleon's courts in Rome and Naples, did not seem in any danger. However, the authorities of the many

Italian states were anxious to avoid the creation of Bonapartist networks in the peninsula, and would not let David set foot in Italy. His nephew, Jean-Baptiste Debret, who had joined him in Rome in 1784 and 1785, and subsequently enjoyed considerable success in Paris, now set off to found the Rio de Janeiro school of fine arts. When independence was declared, Debret was appointed official portraitist to the Emperor of Brazil. But David was not tempted by such exotic locations; he preferred somewhere less remote. His choice fell on Brussels, the capital of Brabant, a city accustomed to the successive waves of French emigrants. Staying first in the rue du Fossé-aux-Loups, then in rue Guillaume, David soon found a studio in the former bishop's palace, and there his furniture was taken when it arrived from Paris. Before his departure, his pupils new and old had been consistently supportive. They now addressed a petition to the Minister of Police, Decazes, demanding his return to France; it was signed by David's pupils Drolling, Espercieux, Gros, Gérard, Isabey, Meynier, and by Prud'hon, Denon, Mongez and Naigeon. The recipient avouched that if the painter solicited this favour, it would be granted. But for David, to ask anything of the new regime was a moral impossibility. He was shocked by the return of the privileges of the *ancien régime*. He had supported the Empire because he believed that Napoleon had maintained the principles of the Revolution. There was no question of his denying Napoleon as he had Robespierre.

His studio, where the nude studies of *Hector* and *Patroclus* still hung as examples to the trainee-painters, was entrusted to Gros. It was necessary to prevent *The Death of Marat* and *Le Peletier* suffering the same fate as the busts of The 'Friend of the People' that had been vandalised in 1795. Gros, most loyal of friends, therefore covered the surfaces of these and another two paintings with white ground, so that they looked like canvases in preparation. The paintings from the rue d'Enfer had likewise been moved to the Cluny studio. For two years, until the State repossessed the premisses, foreign visitors to Paris were able to admire a number of David's most important works. Subsequently, in 1819, Louis XVIII acquired *The Sabine Women* and *Leonidas*, which Napoleon had hesitated to buy. The return to Paris of the *Coronation* and the *Eagles* completed the collection of David's works on view in the great Parisian museums.

His international reputation remained as high as ever. But he was no more susceptible to German blandishments than he had been to the overtures of Decazes. The King of Prussia's ambassador to France informed him that Frederick Wilhelm III would be "delighted to attract so distinguished an artist to his capital". The German ambassador to the Low Countries repeated this "invitation to become Minister of the Arts in Berlin". The idea had originated with the geographer Alexander von Humboldt, the Prussian King's personal representative in Paris. An associate member of the Institut, he had protected the Museum of Natural History against the Allies' rapacity, and wished to offer his famous colleague some form of refuge. But David politely refused every proposition, and even the personal entreaties of the Prussian King's brother, the Prince of Mansfeld, failed to win him over.

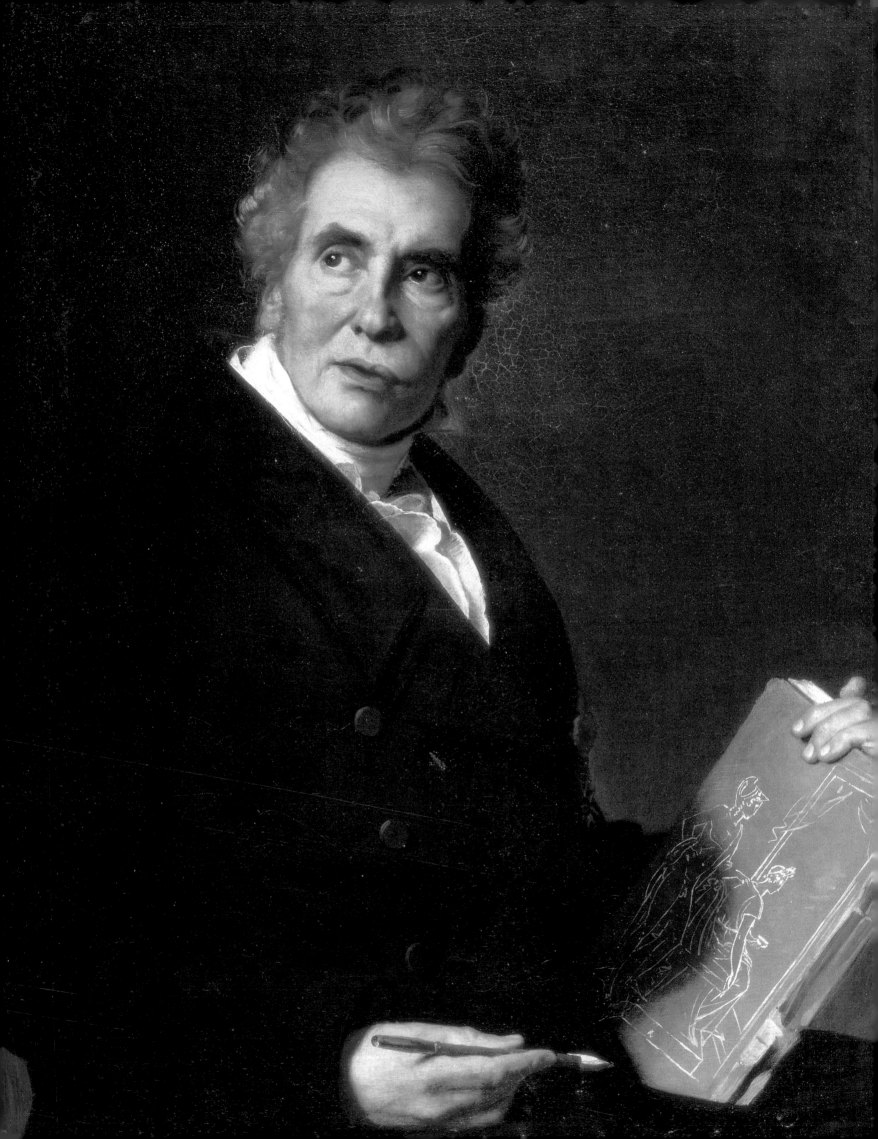

A peaceful exile

David was sixty-eight when he took up residence in Brussels. There he was greeted with discreet but very real esteem, and enjoyed a tranquillity such as he had not known in years. On his arrival, he wrote to Buron, saying "You know how much I like the meditative life." He was able to indulge his long-standing passion for the theatre; Wolf, the director of the Théâtre de la Monnaie, placed a box at his disposal. Having learnt from bitter experience, he turned his back on public life definitively. His financial position was secure; his paintings fetched very high prices and he received substantial royalties on his engravings. He was now able to enjoy the freedom of an independent artist. He threw himself back into painting with a renewed energy: "I am working as if I were a thirty-year-old", he wrote. To Gros, who longed for David's return, he responded in 1819: "We shall never agree, my dear friend, while you are convinced that only in France can one be happy; I am well placed to think the contrary. From the time of my return from Rome (...), I was endlessly persecuted there, tormented in my work by every odious machination imaginable." Exiled he may have been; isolated he was not. He had the satisfaction of meeting his old Belgian students again: Joseph Paelinck, Joseph Odewaere, now First Painter to Guillaume I, King of the Low Countries and François-Joseph Navez, an excellent portraitist who was the leading exponent of Belgian neo-classicism. Sometimes friends would arrive from Paris, among them Angélique Mongez and Jérôme-Martin Langlois, to the latter of whom we owe one of the last portraits of David. His daughters, Emilie Meunier and Pauline Jeanin, would rally round whenever their parents fell ill. Work and contact with pupils new and old remained the best therapy for David.

One of his favourite students from these twilight years was Sophie Frémiet. The wife of another exile, the sculptor Rude, Frémiet showed particular talent. Her very competent *Portrait of Wolf* (now in the Louvre) was painted under her master's eye and benefited from his advice. David's former pupils were unanimous in praise of his teaching. One such was Henri Riesener, who hoped that his nephew, Eugène Delacroix, would "in his own interest" go and study with David. "I have often thought of doing so", replied the young man, and must have thought about it the more while his friend Géricault was travelling in Belgium.

In November 1820, Horace Vernet came to see the great *émigré* of Brussels; with him was Géricault, who had just shown the *Raft of the Medusa* in London. David was very touched by their visit, and mentioned it to several of his correspondents. These "two fine painters" had "delighted [him] by their presence". "They came to Brussels," he said, "intent on seeing me again and embracing me (...). We drank to the health of those of my pupils whose filial affection for me has never waned."

The following year, Gros, ever attentive to his master's interests, brought him a gold medal engraved in his honour. He also sent him the copy of the *Coronation* (now in the Versailles Château Museum) which he had begun in 1808 for a group of American businessmen. David now wished to complete the copy. This made phenomenal demands upon his visual memory, which

EMM. JOS. SIEYES. ÆTATIS SUÆ. 69.

he was well able to meet. "One of the artistic faculties that he possessed to the utmost degree, was that of recalling a face that he had once seen", wrote A. Baron in 1837. With the help of Rouget, this painstaking task was completed. The work was first exhibited in London, and then, in 1822, in the United States, by the organisation that had commissioned it. Brussels had become a sort of Jacobin colony, and here the protagonists of many of the European revolutions were reunited. The kingdom of the Low Countries had been created in March 1815, but Belgium and Brussels, having spent the previous twenty years under French administration, were the focal point of *émigré* activity. Some *émigrés* managed, like Cambacérès, to return home. David was on friendly terms with many of the French regicides, some of whom had rallied to Napoleon: Barère, Prieur de la Marne, Sieyès, Ramel de Nogaret, Cambon and Alquier. David's last portraits were of men from this group. Sieyès – author of the celebrated pamphlet, *What is the Third Estate?* – was one of David's closest companions in exile. His central role in the Estates General had secured him a central place in *The Oath of the Jeu de Paume*. In 1798, he was a member of the Directory; under Bonaparte, he had been a Consul; the restoration condemned him as a regicide. David's magisterial portrait is imbued with the deep sympathy he felt for a man who, during the Revolutionary period, had shared many of his own illusions. Holding a snuff box in his hand, Sieyès is seated against the now classic scumbled, monochrome background. In a portrait painted a few years later (now in a private collection in the United States), *Mme Ramel* wears a cantankerous air in striking contrast with Sieyès' sad gaze. She was perhaps a victim of the boredom that tended to afflict the wives of exiled conventionnels. Her husband had sat with David on the Comité de Sûreté générale and been a minister under the Directory; he too is portrayed as somewhat embittered.

Many notables of the Empire, disgraced by the Restoration, congregated in Brussels. In his *Portrait of comte Henri-Amédée de Turenne*, David registered in quietly imposing fashion the dutiful but opaque expression typical of those who had served under Napoleon's orders. He also painted the portrait of a leading figure in the Imperial administration: baron Alquier. As ambassador to Madrid, the baron had informed David of Bonaparte's desire for an equestrian portrait. Subsequently posted to the Vatican, he had had his ravishing Neapolitan mistress, *Madame Devauçay*, painted by Ingres. David's portrait of *Alexandre Lenoir*, begun in Paris and finished in Brussels in 1817, is a study of a man whose career had run parallel to his own. Lenoir had founded the Museum of French Monuments, which was abolished in 1816. He must have worn just such an attentive, concentrated expression when cataloguing the art objects removed from nationalised buildings. It had been Lenoir's idea to use a former Augustinian monastery (now the École des Beaux-Arts) to house the religious sculptures saved from the iconoclastic rage of the *sans-culottes* and the greed of the dealers.

Joseph Bonaparte had taken refuge in Philadelphia; his wife, the comtesse de Survilliers, was living in exile in Florence, and met David on a visit to Brussels. In 1821, she asked him paint her two daughters, Zénaïde and

Jacques-Louis David |
PORTRAIT OF GENERAL ETIENNE MAURICE GÉRARD
1816, oil on canvas,
197 × 136 cm
(79 1/2 × 53 1/2 in).
The Metropolitan Museum of Art, New York.

Page 192 |
Jacques-Louis David |
PORTRAIT OF JULIETTE DE VILLENEUVE
1824, oil on canvas,
198 × 123 cm
(78 × 48 1/2 in).
Musée du Louvre, Paris.

Page 193 |
Jacques-Louis David |
PORTRAIT OF ZÉNAÏDE AND CHARLOTTE BONAPARTE
1822, oil on canvas,
130 × 100 cm
(51 1/8 × 39 3/8 in).
Musée d'Art, Toulon.

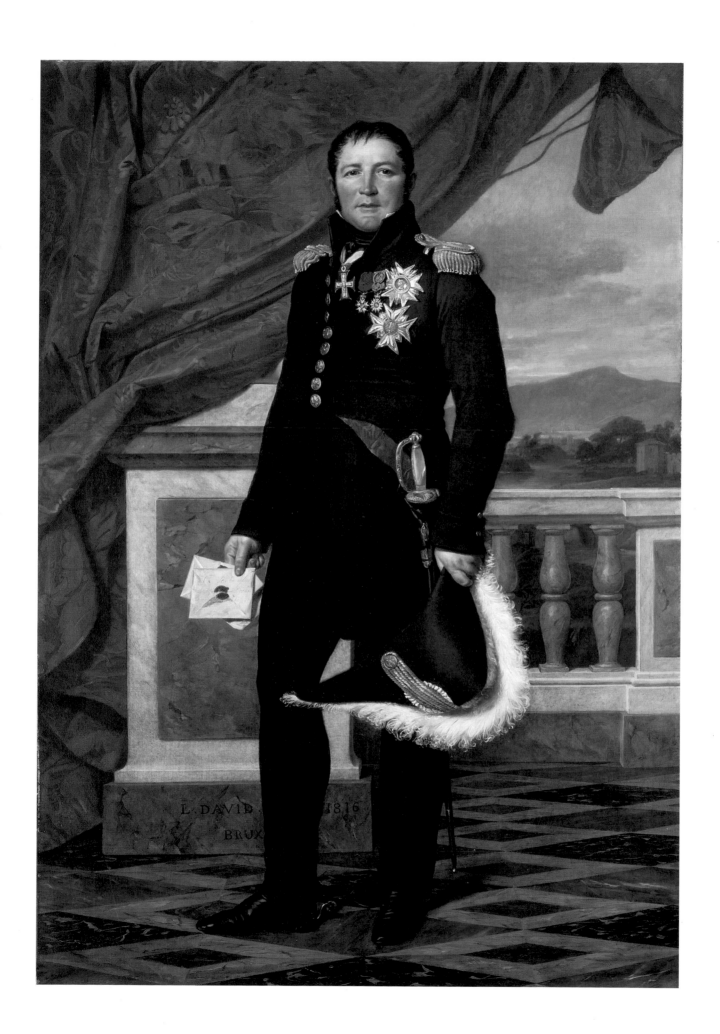

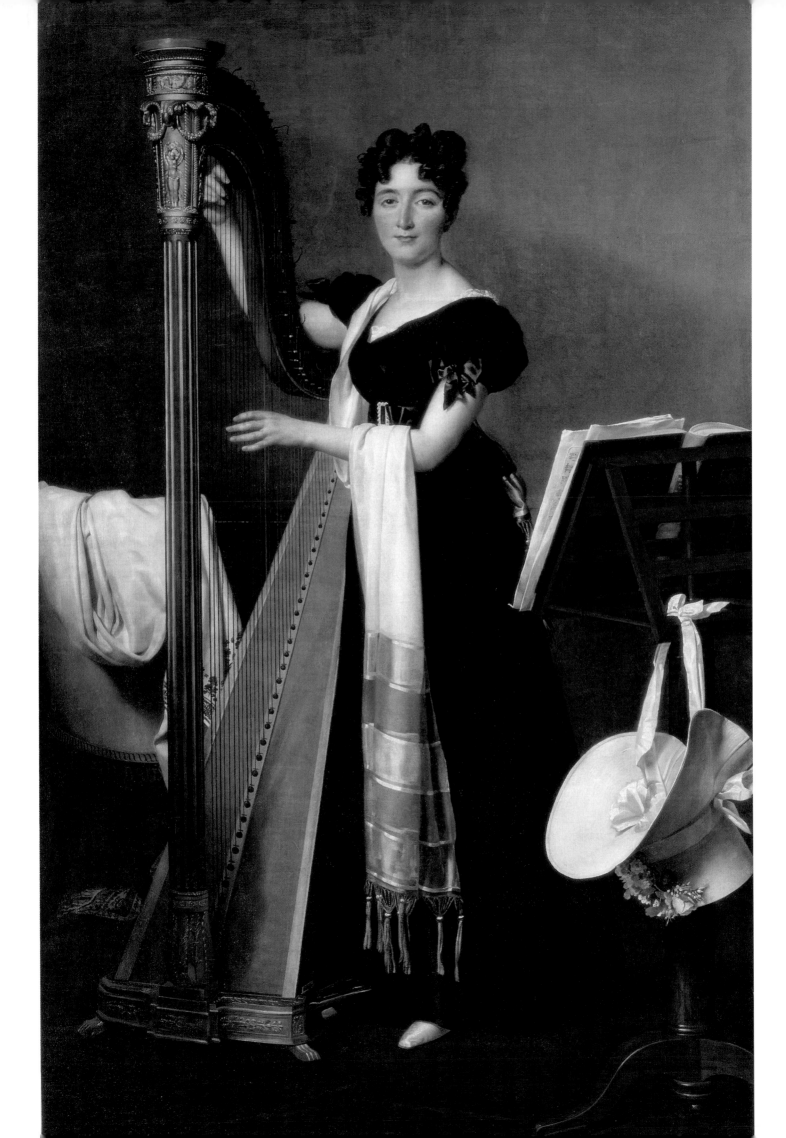

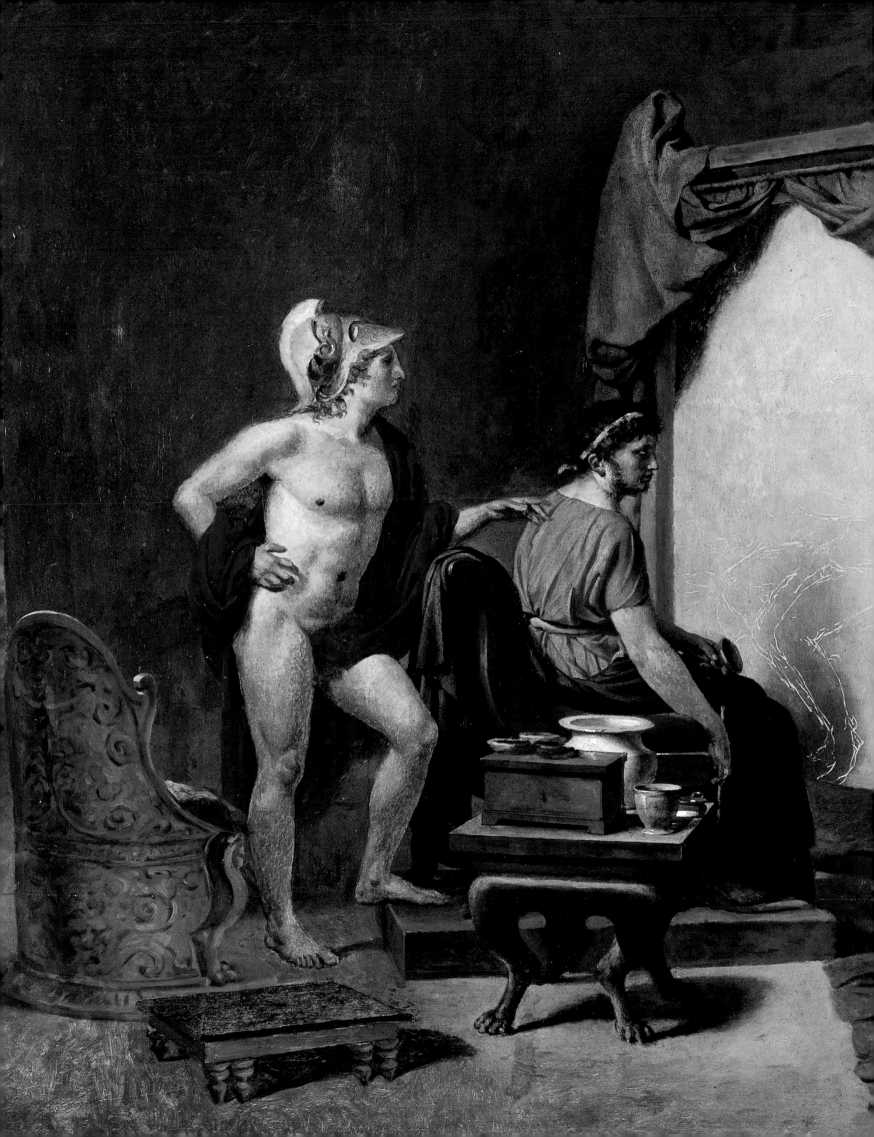

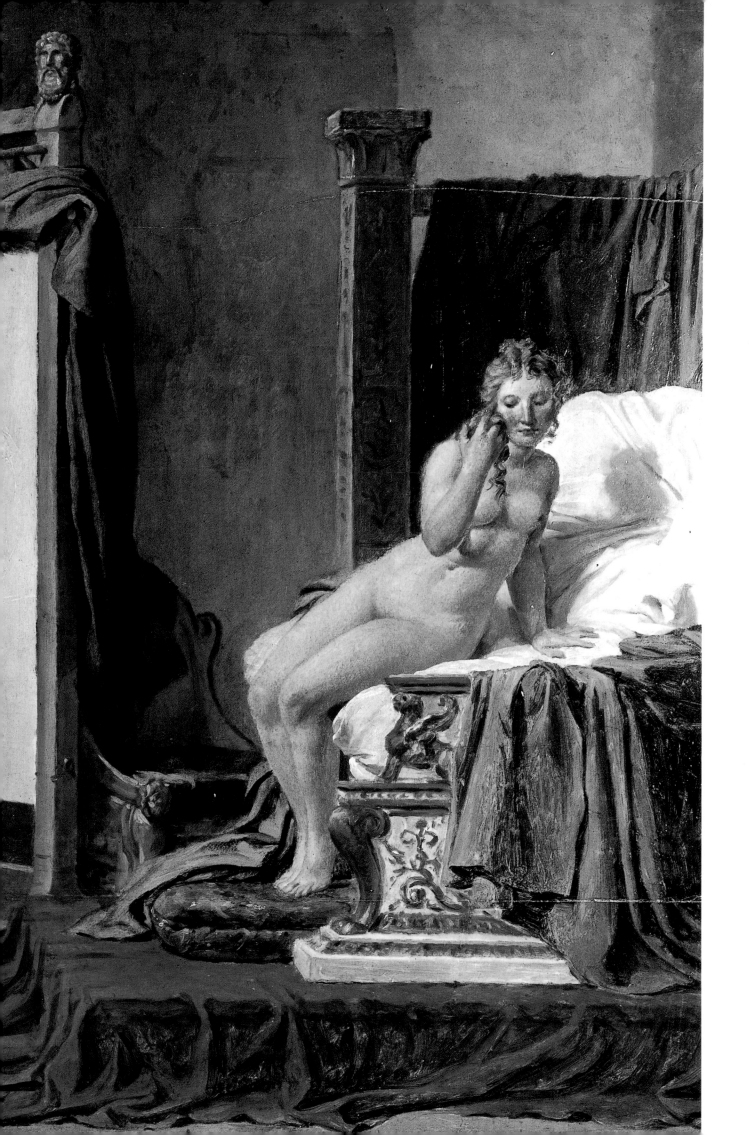

Pages 194-195
Jacques-Louis David
APELLES AND CAMPASPE
1813-1816, oil on wood,
96 × 136 cm (37 3/4 × 53 1/2 in).
Musée des Beaux-Arts, Lille.

Charlotte Bonaparte. The rich impasto of David's implacable portrait reveals two unattractive girls huddled together on a sofa embroidered with stars. Their cousin Juliette de Villeneuve also sat for David; completed three years later, in 1824, her full-lengh portrait is one of the few in David's corpus. in complete contrasr with these intimate works is *the Portrait of General Étienne Maurice Gérard*, the hero of the Berezina crossing on the retreat from Moscow; two days before Waterloo, he had defeated Blücher at Ligny. Decked out in his medals, his massive form is posed in front of an unusual backdrop of drapes, balustrade and chequered marble floor. In the distance, an imaginary landscape evokes the Roman *campagna*. The elaborate decor and brilliant colours suggest that David had returned to the Flemish masters, especially Rubens and Van Dyck, though the influence of Thomas Lawrence is also perceptible.

At the height of his powers as a portraitist, David had not abandoned history painting. In his last years in Paris, a succession of onerous Imperial commissions had distracted him from his passion for Greek art. In Brussels, he returned to the simple, dynamic style of the Ancients. Mythological subjects were enjoying renewed popularity in Europe, alongside the emerging taste for the troubadour period.

Classical myth

Before his abrupt departure for Belgium, David had begun two canvases on mythological themes: *Cupid and Psyche* and *Apelles and Campaspe*. The latter took its subject from a famous anecdote related by Pliny: the Emperor Alexander offering his mistress Campaspe to the celebrated painter, who had fallen madly in love with his model. David reworked the canvas in Brussels, but never finished it; the features of Alexander's face are given only a rudimentary treatment. The composition is reminiscent of David's youthful work, *Antiochus and Stratonice*. The remoteness of the object of desire, and the considerable space separating the woman from the gazing men, attenuates the impression of voyeurism. The theme of the artist at work is rare in David's work, and certain interpreters, such as Philippe Bordes, ascribe an autobiographical significance to the work; it is said to record David's exhaustion after the major works he had executed for Napoleon.

In 1817, he resumed work on *Cupid and Psyche*, which he exhibited in Brussels, before sending it to Alfieri's friend, the collector Count Sommariva. The theme is a common one, but David's unexpected treatment was found rather shocking. His Eros was deemed too carnal; he lacked the spiritual grace bestowed by Gérard's painting of the same theme; neither god nor hero, he was a mere model, and a commonplace one. Delécluze later explained his master's approach: "David was very sensitive to the often-heard criticism that he was a mere imitator, a copyist of the Antique. Gathering all his resources of talent and instinct, he set out to imitate nature without modifying or embellishing it, and completed his *Cupid and Psyche*. He thus demonstrated his ability to represent things as they are, without choice, copying directly from the model." The following year, Prince August of Prussia, wanting to offer a portrait of

Mme de Staël to Mme Récamier, asked David for a preliminary drawing. He was to portray the novelist, who had died the previous year, in a setting evoking her novel *Corinne, or Italy*. David put forward an ambitious project: the coronation of Corinne at the Capitol, with "life-size figures, in sufficient number to give the impression of a triumph". David wanted forty thousand francs for eighteen months' work, and both demands were deemed excessive. Gérard obtained the commission, and his more romantic composition, *Corinne at Cape Miseno,* was completed in 1819.

David's *Telemachus' Farewell to Eucharis* of 1818 was again a brilliant fusion of realism and the neo-Greek poetic ideal. The subject was taken from Fénelon's *Télémaque*, published in 1699. Eucharis, the prettiest nymph in Calypso's entourage, is obliged by Mentor to abandon her young lover, with whom Calypso is herself in love. At the moment of their parting, Eucharis allows herself one last lingering embrace. David may have had in mind the painful separations imposed by his departure for the Académie in Rome in

Jacques-Louis David |
CUPID AND PSYCHE
1817, oil on canvas,
181 × 241 cm
(71 1/4 × 94 7/8 in).
Cleveland Museum of Art, Cleveland.

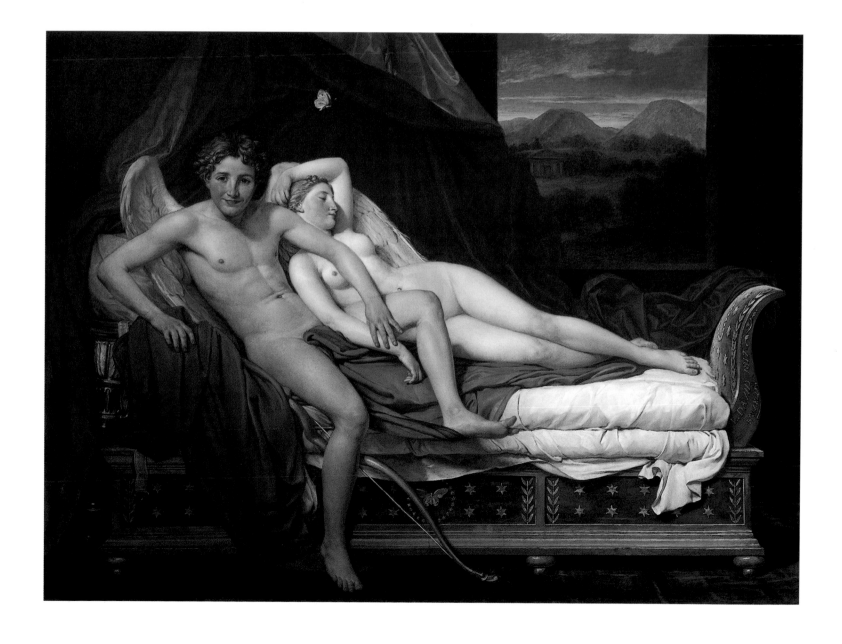

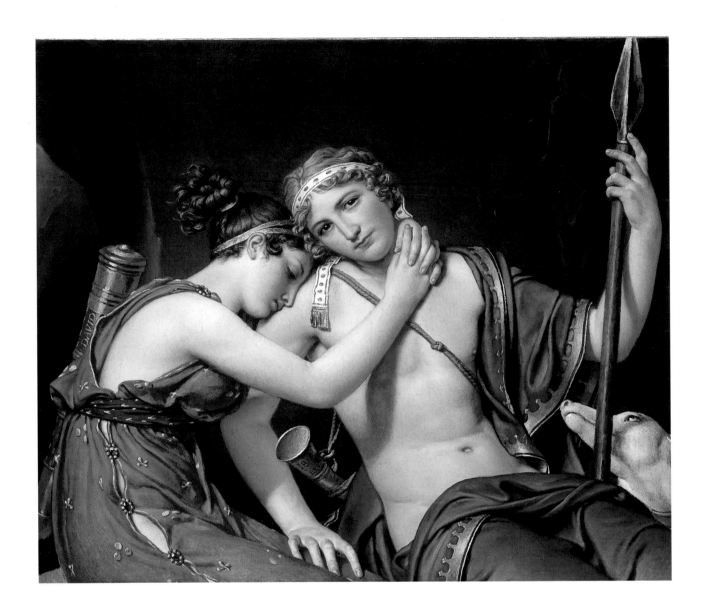

Jacques-Louis David |
**TELEMACHUS' FAREWELL
TO EUCHARIS**
1818, oil on canvas,
87 × 103 cm
(34 1/4 × 40 1/2 in).
The J. Paul Getty Museum, Los Angeles.

1770. He would also have witnessed countless such scenes of despair during the Revolution, when couples were torn apart by prison, war or the scaffold. The *Farewell* was commissioned by Count Schoenborn, and on David's recommendation he commissioned a companion-piece, *Bacchus and Ariadne*, from Gros, who completed it in 1820.

Like the *Telemachus, The Anger of Achilles* (1819) uses half-length figures, and displays the density of colour characteristic of David's Belgian period. Nevertheless, Delacroix pronounced it "weakness itself" by comparison with the *Agamemnon* and *Achilles* of Rubens. Again we encounter the opposition – a constant in David's work since the *Horatii* – between a woman's world steeped in suffering (the central Iphigenia and Clytemnestra) and the continued stoicism of men (Agamemnon and Achilles). The faces were painted from life – Victorine Frémiet is thought to have modelled Clytemnestra, while Sieyès' nephew posed as Agamemnon – and reflect the concern for realism evident in David's compositions of this time.

The last picture in this mythological series, *Mars Disarmed by Venus and the Graces* (1824), shares certain of the props used in *Cupid and Psyche*. His

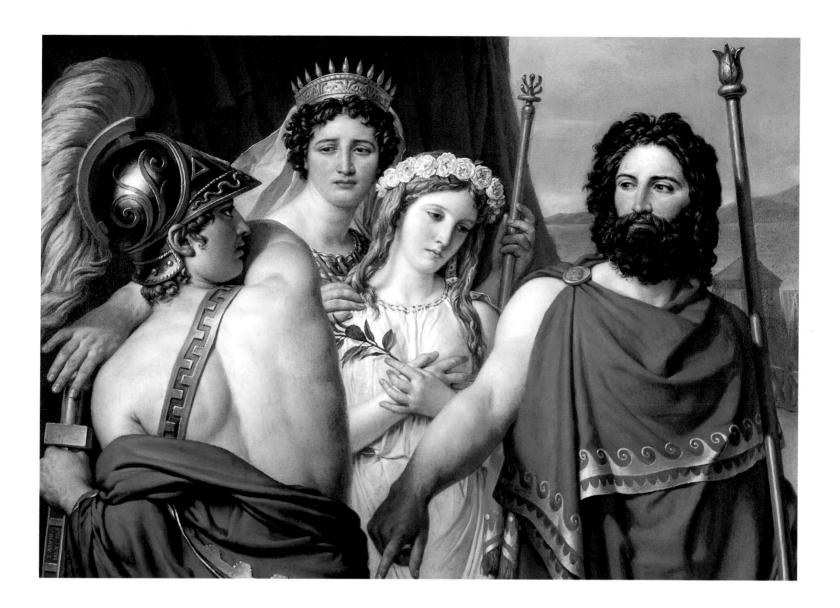

assistants, notably Pavillon and Rouget, prepared the background. David was again working in imaginary competition with a rival – in this case Ingres and his *Jupiter and Thetis*. The backdrop to this ambitious composition is the pediment of a temple set upon a sea of clouds. Classical components (a shield decorated with a *quadriga*, the traceried helmet and the ewer) sit ill next to the hyper-realistic treatment of the god of war, who is confronted by rather clumsy-looking Graces and a Venus straight out of Ingres. Quatremère de Quincy found the painting "very Greek". In May 1824, it was exhibited in Paris in a hall rented for the occasion by Eugène David. "I took it upon me to paint the gods; like a modern Titan, I dared enter their dwelling" David confided to Mongez. It was to be his last exercise in what he called "my grand historical style". During this period, David made many pencil drawings relating to classical subjects. One of these, *The Prisoner*, is particularly significant. It depicts a turbaned man in chains, naked from the waist up, and showing a remarkable resemblance to David's portraits of the Emperor. On 5 May 1821, Napoleon had died in exile on Saint Helena, and this seems to be an act of silent homage from the Emperor's First Painter.

| Jacques-Louis David
THE ANGER OF ACHILLES
| 1819, oil on canvas,
| 105 × 145 cm
| (41 3/8 × 57 in).
Kimbell Art Museum, Fort Worth.

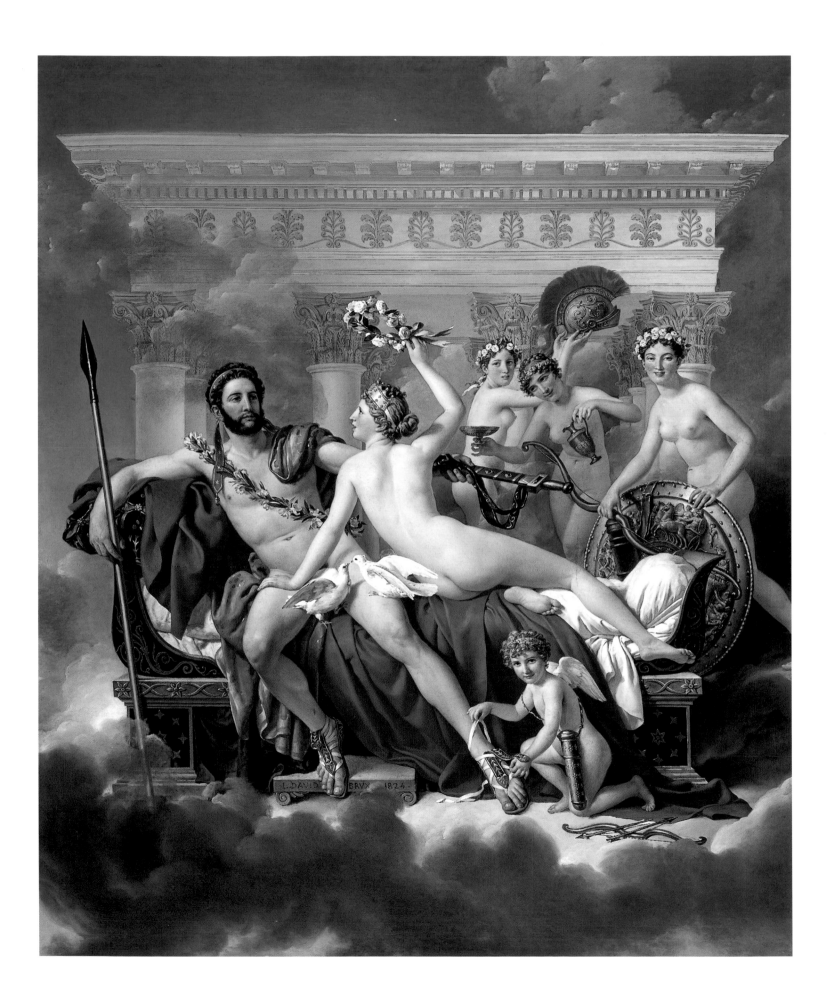

Jacques-Louis David |
**STUDY FOR MARS DISARMED
BY VENUS AND THE THREE GRACES**
Undated, black lead,
20.4 × 27.5 cm (8 × 10 1/4 in).
Musée des Beaux-Arts
et d'Archéologie, Besançon.

| Jacques-Louis David
**MARS DISARMED BY VENUS
AND THE THREE GRACES**
1824, oil on canvas,
308 × 262 cm
(121 1/4 × 103 1/8 in).
Musées Royaux des Beaux-Arts,
Belgique.

One of David's last paintings is also one of his most surprising. *Good Fortune* was painted a year before his death, and testifies to his renewed inspiration. It is, quite unexpectedly, a genre scene. Examples of this theme were available in classical low reliefs, Michelangelo and Caravaggio. Moreover, he himself had often consulted Mlle Le Normand, the most famous medium of her time, in his Parisian years. In this David returns to the austerity of his revolutionary period.

In 1824, when the comte d'Artois ascended the French throne as Charles X, Gros felt confident that David could contemplate a return from exile. Mme Récamier, always ready to help her friends, intervened on his behalf, but without success. Villemain, his former colleague at the Institute, drew up a further petition. But David's reaction was, this time, categorical: "Let me hear no more of the steps I might take to return. I am under no obligation; the duty I owed my country, I have done. I have trained an illustrious school of painters; I have painted classic works, which all Europe will aspire to study. I have performed my task. Let the government do the same."

One evening in early 1824, David was hit by a passing carriage as he was leaving the theatre. The accident weakened him, and he entered a slow decline. The actor Talma, performing in Brussels, found him a shadow of his former self. Painting had been his life; now the palette was too heavy, and his hand no longer obeyed. He died on 29 December 1825. The government of Charles X would not allow his corpse back into France. The founding father of a renaissance in French painting spent the last ten days of his life talking of nothing but painting. At the last – so the legend goes – he whispered "Know this, only David could have painted Leonidas."

| Jacques-Louis David
GOOD FORTUNE
1824 (?), oil on canvas,
62 × 75 cm
(24 3/8 × 29 1/2 in).
The Fine Arts Museums of San Francisco.

| Pablo Picasso

THE RAPE OF THE SABINE WOMEN

1962, oil on canvas,

90 × 130 cm (35 1/2 × 51 1/8 in).

| Musée National d'Art Moderne, Paris.

David and Modernity

David's funeral in Brussels was on a scale commensurate with his renown. The artists of the city, armed with torches and wreathes, and his pupils, carrying banners reproducing his most famous works, walked before the cortège as it made its way to the church of Sainte-Gudule. When news of his death reached Paris, a large crowd of friends, pupils and admirers gathered outside the Palais du Luxembourg, all wanting to organise events in his memory. The government, however, was opposed to the idea, fearing the disorders that might result from public homage to a regicide. In a speech to the Convention, David had looked forward to the day when foreign travellers would say: "I saw kings at Paris, I returned, and they were no longer to be found." He could not be forgiven. Even the transfer of his paintings from the Luxembourg Museum to the Louvre – the procedure was automatic on an artist's death – might, it was felt, pose problems of public order. In 1826 and 1835, the sale at the Galerie Le Brun of works belonging to the painter's family caused the regimes of Charles X and Louis-Philippe considerable disquiet: the portraits of Marat and Le Peletier threatened to re-awaken the violent discords of the past. The portrait of Le Peletier de Saint-Fargeau was bought by his royalist daughter, Mme de Mortefontaine. In an example of the passions elicited by David's work, she had the inscription "I vote for the death of the king" erased from the canvas, along with the bloody sword that hung above the death bed. Fearing that either she or her heirs might one day destroy the work completely, David's family obtained permission to see it once every six months. The picture vanished nevertheless.

Another incident indicates the political disarray into which David plunged his colleagues even after his death. In 1827, when Charles X commissioned Ingres and Gros to paint portraits of celebrated artists on the ceilings of the Louvre, neither of them dared to include David. By the time of the Second Empire, however, Ingres felt able to include a portrait of his master in the *Apotheosis of Homer* (1865), saying: "I could not omit the powerful figure of David, who, a century after Poussin, was the illustrious reformer of French art." The most celebrated of David's pupils, Ingres, had now inherited his master's mantle as grand pontiff of the arts.

But in 1860, Delacroix, Ingres' great rival, declared that he preferred the taste of David and his school to "the bastard genre, mixing Raphael and the antique, that is the style of Ingres and his followers".

After long years of reverent admiration, there came a period when David was largely forgotten. Even before his death, the austere principles of neo-classicism had lost ground to the new Romantic sensibility. Painting once more embraced landscape and movement, and turned its back on classical antiquity in favour of Gothic and legendary themes. At the Salon of 1824, the *Massacre*

at Chios have revealed Delacroix's orientalism to the public. Insulated by a cocoon of praise, the exiled David seems not to have grasped the scale of this aesthetic revolution. In 1826, at an exhibition held in Paris to support the Greek uprising against Turkish occupation, the two styles met head to head; some of David's greatest neo-classical works – *The Death of Socrates, Napoleon Crossing the Saint Bernard Pass* and *Mars Disarmed* – were hung alongside Delacroix's *Greece on the Ruins of Missolonghi*. Twelve months later, Delacroix's *Death of Sardanapalus* confirmed his position as the leader of the Romantic school. For David's disciples, the end of painting seemed nigh. A few years later, finding the transformation in artistic taste quite unbearable, Gros committed suicide.

David's reputation suffered twice over. He was vilified for his political opinions, and mocked for a style whose severity was incompatible with the new aesthetic critieria. He was a victim of the war waged by Ingres and his disciples against Delacroix and the Romantics at precisely the time when the neo-classical style had become an academic convention. Stendhal was exasperated by this fate: "Why does the French school have to be frozen like the interest on an annuity, just because it had the good fortune to produce David, the greatest painter of the 18th century?"

When the copy of the *Coronation* returned from America to be sold, it proved hard to find a buyer; "A fairground canvas showing the apotheosis of the great mountebank" was the verdict of the Goncourt brothers. The extravagant idealisation of the naked, helmeted warriors in the works of David and his school gave birth to the pejorative term, *art pompier*, used to describe a pompous academic style. Delacroix was highly critical of David's manner, which he found cold, but he recognised his historical importance: "He is the master of the whole modern school in painting and in sculpture."

Baudelaire was the first to look at David's work again with fresh, unprejudiced eyes. For him, *The Death of Marat*, which had reappeared in an exhibition in 1846, was "David's masterpiece and one of the great curiosities of modern art." Baudelaire gives a poignant description of the picture, and rails against the denigration of David, crediting him with a veritable aesthetic revolution. David, he writes, followed the "the light of his artificial sun with a frankness, determination and coherence worthy of the virile men of the past". "There is," he declared twenty years later, "a great man who preceded Ingres and had far more talent: David."

It was thanks to the school of Ingres that David finally emerged from the long years of neglect. Yet the painters influenced by him stand quite outside the confines of the academic style. Degas, who studied with Ingres' pupil, Lamothe, was closer to David than to Ingres when he made his history painting *Young Spartans*. During the 1870 war, he adapted the composition of David's *Portrait of Antoine Mongez and his Wife* for his own double portrait, *General Mellinet and the Grand Rabbi Astruc*.

Seurat studied with Lehmann who, like Lamothe, was a follower of Ingres. His radically new vision was grounded in a detailed knowledge of the great masters of the past. The influence of David can be seen both in the *Models*, in

which the figures humorously adopt attitudes made famous by Romulus and Leonidas, and in the frieze-like construction of his *Parade*.

Confronted with the *Sabine Women*, Edmond de Goncourt lamented that "in his compositions, the bodies are not painter's drawings, but architect's diagrams". De Goncourt contributed greatly to the revival of interest in Boucher and Fragonard, and was, on that account, ill-qualified to perceive the merits of their austere successor. But it was precisely the sobriety of David's style that attracted 20th-century artists, and caused him to be hailed as a precursor of Cubism. Henceforth his work was valued less for its historical or mythological content than for the purity of its forms. In 1912, Apollinaire noted "David is the preferred master of certain young painters of the most daring school. For my own part, I believe *The Death of Marat* is a masterpiece, and one which could have been painted today." The strict geometry, masterful organisation of line and superimposition of one plane upon another are all features that David shared with the creators of the first aesthetic revolution of the century, who were so close to him in spirit. Thus Braque: "I like the rule that rectifies emotion." Or Juan Gris: "Every form in a painting must have an absolute value in the system of architectural relations." As the century progressed, further critical comment and further expressions of admiration followed, confirming David's rehabilitation. Fernand Léger gave expression to the simple joys of life under the Popular Front in *Leisure: Homage to Louis David* (1948-49). The transgressive value of Magritte's Surrealist transposition – in his *Perspective (Madame Récamier)*, the reclining woman has been replaced with a reclining coffin – is highly significant. Picasso had been fascinated by the *Death of Marat* when he saw it at the Universal Exhibition of 1900. His own *Sabine Women*, painted late in his life, is a combined homage to David and Poussin. As Bonnard remarked: "There is no art in nature; all art is composition."

| Jean-Auguste-Dominique Ingres
ANTIOCHUS AND STRATONICE
| 1840, oil on canvas,
| 57 × 98 cm (22 1/2 × 38 5/8 in).
| Musée Condé, Chantilly.

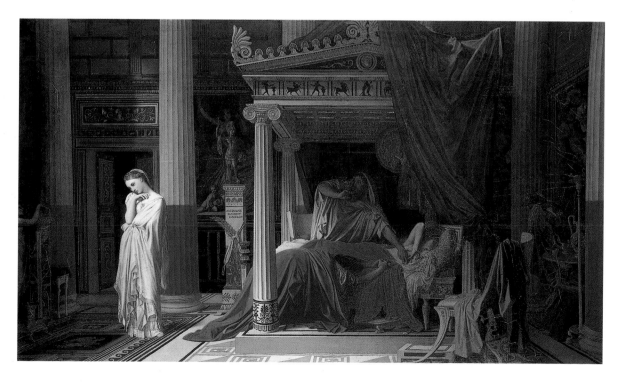

Bibliography

Baudelaire, Charles: *Œuvres complètes et correspondance*, Paris, 1975; *The Mirror of Art*, tr. Jonathan Mayne, London, 1955.

Jonathan Mayne, London, 1955; *The Painter of Modern Life and Other Essays*, tr. Jonathan Mayne, London, 1965.

Biographie universelle des contemporains, Paris, 1827 onwards.

Bordes, Philippe: *David*, Paris, 1988.

Bordes, Philippe: *"Le Serment du Jeu de Paume" de Jacques-Louis David: le peintre, son milieu et son temps, de 1789 à 1792*, Paris, 1983.

Brookner, Anita: *Jacques-Louis David*, New York, 1980.

Chatelain, Jean: *Dominique Vivant Denon*, Paris, 1973.

Crow, Thomas: *Emulation: Making Artists for Revolutionary France*, New Haven, 1995.

Daix, Pierre: *Pour une histoire culturelle de l'art moderne, de David à Cézanne*, Paris, 1998.

David, exhibition catalogue, by Antoine Schnapper, Arlette Sérullaz and Marie-Catherine Sahut, Paris, 1989.

David, Jules: *Le peintre Louis David, 1748-1825. Souvenirs et documents*, Paris, 1880.

David, Marcel: *Fraternité et Révolution française*, Paris, 1987.

De David à Delacroix. La peinture française de 1774 à 1830, Paris, 1974-1975.

Delacroix, Eugène: *Journal 1822-1863*, Paris, 1932. *The Journal of Eugène Delacroix*, tr. Walter Pach, London, 1938.

Delacroix, Eugène: *Correspondance*, Paris, 1938.

Delécluze, Étienne Jean: *Louis David, son école et son temps*, Paris, 1855.

Diderot, Denis: *Œuvres complètes esthétiques*, Paris, 1978; *Diderot on Art*, tr. John Goodman, New Haven, 1995.

Diderot et l'art, de Boucher à David, exhibition catalogue, Paris, 1984.

Géricault, exhibition catalogue, by Sylvain Laveissière and Régis Michel, Paris, 1991.

Haskell, Francis: *Rediscoveries in Art. Some Aspects of Taste, Fashion and Collecting in England and France*, London, 1976.

Hautecœur, Louis: *Louis David*, Paris, 1954.

Irwin, David: *Neoclassicism*, London, 1997.

Johnson, Dorothy: *Jacques-Louis David. Art and Metamorphosis*, Princeton, 1993.

Johnson, Dorothy: *The Farewell of Telemachus and Eucharis*, San Francisco, 1997.

Lee, Simon: *David*, London, 1998.

Lévêque, Jean-Jacques: *La vie et l'œuvre de Jacques-Louis David*, Paris, 1989.

Mercier, Louis-Sébastien: *Le tableau de Paris*, Amsterdam, 1783; *Le Tableau de Paris*, tr. and abridged Helen de Guerry Simpson, London, 1933.

Mercier, Louis-Sébastien: *Mon bonnet de nuit*, Neuchâtel, 1785.

Nanteuil, Luc de: *David*, Paris, 1987.

Néret, Gilles: *David, la Terreur et la vertu*, Paris, 1989.

Ozouf, Mona: *Festivals and the French Revolution*, Cambridge, Mass., 1988.

Schnapper, Antoine: *David*, New York, 1982.

Staël, Madame de: *Correspondance générale*, edited by Béatrice Jasenski, Paris, 1962.

Thibaudeau, Antoine-Clair: *Vie de David*, Brussels, 1826.

Thiers, Adolphe: *Histoire de la Révolution, du Consulat et de l'Empire*, Paris, 1865-1868. *The Historical Works of M. Thiers*, London, 1845.

Un nouveau monde, chefs-d'œuvre de la peinture américaine, exhibition catalogue, by Pierre Rosenberg, Théodore F. Stebbins and Helen Barbara Weinberg, Paris, 1984.

Verbraeken, René: *Jacques-Louis David jugé par ses contemporains et par la postérité*, Paris, 1973.

Vigée-Lebrun: Elisabeth, *Souvenirs*, Paris, 1984.

Wildenstein, Georges and Daniel: *Documents complémentaires au catalogue de l'œuvre de Jacques-Louis David*, Paris, 1973.

Agence AGK, Paris, S. Domingie and M. Rabatti: p.2. Agence Artothek, Peissenberg: pp. 67, 95. Agence Giraudon, Paris: pp. 154, 193, 202, 205. Erich Lessing Archives, Vienna: pp. 58, 59. The Art Institute of Chicago: pp. 22 (Gift of Albert J. Beveridge, 1963), 107 (Clyde M. Carr Fund and Major Acquisitions Endowment, 1967). Agence de la Réunion des musées nationaux (RMN), Paris: cover, pp. 8 (left), 9 (right), 12-13, 48, 49, 54, 80, 81, 82, 98, 99, 103, 108, 116, 120, 132, 141, 142, 150, 152-153, 159, 161, 163, 165, 166, 167, 170 (right and left), 178, 201 (top). RMN, D. Arnaudet pp. 6, 32-33, 60-61, 106. RMN, D. Arnaudet and J. Schormans: p. 62. RMN D. Arnaudet and G. Blot: pp. 176-177, 182, 184-185. RMN, M. Bellot: pp. 35, 36 (left and right), 37 (left and right), 38 (left and right), 39, 40 (top), 114 (top), 121, 133, 148 (below), 156, 164 (top), 175. RMN, J. G. Berizzi: pp. 21, 162, 174, 192. RMN, G. Blot: pp. 63, 83, 97, 100-101, 102, 122, 123, 124, 130, 151, 164 (below), 168. RMN, G. Blot and C. Jean: pp. 8-9 (centre), 70-71, 88-89, 92, 93, 126-127, 157. RMN, F. Dubuisson: pp. 194-195. RMN, H. Lewandowski: pp. 25, 26, 56-57, 85. RMN, R. G. Ojeda: pp. 5, 34, 40 (below), 64, 68, 69, 72, 74 (left), 76 (left), 91 (left and right), 101 (right), 134-135, 136, 137, 149, 155. RMN, R. G. Ojeda and P. Néri: pp. 23, 24. RMN, J. Schormans: p. 139. RMN, J. Schormans and C. Jean: p. 186. RMN, P. Willi: pp. 171, 172-173. Bibliothèque nationale de France, cabinet des estampes, Paris: pp. 17, 114-115, 118-119 (below), 119 (top). The Bridgeman Art Library, London, New York / Hermitage Museum, Saint Petersburg: p. 42 (top left). The Bridgeman Art Library, London, New York / Prado Museum, Madrid: p. 147. The Cleveland Museum of Art, Cleveland: pp. 66 (Gift of George S. Kendrick, 1952), 197 (Leonard C. Hanna Jr Fund, 1962). École nationale supérieure des Beaux-Arts, Paris: pp. 15, 20, 29, 44, 55, 65. The Fine Arts Museums of San Francisco, Gift of M. H. de Young: p. 152 (left). The Fine Arts Museums of San Francisco, Gift of David David-Weill, 1947: p. 201 (below). The Frick Collection, New York: p. 144. Graphische Sammlung Albertina, Vienna: pp. 44-45. Harvard University Art Museums, President and Fellows Harvard College, Cambridge: p. 189 (Bequest of Greenville L. Winthrop). The J. Paul Getty Museum, Los Angeles: pp. 143, 198. Kimbell Art Museum, Fort Worth: pp. 180-181, 199. The Metropolitan Museum of Arts, New York: pp. 28 (Rodgers Fund, 1961), 76-77 (Catharine Lorillard, Wolfe Collection, Wolfe Fund, 1931. [31-45]), 79 (Purchase, Mr and Mrs Charles Wrightsman Gift, in honor of Everett Fahy, 1977. (1977-10), 191 (Purchase, Rogers and Fletcher Funds, Bequest of Mary Wetmore Shively in memory of her husband, Henry L. Shively, M. D., by exchange, 1965. (65.14.5). Musée Calvet, Avignon: pp. 112, 112-113. Musée de Chartres, photographe F. Velard: p. 86. Musée de Grenoble: pp. 52-53. Musée de la civilisation, dépôt de la Fabrique Notre-Dame de Québec, P. Altman: p. 50. Musée de la Révolution française, Vizille: p. 105. Musée des Augustins, Toulouse: p. 60 (top left). Musée des Beaux-Arts de Dijon, H. Martens: p. 109. Musée des Beaux-Arts de Strasbourg: p. 19. Musée des Beaux-Arts de Tours, P. Boyer: p. 90. Musée des Beaux-Arts de Troyes, J.M. Protte: p. 18. Musée Fabre, Montpellier, F. Jaulmes: p. 84. Musée d'Angers: pp. 74-75. Musées royaux des Beaux-Arts de Belgique, Brussels: pp. 110-111, 200. The National Gallery, London: p. 128. The National Gallery of Art, Washington: p. 145 (Samuel H. Kress Collection). The National Gallery of Ireland, Dublin: pp. 46, 47. The National Gallery of Scotland, Edinburgh: pp. 41, 42-43. Ny Carlsberg Glyptotek, Copenhagen: p. 188. Philadelphia Museum of Art, Philadelphia: p. 169 (Gift of Henry P. McIlhenny). Photothèque des Musées de la ville de Paris: pp. 27, 117, 140, 146. Thorvaldsens Museum, Copenhagen, Hans Petersen: p. 148 (left).

© Picasso Estate, Paris, 1998.
© The Metropolitan Museum of Art, 1995,1989,1980.

ACKNOWLEDGEMENTS

The Editions Pierre Terrail would like to thank the staff of the photographic agency of the Réunion des musées nationaux, and in particular M. Richard, for their assistance during the preparation of this book.

Printed in Italy
by OFFSET PRINT VENETA
Verona